GoPro®

Cameras

Date: 4/24/17

for
dummies®
A Wiley Brand

GoPro®
Cameras

2nd Edition

by John Carucci

A Wiley Brand

GoPro® Cameras For Dummies®, 2nd Edition

Published by **John Wiley & Sons, Inc.,** 111 River Street, Hoboken, NJ 07030-5774, www.wiley.com

Copyright © 2017 by John Wiley & Sons, Inc., Hoboken, New Jersey

Media and software compilation copyright © 2017 by John Wiley & Sons, Inc. All rights reserved.

Published simultaneously in Canada

For general information on our other products and services, please contact our Customer Care Department within the U.S. at 877-762-2974, outside the U.S. at 317-572-3993, or fax 317-572-4002. For technical support, please visit https://hub.wiley.com/community/support/dummies.

Wiley publishes in a variety of print and electronic formats and by print-on-demand. Some material included with standard print versions of this book may not be included in e-books or in print-on-demand. If this book refers to media such as a CD or DVD that is not included in the version you purchased, you may download this material at http://booksupport.wiley.com. For more information about Wiley products, visit www.wiley.com.

Library of Congress Control Number: 2016958641

ISBN: 978-1-119-28554-0

ISBN (ePDF): 978-1-119-28556-4; ISBN (ePub): 978-1-119-28555-7

Manufactured in the United States of America

10 9 8 7 6 5 4 3 2 1

Contents at a Glance

Table of Contents

Introduction

Compared with traditional camcorders, the GoPro is a superhero, able to leap tall buildings in a single . . . er, smartphone click. Your first inclination when hearing about such a unique camera is to think it costs a lot of money, but that's not the case. The GoPro is cheap. Very cheap.

The GoPro challenges conventional notions of where you can put a camcorder and continually challenges users to find new and exciting places to capture movies and photographs. You can control the camera from a distance through an app on your smartphone, thus keeping you out of harm's way. It's waterproof too, so you can capture video footage under the wettest of circumstances, submerging the camera to record stunning underwater sequences right out of the box.

The capability to work in weird places would go only so far if the GoPro's image quality were subpar. In fact, the GoPro can capture 4K video at a rate of up to 30 frames per second (fps), depending on the model, so you can capture unique high-quality video at an affordable price. High-definition (HD) offers even higher frame rates, up to 240 fps.

This rugged little camera can go anyplace and produce exciting new perspectives. It works for everyone from amateurs to pros. Families use it to document their daily lives; students experiment with it; photographers use it to supplement camcorder footage. GoPro has even spread to the professional arena, with an increasing presence in broadcast news programs, movies, and television shows.

I've had a blast making movies and playing with my GoPro, so I hope you'll think that I'm the right dummy to introduce you to this camera.

About This Book

The new and improved *GoPro Cameras For Dummies* helps you make sense of GoPro moviemaking. Through my experience as a still photographer and a television producer, I describe how to use your GoPro to make movies, take still images, and make time-lapse sequences with fresh techniques and the latest cameras in the line.

Think of this book as a quick information stop where you can find out what you need and get back to work. It includes cinematic tips, effects that will impress your audience, advice on effective edits, and even some cool uses for your GoPro.

I wrote this book for people who have different proficiency levels but have similar ambition for making compelling movies and pictures. Some readers have already made their mark in conventional video production and want to add one more weapon to their arsenal. Others come from the still-photography sector and are fascinated by the GoPro's still and time-lapse capabilities. Still photography is an untapped resource for GoPro, thanks to its ultra-wide-angle lens and unlimited mounting ability. Simply put, it's a great camera for capturing images with a unique perspective. Hobbyists, family documentarians, students, and now artists are all looking to understand this new, exciting phenomenon. The goal of this book is to make sure that everyone gets the knowledge he or she needs to use the GoPro.

How This Book is Organized

GoPro Cameras For Dummies is divided into four parts; each part details the phases of understanding GoPro moviemaking as effectively as possible. You will no doubt have a preference for a particular area. You may relish the section that pertains to understanding the camera, or you may skip ahead to the filmmaking techniques or the cool places you can use a GoPro.

Part 1: Getting Started with Your GoPro Camera

Part 1 provides the reader with a swift overview and capability of the updated GoPro camera system. Whether you're a beginner looking to make movies with this unique camera, a working professional creating fresh visual perspectives for your movie or segment, or anyone in between, this group of chapters covers the newest GoPro models, types of users, and important accessories for making movies.

Part 2: Moviemaking Technique

If you think the chariot scene in the classic film *Ben-Hur* was spectacular, imagine if they had GoPros back then. The GoPro changes the way you shoot action, yet regardless of the device or camera, the language of cinema remains the most important aspect for making a movie. The following chapters explain filmmaking

technique specific to the camera so you can produce an impressive movie with your GoPro HERO.

Part 3: Movies Are Made in Postproduction

Shooting video is only the first part of the process, unless you want to simply play your raw footage and bore your audience with a few moments of the good stuff, and the rest the warts and blemishes. Editing lets you show the viewer exactly what you want, thus creating the "wow" factor. This section covers editing your movie on a computer loaded with GoPro Studio editing software.

Part 4: The Part of Tens

The Dummies version of a top ten list will provide insight into fun places to mount your GoPro, professional applications, and making your movies and pictures better by avoiding the pitfalls of using it.

Icons Used in This Book

What's a *For Dummies* book without icons pointing out great information that's sure to help you along your way? In this section, I briefly describe the icons used in this book.

REMEMBER

This icon marks a generally interesting and useful fact — something you may want to remember for later use.

TIP

This icon points out helpful suggestions and useful nuggets of information.

TECHNICAL STUFF

When you see this icon, you know that techie stuff is nearby. If you're not feeling very techie, feel free to skip it.

WARNING

The Warning icon highlights lurking danger. With this icon, I'm telling you to pay attention and proceed with caution.

Beyond the Book

Like every *For Dummies* book, this one comes with a free Cheat Sheet that brings together some of the most commonly needed information for people learning to use, in this case, GoPro cameras. To get the Cheat Sheet, head for www.dummies.com and enter **GoPro Cameras For Dummies 2nd Edition Cheat Sheet** in the Search box.

1

Getting Started with Your GoPro Camera

Chapter **1**

Getting to Know GoPro

You've probably heard the old saying, "Good things come in small packages." Sometimes it's true, as in the case of a diamond ring. That sparkly rock is small, and many people would agree that it's good. But a mosquito, which is smaller than a diamond, isn't good at all, especially on a warm summer evening.

Small cameras rarely solicit as much disdain as mosquitoes do. Most of us accept the compromise of function for size, understanding that it's acceptable for a camera to have less quality and fewer features in exchange for traveling well.

The GoPro, however, shatters that compromise like a rock on a plate-glass window. This pint-size wonder not only fits in the palm of your hand, but also easily mounts anywhere. Put it on a bicycle helmet to capture the rider's perspective. Mount it on a surfboard and not worry about frying the electronics, thanks to its watertight housing. How about mounting it on an inexpensive remote-control drone (more appropriately known here as a quadcopter) and recording overhead footage and something that was out of the realm of possibility for consumers a few short years ago? (Check local ordinances first so you don't fly your airship too close to a restricted area or violate privacy and security of others. More on that in Chapter 6.)

Introducing the GoPro

The GoPro is a pint-size, consumer-priced camcorder that yields professional results and does lots of cool stuff thanks to its Wi-Fi capability, superior performance, and extreme portability.

The GoPro doesn't take up much space, so it's easy to pack, carry, and mount in interesting places. The most feature-rich model, the HERO5 Black is a shade under 3 inches long, so it would take a bagful of these cameras to occupy the same amount of space as a conventional camcorder. The HERO5 Session and HERO Session are even smaller. Regardless, the diminutive stature of GoPro becomes even more important when you mount several cameras in a confined area and that's a good thing, because these little guys are often used in bunches.

"The bigger they are, the harder they fall" doesn't apply to the GoPro because it weighs ounces, not pounds. Since the camera is small and lightweight, you can place it almost anywhere with little concern that it will fall because it's too heavy. Earlier GoPro models captured movie files on an SD card, but because the camera got smaller and lighter with each upgrade, it now uses a petite microSD card (see Figure 1-1) that holds up to 128 GB of pictures and movies.

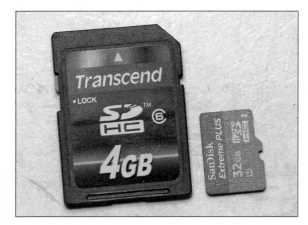

FIGURE 1-1:
SD (left) and microSD (right) cards.

Wishing for the existence of such a camera just a mere generation ago was quite a stretch, like wanting a Pegasus in your barn. Fret no more. Your sanity is safe — at least when it comes to the existence of a durable, inexpensive camera that goes anywhere while capturing high definition video and even 3D video. All it takes to accurately capture whatever situation you have in mind is an optional, inexpensive mount.

Use it anywhere

Just a few years ago, ambitious users who attempted to put an expensive camcorder in a place where it didn't belong usually didn't get a compelling piece of work; rather, they often had to pick up the pieces of their smashed cameras. That's less a worry these days, thanks to the design and durability of the GoPro.

Beyond being small and well designed, a GoPro can go anyplace you go and mount almost anywhere. Moviemaking has always had the dubious distinction of being a cumbersome endeavor, usually because of the size and weight of the equipment. It's quite refreshing to have a high-quality camera with ultra-wide optics that fits in the palm of your hand and that has a mount for almost every situation.

Capturing footage in nonconventional places is the GoPro's job description. The tougher the situation, the more impressive the results. The GoPro is shock-resistant and waterproof, which are good qualities for a camera that can mount on almost anything, moving or otherwise. The next time you're inspired to mount the camera on Fido for a dog's-eye view, feel free. Shock your friends and neighbors when you decide to take the camera into the pool to shoot an underwater sequence (see Figure 1-2).

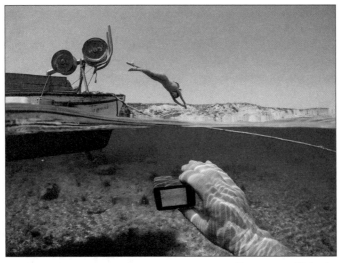

FIGURE 1-2: The GoPro HERO5 Black can do a lot in, out, and under the water.

Photo courtesy of GoPro, Inc.

Forget conventional camcorders

The GoPro doesn't resemble a conventional camcorder, nor does it behave like one. It looks more like a small square box with a protruding lens than a sleekly

designed camcorder. Although you can hold it like a traditional camera, it is equally effective (if not more so) when it's attached to something.

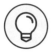

Here are some of the qualities that differentiate a GoPro from standard camcorders:

>> **Size:** The current GoPros are quite small compared with most camcorders and significantly smaller than their predecessors.

>> **Most models don't have a viewfinder:** Though the viewfinder is one of the main parts of a camcorder, only one current GoPro includes a viewing screen. That's okay because you wouldn't look through a viewfinder for most situations. The lack of a viewfinder doesn't mean you have to imagine where the action will take place. Simply use Capture (discussed later in this chapter), which transforms your smartphone or tablet into a monitor.

>> **Wide-angle view:** The GoPro captures an angle of view up to 170-degrees that provides an ultra-wide view unavailable on any camcorder.

Better than a camcorder

Just a few years ago, merely having a moderate wide-angle view on a camcorder was a minor coup. Going reasonably wider often meant using one of those poor quality wide-angle adapters that screwed on the filter or clamped over the lens. Adapters produced exaggerated distortion, especially on the edges, creating a foggy appearance. The GoPro provides a wider perspective than those old accessory lenses, as shown in Figure 1-3, and does it with impressive optical quality.

FIGURE 1-3: An expansive view from the GoPro's wide-angle lens taken relatively close to the subject.

REMEMBER

In a way, the GoPro represents the elusive go–anywhere camera that's everything the camcorder never was: durable, mountable, and affordable.

Here's why:

>> **Waterproof housing:** Thanks to its polycarbonate body on the HERO5, (and Session) and plastic housing on other HERO models, you can use your GoPro in, around, and under water.

>> **Wearability:** Although it's not the kind of accessory that fashionistas clamor for on the catwalk during Milan Fashion Week, the GoPro is still quite fashionable. You can not only wear it, but also capture some pretty impressive video with it.

Here are a few ways to wear it (More will be discussed in Chapter 2):

>> **Chesty:** The Chesty harness allows you to transform yourself into a living dolly. Instead of moving the camera through the scene and capturing choppy footage, be one with the camera and move through the scene in Zen-like splendor.

>> **Head Strap:** The headband attaches to your head so you can get that walk-through look in your video (see Figure 1-4).

>> **Hand and Wrist Strap:** Allows you to wear the camera on your arm or wrist. Capture timely footage simply by twisting your wrist or moving your arm.

FIGURE 1-4:
Mounting your GoPro on the Head Strap lets you establish a subjective perspective simply by moving through the scene.

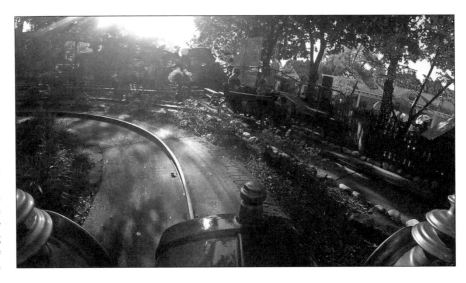

>> **Bicycle helmet:** Wear the camera mounted on your helmet to get the unique perspective of a cyclist.

>> **Seeker:** Include mounting options of Seeker backpack.

Seeing What a GoPro Can Do

What can a GoPro do? Here's a more relevant question: What do you want it to do? Asking this question is more like asking yourself about your own wishes and desires for unique video footage. When you determine what you want to capture, all you must do is connect the camera to the appropriate mount and press the Record button.

The following sections cover a few special capabilities of the GoPro.

Take still photos

Although still-photo capability rarely (and *rarely* means almost never) finds its way onto the list of reasons to buy a video camcorder, GoPro is the refreshing exception to that rule. It not only gets up close and personal with its ultra-wide-angle view (see Figure 1-5), but also does it with extreme sharpness. You can take still capture even further by capturing a scene at preset intervals to create a time-lapse movie. Although the current editions of the GoPro have excellent still-photo quality, it increases with each model.

TIP

For details on still-photo specs, see "Comparing GoPro Editions," later in this chapter.

Capture the scenes of your dreams

The GoPro liberates your imagination by allowing you to capture situations that in the recent past seemed like fantasies. Since the early days of motion-picture capture, people always had the desire to present each shot with a unique perspective. At some point or another, we've all wanted to mount a video camera on a car bumper to capture compelling footage or fly it remotely over the action on some hobby craft, but doing so was never feasible or practical. The ambitious efforts of the more adventurous often ended in a crash landing.

FIGURE 1-5:
Still capture
with the GoPro
is remarkably
good, especially
at a unique
angle.

Now, with GoPro, those creative ideas are not only possible, but also practical thanks to the camera's durability, unique mounts, and Wi-Fi communication. Here are a few things that GoPro makes possible:

>> Connect it to an extension pole to get an overhead shot of the scene.

>> Put it on a guitar.

>> Attach it to your dog.

>> Use it on a surfboard.

>> Mount it on a car.

Capture HD and 4K video

Although all current GoPro models let you capture full-frame high-definition (HD) video, the quality and frame-rate options increase with the 4K setting. Using H264 compression, the GoPro compresses captured video files to fit more information on the microSD card, and the compressed files maintain substantial quality when opened. 4K is a high-resolution setting for video capture. Think HD and then quadruple the quality.

TECHNICAL STUFF

The 4K mode captures 3820×2160 resolution with a frame rate of 30 frames per second (fps) on the HERO5 and HERO4 Black Editions. The higher frame rate cuts down the choppiness when capturing action sequences. The HERO4 Silver Edition and HERO3+ Black Edition capture at 15 fps. The HD modes on all current HERO models capture between 30 and 120 fps. The HERO4 Black and HERO5 Black can record to 240 fps in the 720p mode. The more frames a camera captures, the smoother the playback. At 15 fps, situations that have less movement render much better than those with fast action.

Attach to anything

The GoPro system can make you feel like Inspector Gadget. There's something very spylike about securing your GoPro anyplace you want — high or low, moving or stationary— and then monitoring the scene on your smartphone. Thanks to the camera's various mounting plates, you can put it almost anywhere, even a boat rail as seen in Figure 1-6.

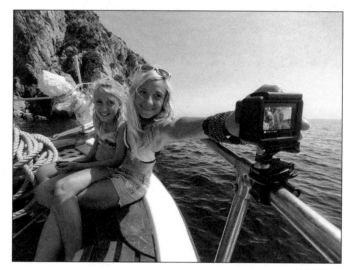

FIGURE 1-6:
You can easily use the Large Tube Mount anywhere, including on a boat rail for a quick family portrait.

Photo courtesy of GoPro, Inc.

TIP

Connect the camera to a skateboard, or mount a bunch of cameras inside and outside a car as it plows through dunes. You can even hold a GoPro underwater with an extension pole to capture underwater video. I talk more about mounting devices in Chapter 2.

Connect to your other devices

REMEMBER

Wi-Fi capability doesn't mean you can check your fantasy-football scores when shooting, but it does provide some pretty radical communication between the camera and your smartphone or remote. You can control the camera over Wi-Fi with your smartphone, tablet, or Apple Watch. You can also use devices as a monitor. The HERO5 also can automatically upload to the GoPro Plus Cloud. You will need a subscription to do it. Check it out at `http://shop.gopro.com/subscription/gopro-plus-monthly/GoProPlusMonthly.html`.

Here's more of what you can do via Wi-Fi:

>> Update firmware.

>> Check battery level.

>> See microSD card info.

>> View still photos and video.

Comparing GoPro Editions

The latest GoPro line, HERO5, features two cameras with varying features and quality levels. Each model offers Wi-Fi capability. The HERO5 Black closely resembles the size and footprint of the previous model, though it no longer needs a waterproof housing. The HERO5 Session looks like its predecessor, but internally it's been given a power jolt too. With 4K video capture, voice control, and some cool night functions, both models are equally amazing when it comes to quality, though each has features consistent with your needs.

Let's delve further into each model.

HERO5 Black

Once upon a time, it was a range of tonal names that differentiated the GoPro HERO, including the Silver and White editions. And while many of these models are still viable choices, the latest version is only about the Black. It's the big kahuna of the HERO line and it has been revamped so much that there's only a need for a single model of this size. The most obvious difference with this model is its ready-to-go waterproof design, good for depths as low as 33 feet (10m), and face it, how many times do you need to go deeper? A lot, you say, then just use the optional Dive Housing; it's good for close to 197 feet (60m).

Besides the built-in water protection, the latest entry is pretty feature-packed. Not only does it capture 4K video that can make your audience feel like they're in the middle of the action, but also it can capture it with one-button simplicity.

Internal improvements help stabilize video in shaky situations, capture crystal-clear audio, and provide pro-quality photo capture. Combine that with voice control and GPS, the HERO5 Black packs a lot of punch in such a portable camera. (see Figure 1-7)

Other new features over previous HERO models include:

>> **Touch screen display:** There's no more guessing at what you're capturing or controlling the camera thanks to a built-in two-inch screen that allows you to view the scene, change settings, and edit footage. You can even upload footage to your GoPro Plus Cloud account, and access it on any device.

>> **Voice control:** If you're going to deal with those funny looks when seen talking to your GoPro, it's nice for the camera to reciprocate. The voice command function will let you control the camera with hands, er, fingers-free operation. It understands 12 commands such as "GoPro start recording," or "GoPro turn off." As you can see by these examples, you must precede the action with GoPro, so the camera knows you're talking to her.

TECHNICAL
STUFF

>> **Stunning 4K recording**: Capture 4K video at 30 fps as well as 2.7K at 60 fps for ultra high-resolution video.

>> **Impressive HD video:** Record HD video at up to 1080p (progressive) up to 120 fps for capturing maximum detail. The higher frame rate also provides the best quality applying slow motion in GoPro Studio.

>> **Improved audio capture:** Thanks to the three-microphone system you can capture the clearest audio ever on a GoPro, both above and below the water. Internally, there's advanced audio processing and improved wind-noise reduction.

>> **Auto Low Light:** The camera adjusts exposure when light values change by changing frame rates to compensate when you move between dense shadow areas and bright spots.

>> **Better control over photos:** Lots of reasons. First, there's Protune for photos, which provides the same control over still photographs as you have for video. Like what? Changing the ISO setting, exposure compensation, white balance, color profile, and sharpness on still images and time-lapse sequences. You can shoot in RAW for increased flexibility in Photoshop, and the WDR modes capture maximum shadow and highlight detail.

>> **Built-in Wi-Fi and Bluetooth:** Allows you to control the camera remotely through the Remo (waterproof voice-activated remote), smart remote and the GoPro App. It also enables auto upload to your optional GoPro Plus Cloud account.

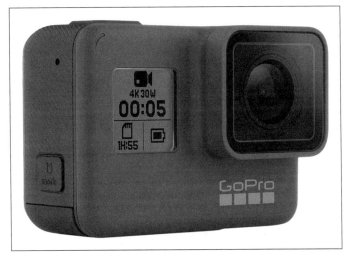

Photo courtesy of GoPro, Inc.

HERO5 Session

Most of the power of the HERO5 Black, but half its size, makes the HERO5 Session a great choice when you're looking to carry a little less camera without sacrificing a whole lot of quality. Not only can you mount it using a wide range of accessories, but you can wear it on your lapel like a corsage and capture the world with this incredibly portable camera. Stunning 4K capture, along with one-button simplicity makes this waterproof powerhouse a force to be reckoned with. (See Figure 1-8)

Other new features over previous Session models include:

- » **Voice control:** This camera is so small that when you're talking to it, a bystander may just assume you're talking to yourself. But it's a necessary function on a camera that's so small to control to get hands-free operation. Like the HERO5 Black, it understands a dozen commands such as "GoPro start recording," or "GoPro turn off."

- » **Stunning 4K recording**: Capture 4K video at 30 fps as well as 2.7K at 48 fps for ultra high-resolution video.

- » **Expanded modes:** Added Time-Lapse, Night-Lapse, and Night Photo modes expand the possibilities for creativity.

- » **Auto Low Light:** The camera adjusts exposure when light values change by changing frame rates to compensate when you move between dense shadow areas and bright spots.

>> **Impressive HD video:** Record HD video at up to 1080p (progressive) up to 90 fps for capturing maximum detail. The higher frame rate also provides the best quality applying slow motion in GoPro Studio.

>> **Protune for photos:** Provides the same control over still photographs as you have for video. Change the ISO setting, use exposure compensation, or adjust white balance on still images and time-lapse sequences.

>> **Built-in Wi-Fi and Bluetooth:** Allows you to control the camera remotely through the Wi-Fi remote and the GoPro App. It also enables auto upload to your optional GoPro Plus Cloud account.

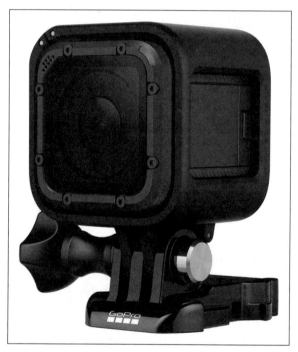

HERO Session

Not only is it the smallest GoPro in the lineup, but it's also the most inconspicuous. Easily worn, or mounted, it allows you capture impressive video and pictures in the smallest spaces. One–button operation makes it easy to start recording, but its small size provides less control on the camera. That's no problem, since you can control the camera from your app.

Some aspects to consider:

>> **Waterproof:** No need to worry about a waterproof housing, since the camera is already waterproof to depths of 33 feet.

>> **Impressive quality:** Sharp, professional-quality video capture at 1440p at 30 fps or 1080p at 60 fps. You can record at the higher frame rate of 100 fps at 720p for amazing slow-motion playback.

>> **Great photo capture:** Captures still frames at 8MP and photo bursts up to 10 frames. In addition, it captures time-lapse at intervals from 0.5 to 60 seconds.

>> **Built-in intelligent battery:** It only uses power when you're recording; otherwise it shuts off the camera. You can capture continuously for two hours or more on a full charge. On the downside, you cannot swap out the battery, so if it dies, you must fully charge the camera before using it again.

>> **One-touch recording:** A single button powers on the camera and starts recording video or time-lapse photos automatically.

>> **Few buttons:** The camera must be controlled through the Capture app to change settings.

>> **Always captures right side up:** Even if the camera is upside down, it will automatically capture the scene right side up.

>> **Protune:** When capturing video, it provides more control for camera settings, including white balance, exposure, ISO, and color. In addition, it captures with less compression than the non-Protune setting.

Previous GoPro Models

Don't worry if you're not using the latest model. The last few generations capture HD video, and even 4K.

HERO4 Black Edition

Every bit as relevant as its HERO5 Black successor, you can do everything with this model with minimal quality issues. Just like the new line, it captures 4K video at 30 fps as well as 2.7K at 50 fps for ultra high-resolution capture. It doesn't have the built-in waterproof case, nor does it have a touch screen. But since it's waterproof to deeper depths in its housing and you can always add an optional LCD Touch Screen Back, this model remains highly relevant.

Here are some of its features:

>> **HD video capture:** Captures HD video at up to 1080p (progressive) at 120 fps, making it possible to capture maximum detail even when applying slow motion in GoPro Studio.

>> **More powerful processor:** Twice as fast as its predecessor, so you can capture video at increased frame rates with more detailed image quality, increased sharpness, and better color.

>> **Auto Low Light:** Automatically adjusts exposure by changing frame rates to compensate when you move between dense shadow areas and bright spots.

>> **Protune for photos:** Apply the same control over images as you have for video. Change the ISO setting, use exposure compensation, or adjust white balance on still images and time-lapse sequences.

>> **Built-in Wi-Fi and Bluetooth:** Allows you to control the camera remotely, using the Wi-Fi remote with the GoPro App. For this model, the remote is sold separately.

>> **Set tags on your video:** The HiLight tag makes it easy to find the best part of your clip by setting markers while capturing footage.

HERO4 Silver Edition

The HERO4 Silver is loaded with features, captures 4K video, and was the first GoPro to include a viewfinder. While it can record 4K video, it does so at 15 frames per second, which is great for still or slow-moving subjects, but not so great when they move fast. On the HD side, this camera is impressive with capture up to 60 fps, making it possible to capture maximum detail even when applying slow motion in GoPro Studio.

Other features include:

>> **Auto Low Light:** Automatically adjusts exposure by changing frame rates to compensate when you move between dense shadow areas and bright spots.

>> **Protune for photos:** Apply the same control over images as you have for video. Change the ISO setting, use exposure compensation, or adjust white balance on your still images, as seen in Figure 1-9, and time-lapse sequences.

>> **Built-in Wi-Fi and Bluetooth:** Allows you to control the camera remotely, using the Wi-Fi remote with the GoPro App. For this model, the remote is sold separately.

>> **Set tags on your video:** The HiLight tag makes it easy to find the best part of your clip by setting markers while capturing footage.

FIGURE 1-9:
Protune
provides the
most control
for video and
photos.

HERO

The most no-frills model of the HERO lineup provides excellent image quality but not much else. It has a built-in waterproof housing with a built-in battery. There's not an accessory port, so you can't add a monitor, extra battery pack or Wi-Fi, so there's a little more guessing with this one since you can't see what you're shooting.

CHALLENGES IN USING A GOPRO

GoPro does so many things well, such as capturing HD video at a high frame rate and shooting high-quality time-lapse sequences, that it's easy to forget that using it involves some challenges:

- Steep learning curve

- Lower quality in low light

- Short battery life

- Fixed focal length

- Few controls on camera.

- Lack of a viewfinder on most models, making it harder to compose the scene

- A lag of 2 to 3 seconds when you monitor a scene on a mobile device

Setting Up Your GoPro

At first glance, the GoPro resembles a miniature version of an early 20th-century box camera or maybe the Instamatic still camera of the 1970s. Its design is simple: nothing more than a small box with a protruding lens, a few buttons, and a small LCD screen up front on most models.

One very important piece *doesn't* come with the camera: the microSD card. Guess what? The camera won't work without it. Ideally, you purchased one when you bought your GoPro. If not, get one before you set up your camera (see the next section).

Setting up your GoPro takes a few minutes (not counting battery-charging time) but is easy. Follow these steps:

1. **Take off the GoPro's protective waterproof housing.**

 (Skip to the next step if you're using a HERO5 Black or Session.)

 Like a turtle uses it shell for protection, so does the GoPro. But you need to take the GoPro out of its case to set it up. Pull the black latch on the top front of the camera. You'll need to pull it back hard because it locks in place. Lift the latch and pull out the camera.

2. **Put the battery in the camera.**

 (Skip to next step if you're using a Session.)

 Slide off the battery door, place the battery inside the camera, and put the door back on. The battery comes partially charged and can be used right out of the box, but it's a good idea to charge it fully (see Step 4).

3. **Load the microSD memory card.**

 Insert SD card on bottom door where battery is located. Push the tiny card into the card slot until it locks in place. If you're using an older model, the door on the side of the camera slides off. Then slide the door back on.

4. **Charge the camera.**

 Plug one end of the charger cable (the one with the mini USB plug) into the camera and the other end into your computer or USB power supply. While the camera is charging, the LED lights turn on; when the camera is fully charged, they go off. You can also use the optional GoPro Super Charger, which charges your HERO5 up to 70% faster with the USB-C cable. And you can charge your phone or other device at the same time.

THERE'S ALWAYS A GOPRO CHARGER

TIP

Because the camera uses a USB mini connector, those old cell phone chargers used by BlackBerry and others work perfectly with charging the camera. So, take them out of the drawer when you need an AC charger for your camera. Newer models now come with a USB-C connector with a mini plug. Those need an adapter.

5. **Power up the camera.**

 Press the Power/Mode button. The LED indicators blink, and the camera beeps three times.

6. **Shoot some video.**

 Once your camera is charged, you're ready to start recording. The video mode is the default mode when you turn on the camera. Press the Shutter/Select button to record video; press it again to pause it.

7. **Take a still photo.**

 Press the Power/Mode button to find the Photo button, which looks like a camera. You can also pick other still-photo choices like Burst Photo and Time-Lapse, but more on that in Chapter 3.

Controlling Your GoPro

If you're a first-time user, you'll find that the GoPro differs from any other camera you've operated. It can take some time to get used to the lack of a viewfinder on the Session (as well as some older models), the camera's ultra-wide-angle lens, and its dependence on Wi-Fi.

The GoPro HERO5 has two buttons, one for shutter, and the other for mode. But it also has a touch screen monitor that provides intuitive access to camera functions, preview, and adjustments. You can also control the camera from a distance using the Capture app. The Session also has two buttons, shutter and a menu button.

Controlling the HERO4

The GoPro HERO4 has three buttons:

» **Power/Mode:** This button acts as both a power button and a means of cycling through camera modes and menus.

>> **Shutter/Select:** Press this button to start and stop video recordings, take photos, and toggle among menu settings.

>> **Wi-Fi:** To turn the camera's Wi-Fi signal on or off, hold this button for three seconds. This button also allows you to enter the Settings menu, connect to the remote, or connect to smartphones and tablets via the Capture app.

Turning the camera off

REMEMBER

Powering down your GoPro requires you to hold the Mode button for a few seconds. Whatever you captured will be saved before the camera powers off.

Setting the date and time

Not setting the date and time on your camera would be the equivalent of not setting the clock on a DVR. All your pictures, including the ones you took during the summer, would be dated January 1. While you can do it on the camera, the easiest way to do this is connect to the Capture app and it will sync automatically.

Syncing your GoPro

Your GoPro connects to your smartphone or device via Wi-Fi so that you can control the camera, clear the media card, and update its firmware when necessary. More important, the Capture app provides a comfortable way to use the camera because chances are you're not always going to be that close to the action, and if you are, then you can concentrate on what you're doing. You can read more about the Capture app later in the chapter.

Mounting Your GoPro

GoPro has a lot of mounts and one for every occasion and situation, as you see in Chapter 2. There are mounts for your ski pole, the roll bar of your all-terrain vehicle, and the top of your bicycle helmet. There's even one that your dog can wear as a harness.

I mention GoPro mounts throughout the book, but I take a little time here to explain some of the key pieces (see Figure 1-10):

FIGURE 1-10:
The pivot arms, quick-release buckle, and double-stick base plates.

>> **Pivot arms:** The pivot arms come in two varieties: straight and angled. You use them to put the camera farther from the mount or to rotate it. When you add an angled extension, it changes the mount by 90 degrees, so each one that you add turns the camera. You can add as many arms as you need, joining them with the thumbscrews that come in the GoPro package.

>> **Quick-release buckle:** You get two of them, one of which is slightly larger and more flexible than the other. The pivot arms attach to many of the mounts as well as the quick-release buckle that locks into some of the mounts. When using the quick-release buckle, you just slide and clip, as shown.

>> **Double-stick base plates:** One of the adhesive mounts that accommodates the quick-release buckle is flat, and the other is slightly curved. The quick-release buckle can be used with either adhesive mount.

These plates are permanent, so be sure to put them where you want them to stay.

WARNING

Even though the base-plate seal is somewhat <u>permanent</u>, you may have to wait a while for it to set and as much as 24 hours during cold weather. It's possible to remove it with heat for reuse. A blow dryer works great.

REMEMBER

Working with the Different GoPro Apps

The GoPro apps are the heart and soul of the operation, providing the means to control the camera, make a comprehensive edit, randomly assemble clips into a movie, or upload to social media. The app family includes the GoPro App for controlling the camera, Splice, for serious video editing, and Quik, for automatically transforming clips and music into a movie.

Downloading the software

The GoPro App is a free download away. Just go to Apple's App Store or Google Play. You can find more information at http://gopro.com/apps.

Using the Capture App

The Capture app (see Figure 1-11) allows you to control the camera from a distance and monitor the scene. It also lets you wirelessly update camera firmware and get the latest features to maintain best performance. The app lets you control the camera and do more with your content than ever before, including sharing it over social media. It provides full remote control of all camera functions so you can start and stop your recording, adjust camera settings, or take a photo.

FIGURE 1-11: The Capture app

Live Preview (see Figure 1-12) lets you see what your camera sees for easy shotming while capturing the scene. You can also play back video and view photos : smartphone.

..... rmware on electronics isn't for the faint-hearted. It's complicated and ...e, and nobody wants to do it, so it doesn't always get done. The Capture ...ver, changes all that by allowing you to keep your camera up to date via

.tarted with Your GoPro Camera

FIGURE 1-12:
Live monitoring of a scene with the Capture app

You can share your favorite video clips and photos via email, text, Instagram, Facebook, and other social networking sites. Although you can't share directly from the camera, you can use the app on your smartphone or other mobile device to access the image files and then share them (see Figure 1-13). It's a free download at http://gopro.com.

Here is a quick list of the things it lets you do:

>> Operate the camera from 50 feet away.

>> Monitor the scene on your smartphone's screen.

Don't expect monitoring to be perfect. There's a bit of lag time between the camera and your smartphone as much as a few seconds. To judge the delay, put your hand in front of the camera's lens and then take it away, and see how long it takes for the change to appear on your smartphone.

TIP

>> Control one camera or multiple cameras, with all the technical settings at your disposal.

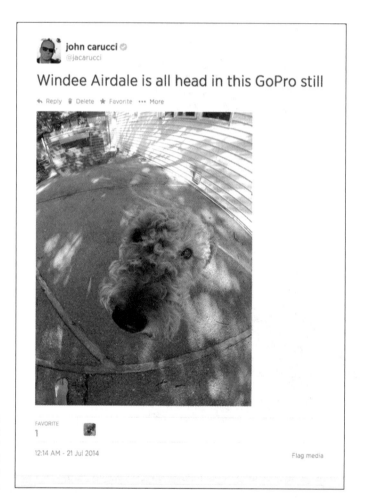

FIGURE 1-13:
Shared image
on Twitter
transferred
from the
Capture app.

>> Select the mode you want to capture.

>> Start and stop video recording, take still photos, and do time-lapse photography.

>> Erase a full memory card or delete just the last item captured.

One caveat: The app doesn't work when the camera is underwater. You can still record by tapping the shutter before submerging the camera. Unfortunately, you won't be able to monitor the scene.

REMEMBER

Setting up the app

Here's how you set up the app:

1. **Activate Wi-Fi on the camera by pressing the Wi-Fi button on the side.**

 The blue light blinks to show that Wi-Fi is activated.

2. **Open the Capture app on your smartphone and then tap the Connect & Control button, shown in Figure 1-14.**

3. **If you see a** `No Cameras Connected` **warning, navigate to the Wi-Fi settings on your smartphone and make sure that the GoPro is selected.**

 Often, your home Wi-Fi network is selected by default on your phone, and you need to select the camera.

4. **Control the camera.**

 Monitor the scene and make changes without ever touching the camera. You can change camera modes, adjust resolution settings, and access Protune settings on the Black Edition.

FIGURE 1-14:
The Connect & Control button.

Giving the app a test drive

Although using the Capture app is intuitive, giving it a test drive doesn't hurt. Follow these steps:

1. **Launch the Capture app.**

2. **Tap the Connect & Control button.**

3. **Tap the video icon.**

 By default, the video icon should be selected, but if it's not, tap the icon that looks like a movie camera.

4. **Point the camera at something, and check the scene on the monitor.**

5. **Make camera adjustments, if necessary.**

 Chapter 4 offers detailed explanations of how these features work.

6. **Tap the red button to start recording video.**

7. **Tap the red button again to stop recording.**

Editing on the fly

After capturing whatever situation strikes your fancy, you can quickly turn it into a movie on your smartphone. Splice lets you assemble a series of clips together, add titles and transitions, and even has a music library to give your movie the right pizazz. Another app can automatically make a movie with clips and music so quickly it's called Quik.

Quik

If you're looking for an automated approach to editing movies, the Quik app is perfect for you. Create edits in a matter of moments by transforming a few clips into a movie with choices for soundtrack loaded in the program, or simply choose a song that's already on your device. Quik automatically analyzes the footage, puts it together, and synchs it to the beat of your soundtrack. The music can come from files on your phone. Quik will automatically make a movie for you by selecting your best clips of the week, and even add a soundtrack (see Figure 1-15).

Here's an overview of what you — er, Quik — can do:

>> **Choose video styles:** Pick the style of the movie. Each selection has its own set of filters, graphics, fonts, and transitions.

FIGURE 1-15:
A screenshot
of Quik in
action.

>> **Custom text overlays:** Add captions, Identifications, and emojis to give your movie the right pizazz.

>> **Soundtrack library:** Allows you to pick the perfect soundtrack for your movie. Whether it's something from your own music library. Whatever soundtrack you use, the app quickly synchs the action to the beat of the music for a really awesome video, regardless that it was automatically variety.

>> **Automatic video creation:** Once a week, Quik will surprise you with a produced movie from footage found on your mobile device over the past seven days.

>> **One–button posting:** Just tap save and you can share video on a variety of social media sites including Twitter, Facebook, and Instagram. You can also save directly to your device or on the Cloud.

TIP

It's great to perform a quick edit in the field and share it immediately from your app, but it's a little more comfortable doing it from your computer. The desktop version of Quik provides the same easy operation when it comes to offloading files from your GoPro. Just connect the camera and the software automatically downloads your movies and photos to your drive. If you're a GoPro Plus member, it will

upload directly to the Cloud, allowing you to access, view, and edit your content on any device wherever you are at the moment.

Splice

Splice brings the power of a desktop editing system to the convenience of your iPhone or iPad, so you can make pro-quality edits moments after you shoot them. You can easily add music, sound effects, and titles before uploading to a sharing site. (See Figure 1-16.)

FIGURE 1-16:
A screenshot of Splice in action.

Here's what you're able to do:

>> **Fully edit on your phone:** Includes all you need to produce video clips. You can trim clips, crop the frame, as well as add titles and special effects.

>> **Great audio choices:** Free music and sound effects allow you to overlay multiple tracks, adjust audio levels, or record a voiceover.

>> **Impressive outros:** Lets you end your video in style.

IN THIS CHAPTER

» **Choosing the right media card**

» **Taking your GoPro underwater**

» **Mounting your GoPro**

» **Making your GoPro wearable**

» **Ensuring a good charge**

Chapter **2**

Accessorize Me

Think about the potato for a second. The tuberous nightshade vegetable lacks the flavor that it has when it's cooked and spiced. Well-prepared potatoes are a much-loved food source that sometimes we love too much (thank you very much, French fries) and at other times just enough (boiled potatoes, you know who you are).

In a strange way, GoPro alone has much in common with a potato. Just as you can eat a raw starchy potato by itself, you can use a GoPro without any accessories. You can still make great movies and pictures with it, but mounts and accessories enhance the experience for sure. This is especially true when it comes to putting the camera in unusual places as well as creating unique perspectives.

GoPro seems like quite the accessory hound, but it already includes the vital accessory: the waterproof housing. That's just the tip of the iceberg. Dozens of other accessories allow you to blaze new trails and do either the wildest or most practical things you can imagine.

Playing the Media Card

It's important to make sure you can capture the action by using the right media card. Just as your grandmother used the very best grated cheese for her lasagna, you should use a microSD card that's optimized for video capture.

REMEMBER

Not just any media card will do. Forget about capturing a continuous movie in high definition (HD) if you're not using the right type, and if you have your heart set on capturing 4K video, the plot thickens. Capacity plays a big part (as you see in this section), but speed matters most.

Observing the speed limit

Because media cards have so many uses, the capacity of a card and the speed at which it transfers data will vary. Regardless of which kind of card you're using, here's a breakdown of the Speed Class Rating system, a system created by a consortium of manufacturers. You can find more information at www.sdcard.org.

>> **Class 10:** 10MB per second

>> **Ultra High Speed, Class 1:** 10MB per second

>> **Ultra High Speed, Class 3:** 30MB per second

>> **Video Speed Class:** From 6–90MB per second

Checking card capacity

HD movie files are large, and the 4K ones are even bigger. That's why it's important to have a large-capacity card so it doesn't fill up sooner rather than later. Today, microSD cards continue to increase in capacity while going down in price. But sometimes the difference in price between using the right card and a slower one isn't that much different. That's why you should purchase the card based on its speed and storage, and not because of its cost.

Not all UHS cards are created equal. They represent the minimum speed requirement, so even cards from the same manufacturer differ in speed.

Here are transfer speeds for a few popular cards that you can use with your GoPro:

>> **Lexar 633x UHS I:** This card comes in several sizes ranging from 32GB to 200GB and offers a maximum transfer speed of 95MB per second.

>> **Samsung Pro Plus:** This media card has capacity up to 128GB and transfer speed up to 95MB per second.

>> **SanDisk Extreme Pro:** SanDisk's Extreme Pro comes in two sizes: 64GB and 128GB. This card is incredibly fast, with a write speed up to 100MB per second, and read speed up to 275MB per second.

GoPro can capture 4K video, with four times as much detail as HD. With great quality, however, comes great size. Capturing 4K video requires a fast, high-capacity card, because 4K takes up far more space than HD does. How much depends on the frame-rate setting. Regardless, 4K video is going to take up more than half of the capacity of the card, so a 32GB card with 4K video on it will hold less than a 16GB card would for the same amount of video capture.

Choosing the right card

The best type of card for you depends on what you're trying to do and on your budget. Still-image capture requires less transfer speed than video does, so if you don't have the fastest card, you can still get by. When you're shooting HD movies, though, you need a card with a write speed that can keep up with movie capture. Using a low-speed card is like having slow workers on a factory assembly line; it makes the operation less efficient.

GoPro recommends SDHC cards with a minimum Class 10 rating. Slower cards, if you happen to come across them, will work, but they process moving images less efficiently. Also, there's always a risk that a slower card will lag and stop record-ing. Worse, you could lose data with a slow card. If you're doing 4K, consider UHS Speed Class 3 cards for seamless capture. They're the most expensive cards but are designed for the fastest transfer rates.

Managing media cards

Unlike calling a bald guy "Curly," or a large person "Tiny," there's nothing ironic about a microSD card. They live up to their name as being a small media card. Not just small, but the kind of small that' s easy to misplace in plain sight. Yet, it's amazing how much data these little memory devices can hold. But it's also pos-sible to easily lose and misplace them because of this size, as shown in Figure 2-1.

Here are some suggestions to keep track of your cards.

>> **Always have a card in the camera:** There are a few reasons for taking the card out of the camera, including to connect to a card reader or switch for a different size card. If you remove the card from the camera, be sure to put it back.

>> **Keep extra cards in their case:** I cannot overemphasize that these cards are small and can easily get lost. And when you consider the cost of some of the bigger, faster ones, you have a lot to lose if you're not careful.

>> **Delete after downloading:** After you securely save the content of your card, purge the card. There's nothing worse than being on an important shoot and running out of space because you have last summer's water balloon fight still on the card.

>> **Format the card regularly:** Think of it as "super" erasing the data on the card. Merely deleting files still leaves extraneous traces of data on the card, while formatting removes everything, allowing you to capture on a fresh data-free card. You don't need to do it every time, but before each important shoot.

>> **Organize your cards:** Don't forget that "micro" in a microSD card means it's small. That's why it's a great idea to store and organize it in a card caddy. If you don't what to be so formal, a small box or a Ziploc bag can work for you.

FIGURE 2-1:
The microSD card is as small as a dime.

Letting the GoPro Get Wet

One of the main reasons to buy a GoPro is to be able to take it into the sloppiest of conditions with little worry. You didn't have that choice with other cameras. Taking a conventional camcorder through a swamp or shooting upward during a torrential rainstorm isn't in that device's best interest. Chances are that you'd burn it out. Most conventional cameras and especially the electronic ones don't like the wet stuff.

Being able to go underwater makes the GoPro as refreshing as a cold glass of water or a swim on a hot summer day, and you can adequately capture each of those locations from the inside out. Isn't it nice to have a camera that has the same tolerance for wet conditions as your diver's wristwatch? Feel free to get it wet. One more thing; if you're not using the HERO5 or Session, don't take it in your bathtub without the waterproof housing, and make sure you don't have the Skeleton backdoor on. That one's not waterproof.

The HERO5 Black comes with an LCD screen that lets you view the scene on the camera under wet conditions. If you're using an older model, you can attach the optional Touch BacPac.

Using underwater accessories

If you're looking to record underwater seascapes or artful pool pictures, GoPro lets you easily capture submerged scenes. Whether you're using the new HERO5 models, or a previous generation model, you can capture underwater scenes with relative ease and little worry.

The HERO5 Black comes with a built-in LCD screen making it possible to monitor and frame the scene right out of the box. Previous versions are a little more challenging, when it comes to viewing the scene. Normally, you would monitor the scene with your smartphone (see Chapter 1), but that's not feasible for underwater recording because of the whole water-is-wet thing. So, there's a little more guessing involved. Of course, you could also attach the optional Touch BacPac (see the next section) on most HERO models, Session excluded. The Touch BacPac allows you to monitor the scene from the back of the camera, but it's submersible only to shallow depths, and the touch panel won't work underwater.

Here are some accessories to consider for underwater recording:

>> **Antifog inserts:** These inserts drop into the camera's housing to prevent fogging in cold and humid environments. You can reuse them several times by drying them out in a 300°F oven for 5 minutes.

>> **A big media card:** You can't change the card underwater (or anywhere that's even slightly moist, for that matter), so it's a good idea to use the biggest one you can afford.

>> **Color-correction filters:** Underwater scenes are beautiful, but they have blue or green casts. An optional color-correction filter in red or magenta can reduce or eliminate the cast.

>> **Floaty Backdoor:** This accessory attaches to the back of the camera and keeps it afloat in case you accidentally let go of it while taking an underwater selfie (see Figure 2-2). Any time you play in the water, there's a risk that the camera will take more of a plunge than you'd like. Thanks to this bright-orange back, however, you'll have no problem spotting it in the water.

>> **Dive Housing:** The waterproof housing that comes with the camera works well for most underwater situations, but if you want to take the camera deeper, consider this housing. It's more durable than the standard model and is waterproof to 197 feet (60m). The kit includes Standard, Skeleton, and BacPac backdoors. Its increased durability makes it perfect for more serious diving encounters. And its glass lens delivers optimal sharpness in and out of the water. While the HERO5 Black is already waterproof to 33 feet, to go deeper requires the optional Dive Housing.

>> **The Handler:** The handgrip provides stability when holding the camera. It's great for use in and out of the water, and will float if you accidentally drop the camera.

- >> **Scuba mask:** The GoMask is a cool third-party accessory that lets you wear the camera on your face while snorkeling or scuba diving so you can see what you're capturing.

- >> **Video lights:** You can get a complete light system that mounts on a rack with your GoPro and provides up to 900 lumens of illumination for densely lit underwater scenes.

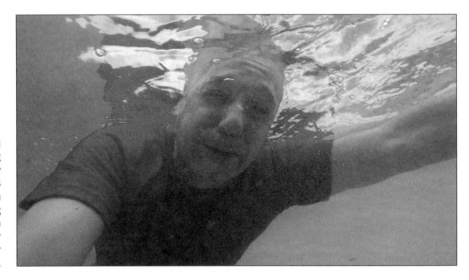

FIGURE 2-2:
Having the Floaty Backdoor is a smart idea when taking your GoPro in the water for an underwater selfie.

Going deep

GoPro plays equally well in and out of the water, with the HERO5 Black and HERO5 Session no longer requiring a waterproof housing. Previous models come with a waterproof housing that can withstand depths of up to 131 feet (40 m). For these models, you can leave the housing on the camera when you're using it for non-water-based fun. (You need it for some mounting options, because they attach to the housing. But I'm talking about waterproof situations in this section.)

Two backdoors come with your GoPro (except for the HERO5): The Skeleton, which provides good sound quality, and Standard, which is waterproof.

WARNING

Make sure that you have the Standard backdoor on when you use your GoPro underwater, because much like the name implies, the Skeleton isn't waterproof.

Here are the maximum depths your GoPro can reach with a couple of other accessories:

>> **HERO5 Black and HERO5 Session:** Both waterproof on their own to depths up to 33 feet (10 m). The optional Dive Housing lets you go deeper.

>> **Dive Housing:** This accessory increases the GoPro's depth rating to 197 feet (60 m) for HERO5 Black.

>> **Touch BacPac Backdoor:** Although it lets you monitor the scene from the camera back, you can't use it deeper than 10 feet (3 m).

Checking your camera before getting it wet

Anytime you plan to take your GoPro in or near the water you need to be sure everything is correctly set *before* you place the camera near water. (See Figure 2-3). So, before taking it for a dip consider the following:

>> **Have enough room on the microSD card:** Remember, if you run out of storage, you can't change cards in the water.

>> **Make sure it's clean:** Not only do they say it's next to godliness, but keeping the glass in front of the lens clean will assure you capture clear and sharp images. The Anti-Fog inserts can help here.

TIP

>> **A test case:** This applies to older models that require a waterproof housing. Yeah, it makes the camera waterproof, but isn't it nice to be reassured? So, without the GoPro inside, close it up and submerge in water, as seen in Figure 2-3. After a brief soak, dry the outside completely before opening and see if it's wet inside. Also, make sure the camera is fully sealed: Push the housing backdoor all the way in before securing the black latch on the top of the case.

>> **Rinse off salt water:** If you're going to take it to the beach, on a dive, or any situation involving salt water, it's always a good idea to rinse the camera and accessories with fresh cool water. The salt can get caught in the case and around the lens, causing rust on the metal parts and a salty coating over the lens.

Remo (waterproof voice-activated remote)

Not only can you command your GoPro HERO5 with your own words, but you can do it from a distance using the optional Remo voice-activated remote. Don't worry if you're in or near the water, since the remote is waterproof, just like your GoPro. And if you don't feel like talking, it acts as a one-button remote.

Here's the lowdown on what it can do:

>> **Works from a distance:** You can be up to 32-feet (10m) away from the camera and command it to capture the scene.

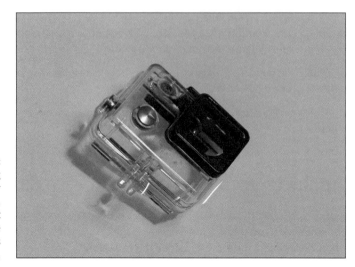

FIGURE 2-3:
When using a HERO4 or older model, it's important to make sure the housing is water-tight.

>> **Wear it:** Much like a brooch, you can talk to Remo from your lapel (or any place else on your clothing) or a wristwatch, and wear Remo with the included clip and wrist housing.

>> **Easy commands:** Understands 13 commands that allow you to shoot video, take still photos, and change settings.

>> **Enhances camera use:** Even when GoPro is close to you, Remo helps enhance the voice control when the conditions are noisy or windy.

>> **Waterproof:** Not only can you use it in the water while swimming, surfing, or doing whatever you like to do in the water, the HERO5 is also waterproof up to 16 feet.

>> **Multi-lingual:** Can understand 10 languages, including English, Italian, Japanese, Chinese, and German.

Keeping the Shot Steady

The ability to place your GoPro almost anywhere makes it a pretty remarkable camera. But to capture all that action and those cool perspectives with little worry, you need to keep the camera steady. The GoPro isn't like any other camera; it's tiny and, except for two models (the HERO5 Black and HERO4 Silver), it doesn't have a viewfinder. Holding it in your hand to take a picture or make a movie is the textbook definition of haphazard, because you can't see what you're shooting or hold the camera comfortably.

You can mount a GoPro on a tripod or on any of the dozens of mounts designed for the GoPro. In this section, I give you an abridged tour of some exotic and basic mounts.

Mounting your GoPro out of the box

When you take the camera out of the box, you'll notice that it comes with some hardware:

>> **The Frame:** Also includes Mounting Buckle & Long Thumb Screw.

>> **Flat adhesive mount:** Makes it easy to connect your GoPro to any clean, flat surface. When the camera is attached to the quick-release buckle, it slides right into the mount.

>> **Curved adhesive mount:** Looks a little like the flat mount but is designed for curved surfaces.

Using a tripod (with an adapter)

For a good part of the camera's 200-year history, the tripod has been the photographer's best friend when it comes to keeping the camera steady and composing the scene. For almost as long, cameras have had a standard socket for attaching to a tripod. Yep, the three-legged amigo has made all the difference between crisply shot movies and a shaky mess.

One problem with the GoPro is that it doesn't have a tripod socket on its bottom, so there's no built-in way to secure the camera to a tripod. No worries. You can still mount it with a special accessory that attaches to your GoPro and provides a standard tripod socket. This accessory also has a quick-release mount that allows you to move the camera conveniently between shots and locations. The GoPro looks comfortable when mounted on a flexible GorillaPod, for example (see Figure 2-4).

Getting Framed

When using an older model GoPro, you can leave the camera in its waterproof housing for most situations, but sometimes you may want to shoot outside of the case. The Frame comes standard with the HERO5 models, as well as being a cool accessory for older models. It allows you to place the camera in a frame, as the name implies. The open design delivers optimal audio capture, providing it's not an activity that puts the camera too close to the noise. The integrated latch makes removing your GoPro from the Frame quick and easy. You also have open access to the camera's microSD, Micro HDMI, and USB ports for easy data offload, live-feed video, and charging.

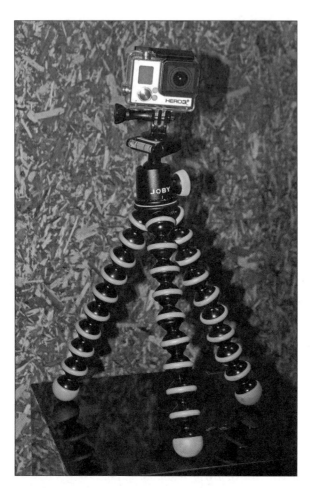

FIGURE 2-4:
Tripod adapter connects a GoPro to your three-legged friend.

Here are some reasons for using it:

>> **Not bulky:** Because it fits around the camera, it doesn't add size to the camera like the waterproof housing.

>> **Better audio capture:** Because the microphone is not obscured by the case, you get the clearest sound reproduction.

>> **No waterproof housing needed:** Provides immediate access to camera ports for downloading data and live-feed video.

>> **Protective glass lens:** Prevents the camera lens from getting dirty or scratched.

>> **Extendable support arm:** Lets you easily attach accessories like the LCD Touch BacPac or Battery BacPac.

Choosing your mounts wisely

There's a mount specific to whatever you're looking to do with your GoPro, from surfing, skateboarding, playing music, or wearing it like a fashion accessory.

Using suction cups

When you think of mounting your camera with suction cups, secure placement isn't the first thing that comes to mind. The first thing is "I hope it stays on," as you worry that the cup will lose suction and the camera will fall off.

Not gonna happen. The industrial-strength suction cup mounts attach the camera to almost any flat, clean surface and even the hood of a moving car, as seen in Figure 2-5. How reliable are they? These mounts have been engineered to withstand a broad range of motion at speeds more than 150 mph. It's a good idea for your GoPro to be in its waterproof housing to provide extra protection.

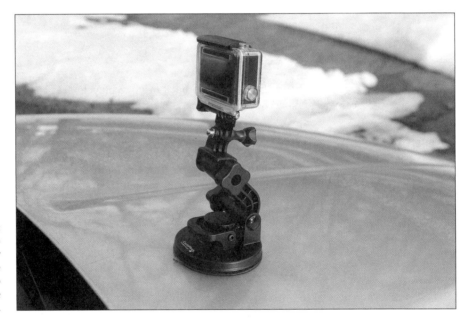

FIGURE 2-5: It's easy to securely mount the suction cup to an automobile hood.

Using the Jaws Flex Clamp

"Jaws Flex Clamp" sounds like a sequel to the shark thriller, but this accessory lets you attach your GoPro to anything it can bite . . . er, clip. The mighty little clamp lets you attach the camera to a variety of objects up to 2 inches thick. You can mount the camera directly on the clamp, or attach it to the optional gooseneck to accommodate a wider range of camera angles.

2-Way

You can use this mount, shown in Figure 2-6, in three ways: as an extension arm, camera grip (when detached from the arm), and tripod. This cool mount expands to 20 inches and collapses to 7.5 inches, and it's waterproof, making it perfect for traveling, hiking, or for selfies and group shots. You can even use it in and under the water.

Handlebar/Seat Post/Pole Mount

It's basically a bar mount. No, not the kind for capturing a movie at your favorite watering hole, though it's entirely possible to put one of these mounts around a beer tap or stool leg. This mount allows you to attach your GoPro to just about any kind of tube with a diameter of 22.2mm to 35mm (.9 to 1.4 inches) and bicycle handlebars and seat posts are the more popular choices. So you can get views both coming and going. But that's not all, as you can use it on any other tube it fits. And did I mention that it also rotates 360° for unlimited capture options? Well it does.

Put the camera on the handlebars on your bike or motorcycle, or a windsurfer or ski pole. Mount it on any pole that it will fit.

Pro Seat Rail Mount

Let's you hang the camera on back of your bicycle seat to capture a rear-facing camera perspective. (See Figure 2-6.)

Large Tube Mount

This hinged mount is perfect for thicker bars – you know, those from 1.4 to 2.5 inches in diameter. This covers vehicle frames, like on go-karts, as well as cars with roll bars. But it attaches to so much more, like a soccer goal, kayak oar, bicycle frames, and any other tube it fits. With a push of a button, its integrated base allows you to rotate to 16 locked positions for 360° versatility.

Swivel Mount

The GoPro version of the ball-head mount provides a great deal of flexibility when it comes to orienting the camera. Instead of using the articulation arms that come with the camera, this mount uses a ball and socket that freely moves and can be locked into any position you decide.

Gun/Rod/Bow Mount

Easily attach your GoPro to sporting equipment such as a fishing rod, hunting rifle, bow or just about anything with a diameter of 0.4 to 0.9 inch. This multipurpose mount has a matte black finish to eliminate glare, and it's compatible with most rifles, paintball guns, and revolvers. It also fits your fishing rod and bow components. You can also mount a second camera to capture both front-facing and rear-facing perspectives.

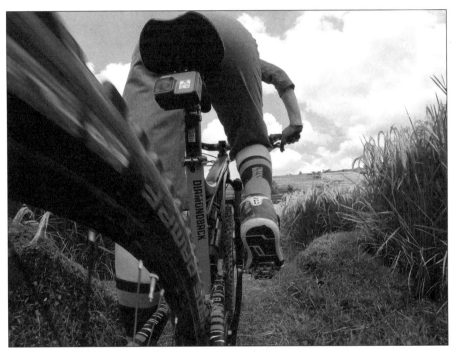

FIGURE 2-6:
The Pro Seat Rail Mount lets you hang your GoPro for a rear view.

Photo courtesy of GoPro, Inc.

Musical mounts

Almost since the beginning of photography, musical performances have been captured from the outside, and the resulting footage often has a two-dimensional appearance. Musicians don't want a clunky camera intruding in their performance space. But the GoPro can go where other cameras can't, thanks to a few mounts specifically designed for music:

» **Microphone-stand mount:** This dandy little device transforms a microphone stand into a tripod of sorts. It's compatible with standard microphone stands when you use the included adapter. It comes with a quick-release base that allows you to move the camera between mounts and locations.

» **Instrument mount:** If you're looking to get a little closer to the action, opt for a removable instrument mount, which allows you to attach your GoPro to a guitar, bass, drums, or keyboard. You can even mount it on a turntable, if spinning vinyl is your jam. These temporary mounts have non-damaging adhesive that's safe for most instrument surfaces. The kit includes three mounts (reusable) and two single-use adhesive strips.

» **The Arm:** Allows you to mount your GoPro to almost anything, including this guitar, as seen in Figure 2-7. It can be used on guitar headstocks, keyboards, horns, or any other instrument you can clamp it on.

FIGURE 2-7:
The Jam showing the action from the neck down.

Wearing Your GoPro

First, the fashion was skinny jeans; then it was iridescent shoe soles; now it's wearing the GoPro like a fashion accessory. Perhaps the only fashionable aspect of wearing a GoPro is the ability to capture great video with an interesting perspective. Regardless of the trends of the day, great video is always in vogue.

GoPro offers a bunch of wearable mounting options that may not improve your attire but can certainly make your movies look better by showing a truly POV perspective (see Figure 2-8). *POV* stands for *point of view*, and it's yours that the viewer will see.

Why wear your GoPro? Because you can. More important, it's more feasible to mount the camera than to try to hold it. For one thing, your hands are a little too big for it. That makes taking pictures or shooting movies not much different from going to your 5-year-old niece's tea party with her dolls and drinking out of those tiny cups.

Another dilemma in holding the camera is that the angle of view is so wide, it's easy to get your hands, nose, or other parts of your body in the shot and because most models lack a viewfinder, you won't know until it's too late. That problem is exacerbated when you try to use your smartphone to view and realize that you're a hand short. For those times when handholding is necessary, consider using the Touch Display (if your GoPro has it) or the optional LCD Touch BacPac; both allow you to monitor the scene on the camera.

FIGURE 2-8:
A POV shot taken while walking down the street.

The following sections cover a few accessories that can help you use your GoPro hands-free.

Headband mount

If you want to capture video from the perspective of what you're seeing and want to look something like a coal miner too, this mount is for you. The fully adjustable strap allows you to attach the camera to your head or a helmet to capture footage from a headlamp-like perspective. Thanks to its design, you can also put it on a baseball cap.

Helmet mounts

Helmet mounts come in several configurations. If you're going to use this mount while riding a bicycle or motocross bike, always select a helmet that meets the applicable safety standard when you use it with a GoPro helmet mount.

GoPro offers several helmet mounts, including these:

>> **Helmet mount:** Whether you take your GoPro on a motorcycle ride down a country road or zip down a windy trail on your mountain bike, this mount allows you to record the view from atop your head, as shown in Figure 2-9. The camera sits on the helmet like a headlamp, letting you capture forward-facing footage. You can adjust the extendable arm so that the camera faces you for self-portrait videos and photos.

FIGURE 2-9:
A helmet mount lets you capture forward-facing footage.

This mount uses a special adhesive that can be removed only by heat from a hair dryer.

» **Vented-helmet mount:** Instead of using adhesive to hold the camera in place, this mount uses straps to attach the camera to any vented sports helmet. The adjustable strap makes mounting the camera quick and easy.

» Helmet front and **side mount:** You can do more than just attach your GoPro to the side of a helmet with this mount. It also works well on vehicles and other moving objects. Three-way adjustability makes aiming the camera easy.

» **Night-vision mount:** This mount allows you to attach your GoPro to a helmet that includes a mounting plate for Night Vision Goggles.

Chest harnesses, or the Chesty!

Sometimes when you're in the middle of the action, it's nice to hold the GoPro near and dear to your heart, literally. The Chesty lets you wear the camera on your chest. Basically, it looks like suspenders with a camera in the middle.

This harness comes in two sizes:

» **Chesty M-XXL:** This harness makes it easy to capture immersive video and photos, as shown in Figure 2-10. One benefit of using this type of mount is that you can include more of your body in the frame. It's perfect for immersing yourself in your favorite activities, such as mountain biking, motocross, skiing, or paddle sports. You'll capture more of your arms, knees, and maybe face (when you lean in). It's fully adjustable to fit a wide range of adult sizes.

» **Chesty XS-S:** This smaller version of the Chesty is perfect for smaller humans. It lets them have fun with the GoPro when they're playing on slides and swings, or skateboarding or bicycling.

Fetch (dog harness)

For too many years, our fine-feathered friends have gotten credit for the shot that looks down on the situation. Well, move over bird's-eye view and make way for the dog's life view. Think of the Fetch as the canine version of the Chesty, allowing you to record the world as seen from the back of your dog. You can use it on any dog between 20 and 120 pounds. Just make sure the dog is never left alone, and not just because she will claim credit for the footage.

FIGURE 2-10:
Getting a chest-level view walking through the scene.

The Strap

The Strap lets you wear the camera on more than your wrist to capture hands-free footage from your arm or wrist. It allows you to capture 360° for unique POV footage or some of the coolest selfies. Ideal for numerous activities and fully adjustable to fit whatever limb works for you, the Strap is one of our most versatile mounts for your GoPro. (See Figure 2-11)

FIGURE 2-11:
Wearing the camera on your wrist lets you swoop down on the subject to capture an effective angle.

Putting Your GoPro on a Drone

Flying your camera above some scenic area to make movies or take photographs was once as much of a fantasy as having a pet unicorn or owning a time machine. But alas, it's true. The drone, or quadcopter as it's sometimes called, has been on the scene for a few years now, and many have even supported GoPro as a worthy passenger. But GoPro has taken it further, entering the fray with Karma, a drone specifically designed for putting your GoPro high in the sky.

It's all about Karma

GoPro has simplified the idea of flying your HERO from above. More than a drone, this vessel centers around the Karma Stabilizer, which is a stabilization device that attaches to the drone itself, as well as allowing you to hold it by hand, much like a steady cam does in movie production. That means you can capture incred-ibly steady footage from the air or when held in your hand, despite how much motion is going on around the camera. The Karma works with current GoPro models, including the HERO4 and HERO5 models.

Here's what comes in the box:

>> **Karma Drone:** Sleeker than other drones on the market, this one is made specifically for GoPro.

>> **Karma Controller**: More than a remote, this video-game style device allows you to control and view the flight of your drone. Want more? The GoPro Passenger App lets you share flight monitoring with friends while you're flying.

>> **Karma Grip:** Helps you get smooth video whether it's on the drone or you take it off and hold it by hand and use it as stabilization system on the ground.

>> **Karma Stabilizer and Harness:** The harness holds your GoPro and the stabilizer attaches to the Karma to keep it steady to produce smooth shake-free video.

>> **Battery and Charger:** All-in-one charger provides up to 20 minutes of flight on a one-hour charge.

>> **Propellers:** Sometimes they're the first victims in an altercation. No worries, six replacements come in the box. And they're color-coded for easy installation.

>> **Mounting Ring:** Use it to attach Karma Grip to GoPro mounts.

>> **Case:** A durable weather-resistant case that's perfect for carrying your Karma and all the necessary accessories. You can also fit the Karma drone in Seeker, the GoPro backpack.

Adding Some Other Cool Accessories

Not every accessory is for mounting your GoPro. Some accessories also enhance the camera's operation. Whether it's housing the camera with a more appropriate solution, making sure you have enough battery power to capture an event, or needing to see what you're doing from the camera's perspective, these accessories can help accomplish that task.

Keeping your GoPro charged

Your GoPro HERO camera offers amazing results while it's powered up, but unfortunately, the power doesn't last forever. Battery life is less than two hours, which can pose a problem when you're out in the field. That's why it's a good idea to have an extra battery or a portable charger with you.

Here are a few other accessories that can keep your GoPro powered longer:

>> **Dual-battery charger:** This device lets you charge two batteries at the same time and is USB-compatible. LED indicator lights display the charging status of both batteries.

>> **Super charger (Wall charger):** The wall charger lets you connect your camera via USB directly to an AC outlet for fast charging. You can record while charging, essentially plugging the camera into a continuous power source.

>> **Portable Power Pack:**

>> **Battery BacPac:** For situations that require longer continuous service from the camera, you should consider using the Battery BacPac. This helpful accessory attaches to the back of the camera to extend battery life. Charge it through your computer or a wall charger. The LCD window displays battery level and charging status.

>> **Auto charger:** This device allows you to charge up to two cameras in your car.

2
Moviemaking Technique

Use Protune for better control.

Explore time-lapse photography.

Discover fundamental moviemaking techniques.

Master composition techniques.

Read the light effectively.

Capture the best sound.

IN THIS CHAPTER

» **Understanding the lens**

» **Taking advantage of Protune**

» **Shooting time-lapse video**

» **Playing with other effects**

Chapter **3**

Getting through GoPro Boot Camp

I f you buy a GoPro camera and expect to use it the way you do a video camcorder or a point-and-shoot camera, you quickly find out that this camera doesn't respond well to convention. It's like a beat poet speaking at a 19th-century French literature seminar: Much will get lost in translation. Yet footage captured on a GoPro has been used in all sorts of conventional capacities, from feature films and television shows to sports and news coverage. You just have to understand that it behaves differently from the cameras you're used to using. Sometimes, success begins with putting everything you know on the back burner.

Before you can shoot successfully with your GoPro, however, you have to know how it works. In this chapter, I show you the fundamentals of working with a GoPro.

Viewing the Lens

If you were playing the "obvious game," the first thing you might say about the GoPro is that the lens is wide (see Figure 3-1). Really wide. A lens this wide is a luxury, and when you realize that it's connected to an affordable camera, it seems more like a luxurious gift.

Yes, this camera offers you boundless creative choices, especially when you're playing with perspective. Still, it's possible to get into trouble with a camera that lacks a viewfinder. Shooting without monitoring the shot isn't much different than drawing in the dark. Both will produce an image, but rarely the way you intended.

FIGURE 3-1:
While only a few feet away from this seal, this ultra-wide-angle-lens captures the entire scene.

Like everything else, the GoPro's lens has pros and cons. Here are the pros:

>> **Fits in tight spaces:** With such a wide angle of view, you can include everything in the shot.

>> **Has great depth of field:** The wider the lens, the more of the scene that appears in focus. Because GoPro is really wide, so is the amount of focus in the scene.

>> **Gets really close to the subject:** You can use this camera in the tightest of places.

And here are the cons:

>> **Records a pretty wide view:** Sometimes it's possible to "under" lens the scene by having too expansive of a view. Even with different settings, the view is still very wide if you're not close enough.

>> **Can't control focus:** The camera has no focus control.

>> **No viewfinder:** That means you cannot monitor the scene on the camera and therefore judge the view of the lens.

>> **Produces geometric warping** (better known as distortion).

Getting up close and very personal

The GoPro is meant to work in close quarters, so it's most comfortable mere inches from the subject. Thanks to that wide lens, the camera is great for tight, confined areas. Because the field of view is so wide, the sense of depth expands, and objects in the distance appear to be much smaller and farther away. You can position your GoPro inches from the subject and still get a full view. Whether you're capturing a bizarre perspective of a street scene or looking to uniquely show the person in his or her environment, getting close to your subject with this camera provides a fresh look at the world.

Here are some situations that are great for your GoPro:

>> **Shooting in tight spaces:** You can capture almost everything that's in front of the camera, such as a small room, the interior of a stock car, or the inside of one of those red British phone booths.

>> **Shooting people:** The GoPro is great for scenes showing the subject in his environment. Of course, you'll need to be careful with distortion or he can end up looking like a bobble head, and not always the good kind.

>> **Capturing street scenes:** The camera matches your periphery of view, so you can capture scenes with both an expansive and personal feel.

>> **Showing relationships:** Shows relationships in size and distance between objects in the foreground and background.

>> **Providing an uncommon view of common objects:** Subjects can include geometric shapes, billowy clouds in the sky, and very unusual angles (see Figure 3-2).

Taking advantage of SuperView

Here's an irony: The GoPro, known for capturing high-definition (HD) and 4K video, uses a 4:3 image sensor — a square-ish one that resembles the ratio used by old television sets. It's not uncommon for a widescreen camera to use a 4:3 sensor, but it's rare to take advantage of all that space on the sensor.

The GoPro takes advantage of the sensor through its SuperView mode. This new feature combines the best of both worlds by recording the scene with the full sensor vertical resolution of 1440 pixels (p) and then squishing it down to 1080p.

This feature is designed for situations in which you want more vertical resolution than horizontal, such as using the GoPro as a follow or point-of-view camera. The resulting image plays back at a 16:9 ratio but shows more of the scene. The image is slightly unrealistic, as shown in Figure 3-3, mainly because parts of the scene appear to be squished.

Here's what you can expect:

- **Immersive wide-angle perspective:** Shows a more inclusive view.

- **Distorts shapes:** Makes a round object appear slightly oblong and tall objects slightly shorter.

- **Produces more distortion**: Compared with normal 1080p 16:9 video, shows more distortion at the top and bottom of the screen.

Keeping the lens clean in messy situations

A camera that you can use anywhere — even submerged in water or mud — lets you do a lot of awesome stuff, as Figure 3-4 shows. But although the camera case is waterproof, the lens cover on the waterproof housing isn't self-cleaning like your oven. You have to wipe it constantly; otherwise, many of your cool shots will be taken with goop on the lens.

TIP

Here are a few pointers for keeping the lens clean:

>> **Clean the case, not the lens.** It's much safer and easier to clean the glass on the case than to clean the actual lens. Just use a microfiber cloth and rub gently.

>> **Don't scrub.** All it takes to scratch the lens is one scrubbed-in speck of dirt. So never scrub the case, let alone the camera lens.

>> **Wipe the lens housing before you shoot**. Nothing is worse than capturing the greatest footage of your life, only to find that you had dirt on the lens.

>> **Use a blower brush on the actual lens.** Use a blower brush to clean the camera lens. It's just not worth scratching the lens with a cloth, especially because that scratch will appear in all your movies and images later.

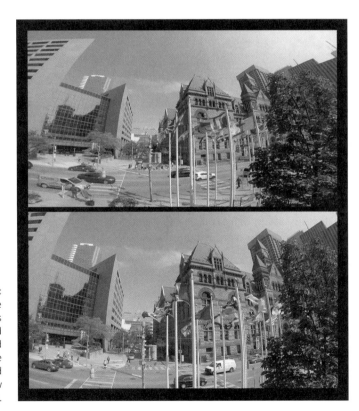

FIGURE 3-3: The same scene was captured in standard 1080p mode (bottom) and in SuperView mode (top).

FIGURE 3-4:
While
capturing this
portrait, I had
to keep wiping
water off the
lens housing.

Mastering Protune

Although a GoPro camera can do amazing stuff, it still behaves like a point-and-shoot camera. You have little power when it comes to focus and exposure, so you need to live with the footage that the camera captures. Most of the time, the camera renders the scene accurately, but if you're an advanced user looking for a little more control, consider using Protune mode.

Here are some of the benefits of turning it on:

» **High-quality image capture:** When you turn on Protune, the high data increases, so you capture images with less compression, and ultimately better quality.

» **Neutral color:** More accurately, it's flatter to provide flexibility during post-production color correction. It also captures more detail in shadows and highlights.

» **Film/TV frame-rate standard:** Offers more choices for image capture, including the cinema-quality 24 frames per second (fps) setting.

» **Compatibility with other effects:** Activating Protune provides more control over camera settings such as resolution and frame rate, which can affect field of view. You can also simultaneously capture video and still images.

» **Control over still photography:** Protune also provides more control over your photographs.

Seeing how it works

TECHNICAL STUFF

Protune puts a little more power in your hands. For one thing, image quality improves because it increases the data rate by more than double. That reduces image compression, thus reducing or eliminating imperfections in the video, such as *artifacting*. Examples of artifacting include jagged edges, showing blocks of pixels, and posterization.

Protune also offers advanced controls. You have a little more control of your footage when you can alter settings such as white balance, exposure, field of view, and color.

In addition, Protune lets you shoot at a more cinema-friendly 24 frames per second (fps). It's not that big a deal for most video shooters, but when you intend to match GoPro footage with other footage captured at 24 fps, such as for a movie, the function is invaluable.

Enabling Protune on your GoPro

Casual users probably won't want to or need to reap the benefits of Protune. But if you're looking for more quality and better control, you may want to turn it on.

To do so, follow these steps:

1. **With your GoPro powered up, navigate to the Settings menu.**

 Press the Power/Mode button to cycle through menus until you reach the Settings menu, the one with the wrench icon.

2. **Press the Shutter/Select button to select it.**

3. **Press the Power/Mode button to cycle through settings until you reach Protune.**

4. **Select Protune by pressing the Shutter/Select button.**

 Make sure that the Protune slider is in the on position on the app.

Setting Protune controls

You can select Protune by going to the Settings menu (the wrench icon) either through the camera or the Capture app. Protune consists of a group of features that let you fine-tune GoPro capture. Adjusting your Protune settings won't affect non-Protune video modes. You can reset your Protune settings to their default states.

Following are some of the powerful settings you can adjust with Protune.

White balance

You can access this setting through the Protune menu. The icon resembles two triangles looking to catch a small rectangle. White balance adjusts the color temperature between the actual color of the scene and the way your camera records it. By default, white balance on your GoPro is set to Auto, which works well in most situations. If you want to control the color temperature, however, you can set the white balance manually with several presets (see Figure 3-5):

>> **3000K:** Comes close to the color temperature of indoor lighting.

>> **5500K:** Matches the color of daylight.

>> **6500K:** Matches the tone of an overcast day.

>> **Camera Raw:** Doesn't apply any white-balance setting, so it's pretty much native out of the camera.

FIGURE 3-5: This image sequence was shot late in the afternoon and shows the following white balance settings: Auto, 3000K, 5500K, and 6500K.

ISO settings

This setting alters the sensitivity of the sensor. For shooting outdoors, you should set the camera to ISO 400, which allows you to adequately capture outdoor scenes with enough light. This setting also captures the scene with the least amount of noise.

When you choose to shoot at dawn or dusk, however, or maybe indoors, you may not have enough light to render the scene properly. To capture a brighter image, you need to bump it up a little bit by increasing the sensitivity of the sensor, which you do by raising the ISO setting. The good news is that you can capture the scene with better exposure. The bad news is that the improved exposure comes at the expense of quality: You'll have noise and grain in the image.

TIP

It's a good idea to keep the camera set at the default ISO 400 and make adjustments when you need more light. That way, you can consistently produce clean video.

Here are the ISO settings for video capture:

>> **400:** The default setting provides the best image quality in normal light conditions, such as on a bright sunny day. When you use it in lower light levels, your video will be darker than normal.

>> **800:** When there is a little less light, such as in shady areas or brightly lit indoor illumination, this setting provides the best combination between acceptable exposure and low image noise.

>> **1600:** Ideal for situations where the light levels are not very bright, or for action scenes where you want the camera to choose a higher shutter speed to freeze the action, this setting produces slightly more image noise but is still within acceptable range. Make sure that you set it back to 400 when shooting in bright light.

>> **3200:** Scenes that consist of very low light levels, such as dusk, a dimly lit room — or for times when you want the camera to catch a higher shutter speed to capture crisp action — benefit from this setting. Of course, it comes at the expense of increased image noise.

>> **6400:** Use this setting when light levels are very low, such as darker areas at dusk or a sparsely-lit interior (but with increased image noise).

Protune ISO settings for still images

In Protune, you can also set ISO settings for still photography. The default setting is at ISO 800, but you can set lower ISO settings with less image noise in 400, 200, and 100.

Sharpness

Like most digital cameras, the GoPro adds digital sharpness after capturing footage to give it the appearance of being sharper. By default, it applies high sharpness to the image, but you can change that setting in Protune to medium or low. The footage will appear softer. You can always enhance it in postproduction, reminiscent of the Camera Raw setting on your DSLR (digital single lens reflex camera). Having control of the footage plays a big part in the look of your movie. You can adjust all these settings on the camera or in the Capture app on your smartphone (see Figure 3-6).

FIGURE 3-6: Protune lets you control image sharpness and can be accessed through the Capture app on a smartphone.

Photo courtesy of GoPro, Inc.

You can choose one of three settings:

>> **High:** The default setting applies a great deal of sharpness to the scene. Sometimes it looks fake. That's because sharpness is added (along with other settings) while the image is being processed after you capture it.

>> **Medium:** This setting is still sharp but provides a bit more realistic appearance to some situations.

>> **Low:** This setting captures video with the least amount of sharpness but provides the most flexibility in postproduction.

Color

By default, your camera is set to GoPro Color, which is vibrant and saturated, and makes the video look great. When you're trying to match what you shot on your GoPro with footage captured with another camera, it's harder to match the color.

If you change the setting to Flatter Color, you can do more in postproduction, especially when you're looking to match footage. If not, the GoPro Color setting works well.

Exposure compensation

Exposure compensation provides a little more control by telling the camera to adjust exposure above or below the normal automatic exposure setting. Figures 3-7, 3-8, and 3-9 show variations in exposure compensation. You can see how greatly they differ. You can adjust brightness only within the existing ISO limit. If brightness has already reached the ISO limit in a low-light environment, increasing it won't have any effect. Exposure adjustments over a two-stop range in half-stop increments can be used to under or overexpose the scene.

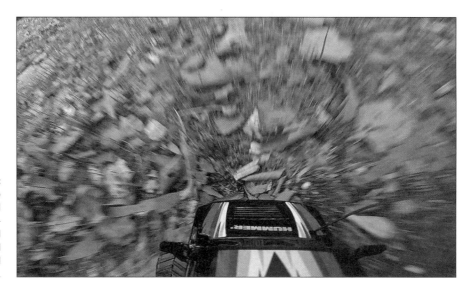

FIGURE 3-7: GoPro mounted to a radio-controlled car captured with normal exposure.

Resolution

Protune gives you access to more resolutions and frame rates. While the HERO5 Black provides the most variations (see Table 3-1), other models offer a wide range of choices.

TABLE 3-1 **Non-Protune Resolutions**

Resolution	Frame Rate (fps)	Field of View
4K / 4K (17:9)	30, 25, 24	Ultra Wide
4K (SuperView)	24	Ultra Wide
2.7K, 2.7K (17:9)	60, 50, 48, 30, 25, 24	Ultra Wide, Medium, Linear FOV
2.75 (SuperView)	30,25	Ultra Wide
1440p	80, 60, 50, 48, 30, 25, 24	Ultra Wide
1080p	120, 90, 60, 50, 48, 30, 25, 24	Ultra Wide, Medium, Narrow
1080p (SuperView)	80, 60, 50, 48, 30, 25, 24	Ultra Wide
960p	120, 60, 50	Ultra Wide
720p	240, 120, 60, 50, 25	Ultra Wide, Medium, Narrow
720p (SuperView)	120, 60, 50	Ultra Wide
WVGA	240	Ultra Wide

Non-Protune capture settings

Non–Protune settings include the following:

>> **Camera Orientation:** This setting lets you shoot the scene upside down, eliminating the need to rotate the video in postproduction. That means you are free to mount the camera and not have to worry about orientation.

>> **Spot Meter:** This setting allows the camera's automatic exposure to base exposure on a much smaller portion of the scene. Use Spot Meter when you're capturing scenes in dark spaces with bright lighting, which can otherwise confuse the automatic exposure setting (see Figure 3-10).

>> **Simultaneous Video and Photo:** This setting lets you simultaneously capture video and still photographs. You can set the camera to take a still image every 5 to 60 seconds while recording video.

Not all video resolutions support this setting, and you can't use it while Protune is on.

REMEMBER

>> **Looping Video:** Like a security camera, this setting continuously records the scene. When space on the memory card runs out, the camera overwrites previously recorded content. You can alter the setting to rerecord after a certain duration (5 to 120 minutes). Like Simultaneous Video and Photo, this feature doesn't work when Protune is turned on.

FIGURE 3-10:
Spot metering
allows you
to capture
accurate expo-
sure in scenes
with wide light
disparities,
such as this
replica of the
transporter
from *Star Trek.*

Using Advanced Features

Delving deeper into your GoPro's feature set can be as thrilling as finding spare change in your couch cushions. But unlike grabbing a few quarters that fell out of your pocket months ago, these functions help you find something else: cool stuff for capturing amazing imagery. And now there are new ones that make it even easier to capture time-lapse, night photography, and both together. For those times you wish to get right to the good parts to edit, the Hi-Light Tag lets you highlight your memorable moviemaking, literally. That's the Hi-Light Tag, and it lets you mark important parts of the movie, while you're shooting it, so that you can find it easily later.

Hi-Light Tag your best moments

This new feature provides the antidote for quickly finding key portions of your video, which comes in handy when shooting a lot of video. The relatively new function found on the HERO4 series as well as the Session models is easy to use, and incredibly efficient when it comes time to edit. This is important as media cards continue to get bigger and hold more content. The Hi-Light Tag simplifies the search by allowing you to add a marker to the footage making it easier to find and share it.

Like many other GoPro features, there's more than one way to access and use the Hi-Light Tag function. You can access it from

» **The camera:** It's the most basic way to use it, and simple too. Just start recording and press the Settings/Tag button on the side of the camera. While simple, it can also introduce vibration into the equation each time you touch the camera.

» **The Capture app:** When you pair it with your smartphone you can control all the camera's functions and monitor the scene without touching it. Just tap the yellow button in the Capture app to tag each scene (see Figure 3-11).

» **The GoPro remote:** The remote allows you to tag important scenes by clicking the settings button — that's the one that looks like a wrench — every time you want to highlight an important section.

FIGURE 3-11: Click the yellow button to tag each part of the scene.

Seeing the Hi-Light Tag in action

After importing the footage into GoPro Studio, every section you tagged is labeled with an orange marker, as shown in Figure 3-12. Just double-click on it, and it will open in a play window when editing in GoPro Studio. The yellow lines on the timeline make it easier to set in and out points for just what you need.

FIGURE 3-12: Highlighted clips show an orange marker.

Trying the Night Photo mode

The HERO4 and Session models provide expanded control over capturing night and low-light subjects with your GoPro (see Figure 3-13). This feature works for movies, still images, and time-lapse sequences. Basically, it allows you to select a longer shutter speed ranging from 2–30 seconds. Like many features on your GoPro, the Night Photo mode is accessible through the camera, remote, Capture app, and the touch screen display.

Here are some useful tips when using the Night Photo mode.

- » **Keep the camera stable:** Shoot in Night Photo mode just as you shoot in any other long exposure situation, and firmly mount the camera. Whether you're using a traditional tripod, mounting adhesives, or a specialty mount, a steady camera is necessary for sharp, non-blurry imagery.

- » **Use in conjunction with Protune:** Not only does shooting with Protune subject the video capture to less compression, thereby creating better imagery, it also lets you alter a variety of functions, including White Balance, ISO setting, and Exposure Compensation. Use these features to your advantage.

- » **Shoot a test exposure:** Take advantage of your ability of the immediate gratification of viewing your footage after you shoot it. There's no sense in investing all that time if you're not going to make sure exposure, color, and composition are just right.

Accessing Night Photo mode by using the Capture app

You can access Night Photo mode on the camera, but sometimes using the Capture app is easier. It's especially helpful when the camera is already mounted and you don't want to touch it. You can also switch modes and make changes directly on your smartphone (see Figure 3-14).

To access Night Photo mode by using the Capture app, follow these steps:

1. **Open the app.**

 After firing up the Capture app, and tapping Connect to Camera, tap the Control button on the Home screen.

2. **Set the app to Night Photo.**

 At the bottom of the preview screen, tap the icon to the right of the record button. It reflects the last mode used, so it may look like a camera.

3. **Select Night from the popup.**

 This mode will allow the shutter to record longer exposure times conducive for night photography.

4. Set the shutter speed.

Click on the wrench icon on the bottom right to change settings. Navigate to the Photo Settings and click Shutter. You can select a range for 2 to 30 seconds. If you're not sure, select Auto, and the camera will decide the proper setting.

5. Now you're ready to shoot.

Notice that the Night Photo mode is represented by a moon and stars over the camera icon.

FIGURE 3-14:
Using the Capture app to shoot a night photo.

Controlling the Night Photo mode from the camera

If you're not using the Capture app, you can set the Night Photo mode on the camera by the doing the following:

1. Press the Mode button and navigate until you get to the Photo mode.

2. Press the Settings/Tag button (that's the one on the side of the camera).

Here you can access the mode of your choice for taking photos.

3. Press the Shutter button to change the mode to Night.

The default setting is single exposure.

4. Press the Mode/Power button to select Shutter Speed.

5. Press the Shutter button to select the desired shutter speed.

You can select a shutter speed from 2–30 seconds. If you don't, the camera will select a shutter speed automatically.

Shooting a time-lapse at night

Another cool feature on newer GoPro models is the Night-Lapse mode. This variation of the Time-Lapse mode lets you shoot time-lapse sequences at night or under extremely low light conditions. So how does it work? Basically, it's the same function as a run-of-the-mill time-lapse, with one major difference: The shutter stays open longer. In the Auto mode, each frame is up to 2 seconds (depending on exposure) while in the Fixed mode, you can capture exposure durations between 2 and 30 seconds. In addition, it can capture single frame at intervals of up to one hour.

The photo shown in Figure 3-15 was captured by placing the camera on the hood of a car using the Suction Cup mount. The interval was set to one second, while the car moved at an average speed of 10 miles per hour, creating the illusion in the time-lapse of travelling more than 300 miles per hour.

FIGURE 3-15:
Using the Suction Cup mount on the hood of a car.

Access Night-Lapse mode through the Capture app, the touch screen display, or on the camera itself.

Here's how to use it:

1. **Open the app.**

 After firing up the Capture app, and tapping Connect to Camera, tap the Control button on the Home screen.

2. **Set the app to Night Lapse.**

 At the bottom of the preview screen, tap the icon to the right of the Record button. It reflects the last mode used, so it may look like a camera or a stack of papers. Tap it, and then tap Multi-shot (the icon looks like a stack of papers).

3. **Change the time interval.**

 Click on the wrench icon on the bottom right. It will bring up the settings menu. Navigate to Multi-Shot Settings and click Shutter. You can select a range from 2–30 seconds. If you're not sure, select Auto, and the camera automatically selects the proper setting.

4. **Make sure the shot is set up to your liking.**

 Now you're ready to shoot. If you have questions on intervals and how long you need to shoot the time-lapse, see Chapter 5.

5. **Start recording.**

 Press the Shutter/Select button to stop recording. The red status light flashes three times, and the camera emits three beeps to indicate that Time-Lapse mode has ended.

Controlling the Night-Lapse mode from the camera

If you're not using the Capture app, and using at least a HERO4, you can set the Night–Lapse mode on the camera by the doing the following:

1. **Press Mode/Power and select Multi-Shot.**

2. **Press Settings/Tag button (Multi).**

3. **Press Shutter to change mode to Night Lapse.**

4. **Press Mode/Power to find interval.**

5. **Press Shutter to select the interval.**

Chapter **4**

Understanding Effective Camera Techniques

ts size is the first thing that lets you know making a movie with a GoPro is very different from using any other camera. After all, not many serious cameras resemble an accessory for your niece's favorite American Girl doll. But don't judge a book by its cover or a camera by its proportions. This formidable camera holds its own despite its diminutive appearance.

Regardless of your expertise in making movies or taking photographs, getting the most out of your GoPro requires a fresh approach, because GoPro shooting is a novel experience. You have limited control of exposure, focus, and focal length, for example, which makes it important to find the best places to mount the camera and compose the scene effectively.

In this chapter, I show you how to devote your time and energy to making a great GoPro movie.

Nailing GoPro Fundamentals

Proper planning is the key to success with a GoPro. It takes a few extra moments to make sure that the composition, color, and light are all right for the shot, but staying aware of how you capture each scene strengthens the final appearance of the movie. That's how the pros do things.

Understanding the camera's limitations

Unlike the camcorder or DSLR (digital single lens reflex camera) you may be comfortable using, the GoPro offers far fewer controls. It handles most of the technical settings automatically, and the focal length is limited to some pretty wide views. Earlier models offered a single, albeit very wide, view. But newer models offer some variations by also providing a narrow and medium angle of view. Basically, it shoots the scene at a higher resolution setting and crops it to fit the frame, so there is no loss of quality. The 2.7K mode provides enough resolution for the medium view; the 4K mode allows you to capture a narrower section.

So, when you're on a lonely, desolate stretch of highway, a single-pump gas station has all that you need. A GoPro isn't much different. The camera is simple to operate, leaving the creative stuff up to you. That "creative stuff" includes setting up the camera properly, arranging each shot effectively, and solving each problem that pops up. Every time something changes in the scene or you move the camera, it's important to make adjustments.

In many ways, not having to focus or set exposure is one of the camera's greatest assets. Still, you'll need to find ways to work around (or work with) the following limitations of the GoPro:

>> **No adjustable aperture setting:** The *aperture setting* determines the amount of light that goes into the lens. GoPro sets it automatically. With another camera, you might adjust the aperture setting to increase or decrease depth of the focus in a scene, but you don't have that option when you're working with an ultra-wide-angle lens.

>> **No adjustable shutter speed:** Depending on the subject, lighting, and level of action, adjusting the shutter speed offers a little more control. Slow speeds produce blurred images; higher ones can capture crisp action. Except for the Night Photo mode, GoPro doesn't allow you to change the shutter speed. But it does offer a wide range of frame rates, which you *can* adjust to achieve the same effects.

>> **No manual focus:** You don't have much to focus with a lens that covers a wide angle view up to 170 degrees. Just about anything in the scene is in focus as long as it's more than a few inches away (see Figure 4-1).

Checking your setup

"Measure twice, cut once" works well for carpenters, so why wouldn't it for moviemakers too. Taking a little extra time to make sure that everything is set right

goes a long way. Making sure that a shot is technically perfect means double–checking the monitor, ensuring that the mount is secure, and verifying that the camera is set properly.

FIGURE 4-1: Though the GoPro is only a few inches from this reflective warning on a train platform, the entire picture is in focus.

THE GOPRO ISN'T A POINT-AND-SHOOT CAMERA

I overheard someone comparing the GoPro with a point-and-shoot camera. Although the camera's manual controls are somewhat limited, it's more than a point-and-shoot.

Still, the term is misleading for referring to automatic cameras. Even the most expensive DSLR can be used in a fully automatic mode. So, while GoPro limits your control over exposure and focal length, if it's a point-and-shoot camera then it's one on steroids. Great movies are always made by hand, so be more concerned with setting up the shot and less about the automatic stuff.

Getting exposure just right

It's a tall order when you need to figure out how to fine-tune exposure with a camera that offers no manual settings, but GoPro moviemaking requires a different way of thinking. You can still control image quality, but the process is different from changing the aperture or lowering the shutter speed.

Here are some pointers:

>> **Monitor the scene with the Capture app.** Because most of the time you will be nowhere near your GoPro, it's necessary to monitor the scene so you can compose it properly and check the exposure. You probably already spend a lot of time checking your smartphone, so why not use it to check each shot on your GoPro, too? (I cover the app in detail in Chapter 5.)

>> **Use exposure compensation.** Exposure compensation is the next-best thing to setting exposure manually. This feature (activated when you turn on Protune; see Chapter 3) lets you increase or decrease the automatic exposure setting a few steps.

>> **Set your ISO manually.** Depending on the situation, you can alter the camera's ISO setting to capture bright or dimly lit scenes properly. A bright daylight scene does well when you set the camera at ISO 400, for example; for a low-light situation such as a night scene or a dark club, try using ISO 6400 to increase sensor sensitivity. As with exposure compensation, you must enable Protune to change ISO settings manually.

Maintaining accurate color (with Protune)

The GoPro normally reproduces a scene with punchy, saturated color. That setting works well for many situations, but on some occasions, you want to fine-tune color or take a more stylized approach. Maybe you want to use color temperature to convey a feeling in the scene. A warmly lit scene may evoke coziness, whereas a cool blue rendering evokes distance and isolation or tells the viewer, "Hey, it's pretty cold here."

When Protune is turned on, you can navigate through the Capture app to the Color setting to adjust the color profile of your video footage. Here are the settings:

>> **GoPro Color:** The default color setting, providing user with the color profile they know and love.

>> **Flat:** Provides a neutral color profile that captures more shadows and highlights. Uncorrected, this setting doesn't look very appealing, as seen in Figure 4-2, but it provides the most flexibility when it comes to postproduction. Figure 4-3 shows corrected color.

FIGURE 4-2:
The color of
this mural
is dull.

FIGURE 4-3:
After a tweak,
this image
looks much
better.

Keeping the camera steady

Although technical settings contribute to the success of each shot, none of them matters much if you can't keep the camera steady. Camera stability is an impor-tant part of the equation, like following your grandmother's recipe for reindeer cookies.

USING THE CAMERA ON A TRIPOD

For general image stability, nothing beats a tripod. Using a tripod with your GoPro requires the accessory tripod mount (see Chapter 2), which serves as an adapter between the camera and the tripod head. If you opt to use one for your next GoPro capture, try the following tips:

- **Place the tripod on level ground.** Make sure that you plant the tripod firmly on a level surface.

- **Check that everything is tightened.** This includes the GoPro mount.

- **Keep an eye on the horizon.** Because the camera has such a wide view, any slight movement of the mount will make the footage look as though the world is sliding downhill. Unless you have a specific creative purpose in mind, an evenly balanced horizon is essential. Be sure to monitor the scene in the Capture app on your smartphone before pressing the Shutter/Select button.

- **Position the tripod properly.** Chances are that you'll be close to the subject, so if you're using a standard tripod, try *not* to point one of the tripod legs toward the subject. Otherwise, you risk getting the tripod leg in the shot or causing someone trip to over it. If you're using something like a GorillaPod, make sure that it's wrapped securely around whatever you wrap it around.

Make sure that the camera remains steady throughout your shots. GoPro offers more mounting accessories than an equestrian boutique (see Chapter 2), so choose the right mount for the job to make sure that the camera is secure. Also, check that everything is tightened properly. If you mount a GoPro on your skateboard,

and the thumbscrew on the mount is loose, the resulting footage will show the camera slipping.

At one point or another, you may consider holding the camera in one hand and your smartphone (running the Capture app) in the other. Don't even think about hitting the wet stuff with your GoPro with smartphone in tow. It's like going out with Superman and finding that bullets don't bounce off your chest.

Shooting Your Movie

The success of your movie depends heavily on how effectively you capture each scene, and part of that process involves shooting enough variations of each scene. Having several angles and perspectives to choose among helps you alter the movie's visual rhythm and give it a nice flow (see Figure 4-4).

Deviations within shots make for powerful editing and help you pace the movie. It's not unusual for a movie to have a 20:1 ratio (or greater) of shots captured to shots used.

But not being stingy about shooting variations of each shot doesn't give you license to overshoot. If you do, you'll spend too much time going through the footage and second-guessing what you included in the edit and what you put on the storyboard.

FIGURE 4-4:
Unique angles help make your movie more interesting.

Finding the best position for the camera

There's a certain swagger to GoPro movies that makes them stand out from their more conventional counterparts. Whether it's a segment of breathtaking action sequences, unique perspectives, or a little of both, there's something truly distinctive about movies made with this camera. But they're not impervious to the fundamentals of the best places to put the camera.

That's because great moviemaking revolves around assembling an array of shots that come together like a visual symphony. If you think of each shot as a note of music, you will realize that sometimes it doesn't matter how beautiful that note sounds on its own, because it needs other notes for it to sound complete. The same thing happens when you apply a nice mix of shots to your movie.

So, variety isn't just the spice of life; it also adds flavor to your movie. That means altering the camera-to-subject distance or mixing in different angles keeps the viewer more interested in your movie than, say, using a bunch of eye-level shots. Don't get me wrong — they're necessary, but if that's all you got, your audience will suffer from terminal yawning.

It also means putting the camera in unusual places to show a unique view, such as using a roll bar mount to attach the camera on a shovel, as seen in Figure 4-5.

FIGURE 4-5: Attaching the camera to a shovel handle during fall leaf cleanup shows an interesting perspective.

Shooting to edit

Rather than shoot everything that happens in front of the camera, it's more effective to shoot to edit. Shooting to edit means having an idea about the structure of the movie — or the number of scenes you want to include — and then creating each scene with three or more variations. The simplest form of shooting to edit means getting a wide-angle, normal, and close-up view of each subject.

Shooting to edit is a little more complicated with the GoPro, however, because its fixed lens covers a very wide angle of view, making normal view hard and zoom impossible.

Here are some options for varying your shots:

>> **Shoot variations of each shot in the scene.** At the very least, include variations to subject size and angle. This makes it easier to choose shots in the editing process.

>> **Change the Field of View.** Altering the size of the subject in the frame provides de facto versions of wide, close-up, and normal views.

>> **Shoot at different angles.** Besides shooting at eye level, place the camera high and shoot down on the subject, or mount the camera low and shoot up at the subject.

>> **Alter the composition.** You have a lot of frame to play with, so use it to your advantage by incorporating various compositional devices such as the rule of thirds, subject placement, and framing (see Figure 4-6). For a more thorough list of compositional choices, look at Chapter 6.

FIGURE 4-6: Framing the subject provides a nice option for your edit.

Alternating shots, GoPro style

GoPro uses a pretty wide focal length to make movies, but that's not so unusual. Often, feature films are shot with a single lens. Changing the camera-to-subject distance and perspective varies shots. You can also select a less wide setting. (See Chapter 1.) But the big difference is that cinema cameras generally use a lens with a normal perspective. In the 35mm world, that would be the 50mm normal lens. Its perspective lies between being slightly wide and slightly telephoto.

GoPro makes alternating shots a little more challenging because it's just wide. It's still possible to get a good variation of shots with your GoPro; you just need to get a bit creative.

Maintaining continuity between shots

Most films are shot out of sequence and put together in postproduction like a giant puzzle. Sometimes when the movie is being assembled, though, a scene may be compromised because something changed from shot to shot. Maybe that can of soda that was on the edge of the counter in one shot is on the other side in another shot. Or maybe the actor's shirt was buttoned differently in a couple of shots. Isolating all the details makes for logistical nightmares. Many mistakes are so minor that audiences wouldn't even notice them. But that doesn't mean you shouldn't be as careful as possible.

TIP

These pointers can prevent problems in your movie:

>> **Keep a detailed record of each scene.** The proof is in the picture. The better your recollection of a scene, the better your chances of ordering other shots properly.

>> **Keep the action plausible.** Successful editing thrives on the rhythm between shots, so it's necessary they remain plausible. Don't show a sequence of someone getting into a car, and then showing it moving in the opposite direction because the light was better.

>> **Watch the subject's primary movements.** Sometimes it's hard with this camera, especially when shooting action. Regardless, be sure the subject's actions remain consistent (See Figure 4-7). For example, if the subject has his right hand raised slightly in the wide shot, then make sure it's not lowered in the medium shot. These minor breeches can still break the suspension of disbelief in your movie, so be aware of them.

>> **Try not to break the 180-degree rule.** This establishes the screen direction of the action. It's the same premise as a stage production, where everything happens in front of the audience, or within their peripheral view. Think of it as

an imaginary line that the camera must stay behind to maintain continuity. Easier said than done with a GoPro, but many continuity problems occur when the succeeding shot does not maintain the periphery of human vision.

FIGURE 4-7: Video from these street performers was captured from the start of the performance.

When to stop and start the camera

When to stop and start the camera is a practical question. You can't peek through a viewfinder on most models and press the shutter at the right moment. Nor can you fully trust the Capture app on your smartphone because it has a 2-second delay. So, here's some advice on when to stop and start:

>> **Use the Capture app on your smartphone:** Whenever possible, this provides the best way to record each scene, even with the 2-second delay. Not only can you look at the shot, but also you don't have to touch the camera, possibly overturning it. You can control up to 50 cameras. You can also use the GoPro remote.

>> **Start early:** No matter what kind of camera you're using, it's always best to pre-roll so that the action begins after you started recording. The same applies for stopping the record. Let it breathe a bit before ending the record.

>> **Use the Photo Burst mode for stills:** You can alter its setting to how many frames it captures as well as the duration. For moving scenes that you don't want to miss, set the camera on burst and press the Shutter/Select button. You can always discard the outtakes.

Tooling with Time-Lapse Mode

GoPro is an equal-opportunity camera because it allows you to capture still images that are every bit as impressive as its video. The wide-angle lens provides a crisp, sharp image for pictures that move and the ones that stay perfectly still. The only thing more impressive would be finding a way to mix them. Well, you don't have to look; the time-lapse mode on your GoPro provides the best of both worlds.

Getting started with time-lapse

A *time-lapse* sequence consists of a bunch of still images that are captured at a constant rate. It's like animation with photographs instead of computer-drawn pictures. By default, time-lapse mode on a GoPro shoots a frame every 0.5 second, but you can capture the scene at intervals as high as 1 frame every 60 seconds. In Figure 4-8, for example, the GoPro is mounted on car hood, and the duration was set at a 1/2 frame per second. The car was moving at 20 miles per hour, creating the illusion of moving at 300 miles per hour.

After you capture the sequence, the numerous images are processed in a video editing program (such as GoPro Studio Edit; see Chapter 11) and brought together in order. Sometimes, a time-lapse sequence consists of thousands of images, so you need an application to put them all together.

Shooting time-lapse footage

After you power up your GoPro, here's how to record time-lapse footage:

1. **Press the Power/Mode button to cycle through the available modes.**

2. **When you reach Time-Lapse, press the Shutter/Select button to select it.**

The icon for Time-Lapse mode is a clock next to a camera.

3. **Change the time interval.**

Go to the Settings menu on the Capture app and click Time Lapse to find the desired interval.

The default setting is 0.5 second, but you can capture a frame every 1, 2, 5, 10, 30, or 60 seconds. (For more information, see the nearby sidebar "Calculating duration.")

4. **Press the Shutter/Select button to start time-lapse capture.**

The camera initiates countdown, and the red status light on front of the camera flashes each time a frame is captured.

5. **Press the Shutter/Select button to stop recording.**

The red status light flashes three times, and the camera emits three beeps to indicate that time-lapse mode has ended.

Making time-lapse easier

Making time-lapse movies beats a lot of other cool ways to tell a story, but it can be nerve-wracking, too. For one thing, it's a huge time investment. Also, if a glitch occurs, you lose the sequence but gain a few thousand images — not really an equal trade. For that reason, it's important not only to set up the camera properly for time-lapse recording, but to also take a sensible approach to it.

CALCULATING DURATION

Suppose that you want to create a 30-second time-lapse movie of Thanksgiving dinner with your whole family at the table. You're planning to capture all 2.5 hours from soup to nuts, but you're not quite sure about the duration between frames. If you use a setting of 1 frame per second (fps), for example, your sequence would be around 6 minutes long. Yikes!

The difference between a good time-lapse sequence and a great one often lies in the interval between frames. Striking the proper balance takes a little trial and error. You can select the duration between frames randomly, or you can use a formula.

Instead of guesstimating, use the following formula to calculate exactly how many frames you'll need and the duration between them:

1. **Determine the desired length of the sequence as follows:**

   ```
   (Desired duration in seconds) x (Frames per second for playback) = Amount of
       frames for playback
   ```

 A 30-second sequence that plays back at 30 fps would require 900 frames:

   ```
   (30 x 30 = 900)
   ```

2. **Translate total time into seconds with this formula:**

   ```
   (hours) x (60) x (60) = seconds
   ```

 To record your 2.4-hour family dinner, for example, you'd use the following formula:

   ```
   (2.5 hours) x (60 minutes) x (60 seconds) = 9,000 seconds
   ```

3. **Divide the time in seconds (Step 2) by the number of required frames (Step 1) to come up with your frame duration.**

 To make a 30-second movie of your 2.4-hour event, set the digital timer at 1 frame every 12 seconds and then find something to do for the next 2.5 hours.

   ```
   (9,000) / (900) = 10 seconds
   ```

Here are a few pointers:

>> **Mount it securely.** Whether you opt for a GoPro mount or decide to use a tripod (with the GoPro adapter), be sure that you mount the camera securely. You don't want to introduce motion where it shouldn't exist.

>> **Take your time.** Plan the shot, and make sure that the subject is properly framed (see Chapter 6). Be on the lookout for elements that can detract from the sequence, such as a bright light or an extraneous object.

» **Understand that a time-lapse sequence is a sequence.** Time-lapse recording depends on activity in the frame. Sometimes, that activity is going to be fantastic. At other times, you'll have unpredictable motion in the scene or pedestrians getting too close to the camera, and maybe you'll even catch yourself checking the camera. These moments pose little threat, if any, because they're fleeting and won't be noticed or can be deleted in postproduction (see Part 3).

» **Use a large, fast memory card.** The card you select should be like an NFL wide receiver: big, strong, and fast. Because time-lapse sequences have the potential to capture a lot of frames at a high resolution, you want a card that has enough capacity to hold them all and enough speed to perform smoothly. Few things are worse than missing key action because you filled the card or the card wasn't fast enough to keep up. A 32MB Class 10 card is ideal (see Chapter 2).

» **Have a fully charged battery.** GoPro batteries are notoriously short-lived — battery life is around 2 hours — so it's entirely possible for your camera's battery to drain before the time-lapse sequence ends. Always use a freshly charged battery, and check on the camera often.

» **Hurry up and wait.** The name of this process alone — time-lapse — should tip you off that it's quite lengthy. You won't have to do much except wait. You can get some other things done and even walk away from the scene for a while if you'll be nearby.

Using Other Photo Modes

Besides banging out the occasional still frame and capturing a time-lapse sequence, your GoPro offers more options for capturing still images. You'll notice them when you're scrolling capture modes.

Here are a couple of other photo modes that you may want to check out:

» **Continuous:** This mode allows the GoPro to work like a motor drive on a DSLR by capturing 3, 5, or 10 fps for as long as you hold down the Shutter/Select button. Continuous mode is great for capturing action scenes.

» **Photo Burst:** This mode acts something like Continuous mode, but it shoots a burst of frames that you set ahead of time. It's great when you want to have a choice of frames in an action sequence. Figure 4-9 shows a few of the frames that were in the capture using Photo Burst mode; Figure 4-10 shows the perfect one. In the Photo Burst mode, the burst was set to capture 30 frames in 3 seconds; Figure 4-9 shows five frames.

FIGURE 4-9:
Photo Burst
mode.

You can use one of the following settings:

- 3 photos in 1 second
- 5 photos in 1 second
- 10 photos in 1 second
- 10 photos in 2 seconds
- 30 photos in 1 second
- 30 photos in 2 seconds
- 30 photos in 3 seconds

FIGURE 4-10:
There's a
monster at
the castle
door! This
frame shows
the furry kid
noticing the
carrot before
devouring it.

Chapter **5**

Framing the Shot

G reat films are built on the creative use of visual elements such as composition, camera angle, color, and lighting. The GoPro adds its own perspective to the mix, thanks to its extremely wide-angle view and its capability to go almost anyplace.

Although the GoPro has become a recent phenomenon, shooting with an ultra-wide-angle lens is not. Some professional directors rely on it for an occasional shot; others swear by it. Terry Gilliam (director and founding member of the British sketch-comedy group Monty Python) shoots nearly all his films with a rectilinear wide-angle lens, which gives his films a unique look. Wes Anderson also favors a very wide view as a stylistic device.

These directors accomplish what we're all looking to do: differentiating ourselves from the pack through our special way of seeing a story. Finding your own visual style begins by understanding the fundamentals. That's what will make you

different from your cousin Jim or your former college roommate who also has a GoPro. The goal is to find your visual style and build on it.

This chapter shows you how to use classic visual elements to create a compelling film — GoPro style.

Understanding Time-Honored Visual Basics

Here's a way you could look at composition: "What happens in the frame stays in the frame." More accurately, what happens in the frame is all that people can see. Take the time to provide essential visual content, but do it economically enough that you don't clutter the frame.

How you choose to occupy the frame plays a big part in the success of your movie. No matter what technology you use, what happens in each shot stands on its own but also influences other shots. Not sure what I'm talking about? Check out the shower scene in Alfred Hitchcock's classic thriller *Psycho* or the "Here's Johnny" close-up of Jack Nicholson in *The Shining.* There's nothing random about these shots; they were strategically arranged. The directors understood how to fill the frame, as well as the relationship between each shot when it comes to assembling the movie.

Creating an effective composition has its challenges, especially with a camera that captures the world with an ultra-wide-angle view. But that doesn't mean you can't find a happy medium. Besides, each of us sees the world a little differently, so here's a breakdown of the components of visual technique.

Properly composing the scene

Composition is about understanding how to fill the frame in a way that effectively and efficiently communicates your intention to the viewer. There's psychology behind arrangement of scenes. Normally, people look from left to right and top to bottom. That mechanism works for reading and for effectively arranging a scene to capture video or a still frame.

Here are two examples of how a viewer can interpret a scene, based on the way it's arranged:

» **Positioning the subject at bottom right:** This arrangement draws viewers to the subject (see Figure 5-1) as they look across and down at the frame.

» **Positioning the subject at top left:** When the subject is in the top-left corner of the frame (see Figure 5-2), the viewer can share the perspective of the subject in the scene.

FIGURE 5-1: When the subject is in the bottom-right corner, the viewer's eye follows him.

FIGURE 5-2: Subject at top left.

Coherently arranging the shot

Basic shot structure with a GoPro differs somewhat from the approach you would take with a conventional camcorder or DSLR (digital single lens reflex camera). The GoPro uses a fixed wide-angle lens, whereas the others use a zoom lens that covers lots of focal lengths (but nowhere as wide as the lengths that the GoPro's lens can cover).

Instead of using focal length to bring a shot in tight, control the variations in the size of the subject in the frame solely with camera-to-subject distance. Typical shot arrangements such as wide, medium, and close-up take on different meanings with the GoPro. If you're using the Black Edition, it's possible to change the Field of View. Here are some of the shots you can get:

>> **Ultra-wide:** This shot covers a wide area of the scene with nothing looking as though it's anywhere near the camera (see Figure 5-3).

FIGURE 5-3:
Normal
ultra-wide
GoPro view.

>> **Very wide:** This shot still covers an expansive area, but some objects appear to be closer (see Figure 5-4).

>> **Fairly wide:** Objects in the scene are much closer to the lens, though not that close that the ultra-wide-angle view makes them seem a little distant. Meanwhile the subject is probably only a few feet away, as seen in Figure 5-5.

» **Intimate wide:** This shot is still wide but fills the frame with the subject, who may be just inches away (see Figure 5-6). Think of this view as being the GoPro's version of a close-up.

FIGURE 5-4:
Expansive
GoPro view.

FIGURE 5-5:
Wide GoPro
view.

FIGURE 5-6:
A shot taken
right next to
the subject.

Breaking Down Shot Lingo

Great filmmaking weaves different shot types throughout a story. The different sizes at which you depict a subject in the frame help create a visual narrative.

Here's an in-depth description of various shot types:

» **Long shot:** Some people call this shot an extreme wide-angle shot, but I call it the result of using your GoPro like a conventional camera. This expansive shot establishes an overall view of the setting and is often used as the first shot in the edit. It's not always necessary to include actors; a wide landscape with few identifiable subjects qualifies for this type of shot.

» **Very wide shot:** This shot isn't as expansive as a long shot but is still wide. It can also work as an establishing shot.

» **Wide shot:** In the wide world of wide shots, this shot isn't that wide. It works well with people, presenting them from head to toe. Frequently, this shot is used to set up medium and close-up shots.

» **Medium or normal shot:** This shot takes a more distinct view of the subject, showing more of him than in a wide shot and much less than in a close-up — perhaps from the waist up. If you shoot from a higher angle, you can make the subject look like a bobble head doll, with his head being much larger than the rest of his body.

>> **Two shot:** This shot shows interaction between two subjects: a conversation or confrontation. Sometimes, the subjects are shown full-figure; at other times, they're shown from the waist up.

>> **Medium close-up:** One way to think of it is as the close-up for people who don't like close-ups. This shot captures a person's entire face, with a little bit of her neck and chest. If the subject is an object instead of the person, the object can loosely fill the frame. Often, this shot is the closest you're going to get to a subject with a GoPro without totally distorting that subject.

>> **Close-up:** This shot is pretty close, and some people may not like you coming this close. The frame shows the subject from the neck up. It shows the head, hair, and face but not pores and blemishes.

>> **Extreme close-up:** This shot shows lots of detail on inanimate objects, but you may get hit with an object if you try to use this shot on a human with your GoPro.

>> **Point of view:** This shot shows the scene as the subject sees it (see Figure 5-7) and makes for a great selection of shots for editing. Many GoPro mounts help you achieve this type of shot; see Chapter 3 for a few examples.

>> **Cutaway:** All sorts of productions, from news broadcasts and documentaries to feature films and reality television programs, use this device to provide more options for editing. This shot shows details such as the subject's cracking his knuckles, picking up a glass, or tapping his fingers.

FIGURE 5-7:
Point-of-view shot using the Suction Cup mount on a car hood.

TAKE SOME TIPS FROM THE MOVIES

The next time you're watching a movie, analyze the shot structure. Feature films include the following shots:

- **Establishing shot:** Generally, this shot is a wide-angle shot that lets the viewer get a sense of the landscape, place, or logistics of a scene. An establishing shot usually is the opening shot of a movie, but it can also depict location or time changes.

- **Wide:** A wide shot is an expansive view of the scene that shows the subject in relation to his or her environment.

- **Medium:** A medium shot is an average perspective, not too close and not too far. It's excellent for shots that include dialogue.

- **Close-up:** A close-up is a magnified view of a scene. Sometimes, it brings distant objects closer or emphasizes important details.

- **Pan:** A pan is a sweeping motion over a scene, from side to side.

- **Tilt:** A tilt is the camera's way of looking up, down, or up and down.

- **Tracking shot:** A tracking shot uses focal length to draw the subject closer or farther away in a scene.

Following Simple Framing Rules

Cinematic composition can follow the same time-honored rules as traditional pictorial composition. The following sections present some of the most prominent rules of composition.

Observe the rule of thirds

Have you ever wondered why Greek architecture remains aesthetically pleasing more than 2,000 years later? The reason is the Greeks' time-honored approach of balancing a shape in thirds — an approach that they called the Golden Mean. Today, we call this approach the *rule of thirds.*

Here are a few guidelines:

>> **Don't place the main subject dead center.** Imagine the frame divided into three parts — horizontal, vertical, and center — with the center being off limits to the subject (see Figure 5-8).

>> **Lead the viewer.** It's your choice to lead the view into or out of the frame. Remember the earlier discussion of positioning the subject.

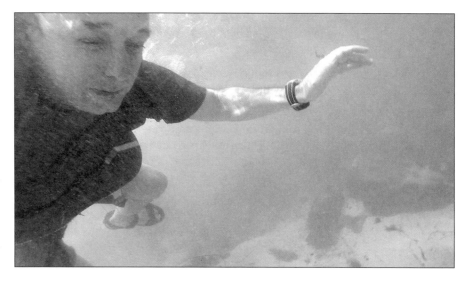

FIGURE 5-8: This underwater selfie follows the rule of thirds, because the main subject does not occupy the center of the frame.

>> **Be mindful of the horizon.** Placing the horizon line in the center of the frame is almost as boring as placing the subject in the middle. Instead, place the horizon on one of the dividing lines to show more sky or foreground. Make sure that the GoPro is level; otherwise, the shot will have image distortion because of its wide-angle lens.

>> **Mind your subject's head.** Always have a little room to avoid giving your subject a flat top.

Keeping things simple

Although the axiom "Less is more" can apply to many things, in filmmaking, it refers to including only pertinent visual information. When you keep the scene free of extraneous clutter, the viewer immediately recognizes the center of interest and doesn't have to take a moment to figure it out. Sounds easy, right? Not all the time. Sometimes, you don't notice clutter in the frame until you start editing. Before pressing the Shutter/Select button, make sure that the shot is concise and that the viewer clearly understands the center of interest.

Keep in mind the following guidelines:

>> **Avoid complicated backgrounds.** A complicated background features a laundry list of elements that can range from objects strewn behind the subject to a light ratio beyond what the camera can handle. Recompose the scene if the sky is too bright or if a telephone pole appears to be growing out of the subject's head.

>> **Focus on simplicity.** When a scene concentrates on the subject, try framing the subject against a plain background, even if the scene takes place in a busy area.

>> **Keep competition among scene elements down.** Make sure that the subject isn't fighting other parts of the scene for the viewer's attention — unless the conflict is intentional, of course. Look at the scene through the viewer's eyes; see whether you understand what the subject is.

>> **Track the shot efficiently.** If the camera follows the subject, be sure that it doesn't lead the viewer into a heap of clutter. Tracking the subject in an open field that leads to a cluster of telephone wires would be leading the viewer into clutter. Recompose the scene if necessary.

Taking advantage of the background

Not placing the subject against a complicated background qualifies as good advice. But at times, the space behind the subject works to your advantage. Colorful, simple, or picturesque backgrounds fall into this category and can even enhance the quality of the scene.

The human eye can effectively distinguish elements in a scene thanks to depth perception, but the camera can't. A movie frame is two-dimensional, so sometimes it can't differentiate screen elements properly. Because the GoPro has such a wide lens, almost the entire scene is in focus, so discrepancies between the foreground and background can blend together.

When dealing with backgrounds with your GoPro, consider the following:

>> **Keep an eye on vertical lines.** Be sure that telephone poles, trees, street lamps, and other sticklike objects don't converge with the subject. These objects can appear to be unusual appendages or look like part of a shish kabob.

>> **Understand that the scene is two-dimensional.** Movies and photographs appear to be compressed, mainly because humans see the world as 3D, but the camera renders it as 2D.

>> **Complement the subject.** Let the background work for the subject. The interview in your skateboarding movie, for example, should have something going on in the skateboard park behind the subject, such as someone doing a halfpipe. In a skydiving movie, a plane or hanger could complement the subject.

Putting people first

Whether you're posing the subject against a background or capturing yourself in an action scene, follow these guidelines:

>> **Determine whether the subject should look into the camera.** Whether the subject is you or someone else, decide whether the subject is going to talk to the audience. Generally, in an interview, the subject shouldn't look into the camera. But if you're filming a first-person account of some event, it's completely acceptable for the subject to look at the camera.

>> **Don't ignore the basics.** Follow the rule of thirds (see "Observe the rule of thirds" earlier in this chapter) for subject placement in the frame. Avoid putting the subject in the center. Also, keep an eye on the background.

>> **Find a flattering angle.** Because the GoPro has a nearly fish-eye view, the difference between a subject's looking like a man and looking like fish may be a matter of a few inches.

Use shadows and reflections wisely

Shadows and reflections not only look good onscreen, but also help unify a scene, especially when it includes a one–sided arrangement. Including shadows in the frame can provide a variety of effects, including a sense of depth, warning, or foreboding (see Figure 5-9). Reflected images tend to grab viewers' attention, especially when they involve rich textures. Sometimes capturing shadows and reflections also works as the main subject.

Balancing the frame with a shadow or reflection serves many purposes. It can make a statement about the scene, such as the time of day, or it can make a nice selection for your shot arrangement. Also, it makes a drab subject look more interesting.

FIGURE 5-9:
This wide view
of pedestrian
shadows
creates an
abstract
depiction of
the scene.

Here are some things to consider about using shadows and reflections in your shots:

» Treat a shadow like any other subject, either by including it in its entirety or by defining a segment (shape, form, or feature).

» If the shadow or reflection is the center of interest, focus attention on it instead of the subject.

» Be careful not to get a reflection of your GoPro in the shot, and make sure that the light behind the camera doesn't create a shadow.

CONSIDERING OTHER COMPOSITIONAL DEVICES

TECHNICAL STUFF

If you follow the rule of thirds and watch the background each time you record, you probably don't need to worry about much else. When you decide to add more visual magic, however, you have a couple more visual devices to consider:

- **Sweeping curve:** Lead the viewer on a sweeping diagonal journey from the top of the frame to the bottom, or vice versa. This technique works best when the scene is shot from overhead, because it leads the viewer on a visual journey.

- **Shape and form:** Sometimes, it's effective to depict the subject as a shape or form. Viewers are attracted to geometric patterns.

Art-Directing the Scene

In this section, I present more advanced approaches to unifying your vision for the movie.

Arranging elements in the scene

It's a bit deceptive to say that you're arranging elements in the scene when you're positioning the camera to include, omit, or capture the subject at a specific angle within the context of the frame. Because the GoPro has an incredibly wide-angle view, sometimes it's challenging to compose a scene.

It's visually effective to position the camera as close to the subject as possible for an intimate view. Using foreground objects to frame the scene works well as another creative device that makes for an interesting shot. Whether you're capturing a doorway, archway, tree branch, peephole, or just about anything else on the periphery of the shot, this technique can define the center of interest in the frame.

Making the GoPro's view work for you

Thanks to the camera's super-wide view, it's best to think of each scene you shoot with your GoPro as having a foreground, middle ground, and background. By paying attention to all three elements, you'll be able to follow basic cinematic principles, and before long, the limitations of focal length will become an asset.

Here are a few pointers:

>> **Maintain attention on the subject.** Don't worry if the framing elements are out of focus, as in Figure 5-10. Besides, when you're capturing such a wide view, it's unlikely much of the scene will be out of focus.

>> **Frame the people too.** If you frame the main subject with people in the shot, it's best to have the people look into the center of the frame, as opposed to out of it. This technique affects the audience's view of what's important; that view is based on where the people onscreen are looking.

>> **Don't place the subject on the edge of the frame.** While dead center is often a boring place for the subject, the GoPro's wide-angle view can severely distort it.

Keeping things in balance

Balancing elements such as color, shape, and light in the frame creates a legitimate order in which the viewer can process the scene. Another method places

subject matter on both sides to form an even composition. In this sort of arrangement, it's acceptable to put the subject in the center.

FIGURE 5-10: Framing the shot of this Halloween scene.

Then there's asymmetrical balance, in which the subject shares the frame with negative or blank space to depict vastness or difference. Also, the juxtaposition of color is another means of making the scene look interesting. You can position a warmly lit subject against a cool blue backdrop, for example. Complementary colors are described as the opposite pairs of colors that produce the strongest contrast to one another. Here are a few colors and their complementary colors:

>> Green/magenta

>> Red/cyan

>> Blue/yellow

Creating subtext in a scene

There are many definitions of subtext in film, but one of the most common ways of showing it is called mise-en-scène (a French term that translates to "placing on stage"). Mise-en-scène occurs when everything comes together in the frame to convey the intention of a scene. Essentially, it's a poetic way of visually conveying what you want the audience to take from the scene.

This message comes together in a variety of ways, mostly through the decor of the set, the arrangement of elements, and the lighting. Sometimes, it's created in the

editing process. One example is cutting away to a locomotive blowing its whistle when the subject begins to show anger.

Here are a few other ways to get this message across to your viewer.

» Use cool blue lighting to depict the subject's despair.

» Having the subject look up to the sky after a confrontation may suggest that he's looking for guidance.

» Having the subject take a walk early in the morning can alert the audience to the start of something new.

Taking advantage of perspective

The GoPro sees the world through an ultra-wide-angle view, as shown in Figure 5-11, so you don't have the luxury of varying focal length to alter subject size when you're shooting from a fixed distance. Instead of treating this limitation as a liability, let it work to your advantage by concentrating on the way you frame the subject matter.

The first time someone loaned me a fish-eye lens for my SLR (single lens reflex camera), I was amazed by how much of the world it captured. At one point, I placed the camera on the curb to get a low-angle view of Times Square, and a cab blocked my shot as I pressed the shutter. After the film was processed, I saw an amazingly distorted image of the taxi, even though it couldn't have been more than two feet from the camera. The GoPro provides a similar experience, and because you're not always nearby, it may deliver similar surprises.

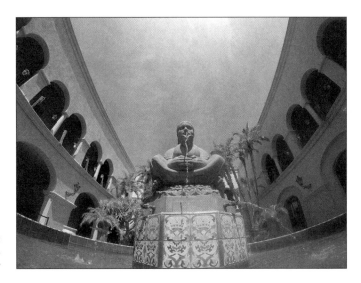

FIGURE 5-11:
Ultra-wide-angle view

Thinking About Where to Put Your GoPro

Most cameras can only be mounted on a tripod or handheld. The GoPro, however, can go anywhere. This section focuses on ways to maximize your opportunities when out shooting with the camera.

Grabbing static shots

By its very nature, the GoPro thrives on action conditions, but that doesn't mean you're not going to need a static shot every now and again. A *static shot* is a still shot of a scene with very little or no activity. Think of it as being the movie version of a photograph. The length of the shot depends on the context.

Here are a few reasons to use a static shot:

>> **Setting a scene:** A wide shot of a stadium before the big game, a downtown block on a Sunday morning, or a local landmark on a fall day can open the film to provide a sense of place.

>> **Depicting a living creature that isn't moving:** Static shots don't always involve inanimate objects. You might take a static shot of your dog taking a nap, an athlete meditating before an event, or your dad snoozing on the couch.

>> **Focusing on details:** Depending on what you're shooting in the movie, concentrating on a key part of the scene gives the viewer a sense of the subject. For example, you can mount the camera on your motocross bike for an action movie.

Using motion

The GoPro allows you to use motion as a creative device. Besides capturing an action sequence with incredible sharpness and exposure, you can alter the speed of the action, creating both slow motion and accelerated activity onscreen. Here are some ways to alter the normal rate of motion:

>> **Slow motion:** The GoPro offers a variety of frame rates with most resolution settings. Frame rates differ from model to model, with the HERO4 Black Edition offering the most options. If you want to shoot slow motion, you should pick the highest frame-rate setting available — generally, 120 frames per second (fps) or higher. Then you need to process the footage (more on that in Chapter 11).

>> **Fast motion:** Although you can achieve this effect by playing with the frame rate in GoPro Studio Edit, you can also shoot a time-lapse movie. The latter technique surely provides better quality because the footage is constructed of individual still images.

Finding your unique point of view

Having a camera that provides a unique view of the world can stimulate your creative approach to arranging a scene. That's why it's important to find the best position for your GoPro by changing its position — higher, lower, or even tilted — to make a shot more interesting.

Where you position the camera speaks loudly about the message you're trying to convey and affects how you edit your movie.

Try including some of these shots in your next movie:

>> **High angle:** Whether you mount your GoPro on a pole or use a handheld extension device, you elevate the camera and change the perspective, providing a more graphical composition of the frame. Besides providing a unique perspective, this shot can make the audience look down on the character, perhaps to depict weakness. It can also produce a bobble head effect when you're shooting a person (see Figure 5-12).

FIGURE 5-12:
Bobble head
effect.

» **Bird's-eye:** Although this shot isn't easy for most cameras, GoPro makes it possible to capture an angle that would make Alfred Hitchcock proud. Positioning the camera high and directly above the action creates a topographical view, often making common objects unrecognizable.

» **Low angle:** Mounting the camera as low as possible and pointing it upward provides another dynamic option for your movie. With this perspective, you can change the horizon. A low-angle shot also shows the viewer something he or she normally doesn't see. You can also use it to show the perspective of a child.

» **Dutch angle:** Intentionally tilting the frame provides a refreshing break in conventional viewing. This perspective, which is popular in horror flicks, independent films, and music videos, can depict alienation, uncertainty, and tension. Whenever possible, try to use this creative device; it can make your movies more visually appealing. But use it sparingly. It gets old rather quickly.

Moving the camera

Because your GoPro is mostly attached to a mount, it's going to move with the subject. At other times, you can also use it like a conventional movie camera when it comes to following the action or making a visual statement. Consider the following:

» **Pan:** A sweeping motion of the scene that goes side to side.

» **Tilt:** It's the camera's version of looking up, down, or up and down.

» **Tracking shot:** A means of using the focal length to draw the subjects closer or farther away while shooting the scene.

Working with the Capture App

The Capture app lets you control the camera and see what's going on. All the tips in this chapter about managing the contents of the frame won't matter much unless you can see exactly what you're doing. Also, because the GoPro isn't always in front of you, using your smartphone with the Capture app is the only game in town.

Controlling the camera remotely

Because of the interesting places you can put a GoPro, you're rarely close to the camera. That's what makes the Capture app so invaluable. You can not only see the shot, but also have complete access to camera controls. Among other things, you can start and stop the recording, adjust camera functions, switch modes, and check your battery level from a distance.

Monitoring the shoot

The first time I picked up a GoPro, it felt like something was missing. Of course, that something was the viewfinder. Most GoPro cameras do not have a viewfinder, nor do they need one since the camera is often in the middle of action that you are not. That's what makes the Capture app, as seen in Figure 5-13, so important: It allows you to monitor the scene from a safe distance and make mode and settings changes.

Viewing footage on a tablet or smartphone

After you shoot your footage, you can watch it on a mobile device. In film lingo, this footage represents dailies you can watch anywhere you want. You can even browse and delete content from your camera to free space or include more compelling footage.

FIGURE 5-13: Monitoring a scene in the Capture app.

Shooting Some Variations

Editing a movie is a lot like assembling a jigsaw puzzle: Success depends on putting the right pieces together. Puzzle pieces are predetermined, but your movie isn't. That's why you need to capture variations in your setup shots and cutaways.

Don't be stingy when it comes to shooting your movie. That extra footage can not only better capture your movie, but also add more flexibility when it comes time for editing. So why settle for a single take when you can capture it several more times to get it perfect? Besides, it wasn't unusual for a movie to have a 20:1 ratio when it was shot on film. You're shooting on a *memory* card that you can download and erase.

But making sure you've shot enough variations of each scene differs from haphazardly capturing whatever you see and expecting to turn it into a cohesive movie. Instead, carefully decide the content of your film and then make sure that the technical and aesthetic settings match your intentions.

IN THIS CHAPTER

» **Wearing your GoPro well**

» **Capturing thrills at the amusement park**

» **Shooting action of your favorite sports**

» **Making your own action**

» **Flying a drone**

Chapter **6**

Shooting Fun Stuff with Your GoPro

O nce upon a time, those edge-of-your seat extreme action scenes were best left to the professionals. Compelling, yet risky situations like base jumping, extreme biking, or shooting from a high-speed roller coaster required a certain skillset for capture — with a good part of that skillset being the ability to keep yourself out of a body cast. Even slightly less intense action like mountain biking or skateboarding posed a potential threat to your physical safety, not to mention the equipment. Adventurous shooters often left behind a trail of smashed cameras, shattered lenses, and broken dreams.

GoPro changed the game, allowing you to capture thrilling situations while keeping you and the camera safer. With the right flair, you can introduce excitement to your movies and photos, without necessarily putting yourself in harm's way. By no means does that give you license for recklessness, especially where your life is concerned. It's just that some situations look daring, yet are no longer as dangerous to shoot because you're not attached to the camera as much. Simply put, mounting the camera and controlling it from a distance can keep you and the camera safe. Other situations are bit more docile, so you can hold or wear the camera, while still providing a thrill for the audience.

Using Wearable Mounts

Wearing a GoPro is the latest rage in fashion, said no one, ever. But what these wearable mounting options lack in fashion sense, they make up for in practicality. While you can handhold your GoPro, it's simply better to mount it when shooting movies or taking pictures. Handholding your GoPro isn't much different than walking your cat on a leash. Yeah, it's possible, but there's something unnatural about it. Instead, cats do better when untethered from your hand, and so does a GoPro. This mighty little camera was meant for mounting, and one of the best ways to do it is by wearing it. You can read about the individual ways in Chapter 2, and say, "Look Ma, no hands."

Is that a camera on your head?

It's highly unlikely that wearing the Head Strap lands you on the cover of *GQ* or *Vogue*, yet it does provide the ultimate perspective for a POV shot. Thanks to the camera being so close to your eye line every time you turn, pivot, or tilt, the viewer can feel what you feel and see what you see. So, while resembling something between a spelunker and a walking bipod, you can capture each situation with a compelling perspective, as shown in Figure 6-1.

Here are few tips for doing it as gracefully as possible:

FIGURE 6-1: This nothing-but-net shot was made possible by wearing a GoPro on a Head Strap under the basket and just looking up at the action.

>> **Walk at a steady pace:** Even, level strides lead to smooth, professional looking capture, while the not-so-even ones scream to the viewer that you have a camera stuck to your head.

>> **Fit it comfortably:** The Head Strap is adjustable, so the better it fits, the better your chances for stable video, not to mention also keeping it from falling off your head. (Taking the time necessary to fit the attachment comfortably is of particular importance if it is to be worn over extended periods of time.)

>> **Limit jarring moves:** While we're used to moving our heads rapidly at times, it doesn't always translate to video, unless of course the goal was to make people queasy. Instead, pretend you're in slow motion and make slow, deliberate motions as you change camera perspective.

Wearing the camera in a crowd

When it comes to using a camera in close quarters, GoPro seems perfect for shooting in a New York City apartment. Because it offers the perfect combination of diminutive size, ultra-wide-angle lens, and fashionable wearability — all right, maybe *fashionable* is a stretch — GoPro is the perfect camera for capturing subjective perspective on the move as you navigate through a sea of humans. Standing in lines, meandering through a crowd, or Walking on a busy city street can all produce impressive imagery when wearing your GoPro camera on the Head Strap, Chesty, or using the Strap.

Here's some advice when wearing the camera around a lot of people:

>> **Use the app to monitor:** While personal perspective is charming, accurate composition is sublime. That comes from using the screen as an aid to effectively navigate the shoot, control settings, and adjust the angle of view.

>> **Watch your step:** Since it's unlikely you'd want to trip over a curb, bump into someone, or have a pedestrian collision, it's important to be careful when you're capturing a scene in the middle of a crowd. So, walk carefully, and keep an eye on where you're going when watching the monitor.

>> **Keep a safe distance:** Not just because you want to avoid contact with other humans, but also because being too close to the subject can affect focus, and not in a good way.

>> **Chest or head:** Sometimes you get the orchestra, and other times, you get the balcony. You know, top and bottom. Wearing a GoPro on your head or chest is the same way. Each has its own charm with a specific purpose. Wearing the camera on your head lends itself nicely to those point-of-view shots with twists, turns, and peeking inside places. Wearing a GoPro on your

chest is more stable and better for linear walks through a crowd. One problem, though, is that it points slightly downward.

Capturing life behind the scenes

Sometimes working the crowd relies less on walking the line and more about making the viewer feel privy to something that seemed off-limits. Take them on a walk-thru of a house you're looking to sell, backstage at a rock concert, or on the field for the festivities of a sporting event (see Figure 6-2). All these situations come to life when you depict them from your point-of-view. It makes the audience feel like they're walking through the scene.

FIGURE 6-2:
Wearing the camera on a Chesty provides this intimate view of the field during a firework display.

Consider the following:

>> **Be deliberate:** Move slowly through the scene so that the viewer can absorb the action. If you're shooting a real estate video, walk slowly so that the viewer can see the key features of the dwelling.

>> **Get up close and personal:** Walk closer to the more interesting parts of the scene, and stay on them to help the viewer know those parts are important. For example, if you're backstage at a concert, meandering through the circus atmosphere before the show can make an interesting scene. You can watch the guitarist tune up, watch the band play before an empty venue at a sound check, or record the drummer gorging at craft services.

Not everyone has access to all situations, yet there's always something that you can shoot. Here are a few places you can try:

>> Construction sites

>> Real estate viewings

>> Sporting events

>> Amusement parks

>> Museums and galleries

>> Family picnics

Strapping the camera on a limb

The Strap is the newest wearable mounting accessor that fits over any of your appendages. Wear it on an arm or leg so that you can capture uniquely immersive POV footage, capturing the scene, literally *hands-free*. This comes in handy, no pun intended, for situations that demand the attention of your hands, like riding a horse, swimming underwater, snowboarding, and other activities. The mount is fully adjustable with a 360 degrees rotation and tilt for maximum control.

Shooting on Amusement Park Rides

Taking your GoPro to the theme park lets you relive the thrill of screaming your head off without any of the motion sickness that sometimes goes with it. It sounds like a win-win when you're out there recording the energy of a roller coaster, the exhilaration of a water ride, the simple aesthetic of a carousel ride, or the freedom of the chaired swing ride, as shown in Figure 6-3. Each situation provides different levels of adventure, albeit one being more dulcet than the others. It's the last one if you weren't sure, and one of the most interesting.

Consider the following when recreating the magic of your day at the amusement park:

>> **Putting safety first:** While each attraction offers its type of thrill, you should always err on the side of caution by abiding by the rules of the ride. Keep your hands and feet inside, and don't wear the camera in a way that affects any restraints.

>> **Loving the POV shot:** Effectively capturing your point of view lets you recreate the excitement of the ride as your eyes saw it. Both the Head Strap and Chesty let you subjectively capture this view. Both mounts are effective. Wearing the camera on your head better matches your eye line, creating a more natural perspective. Wearing it on your chest produces a lower angle, as it naturally sits downward.

>> **Capture your expression:** Turn the camera around and record the look on your face as you negotiate the ride, or more appropriately, capturing the most fun kind of selfie. All right, it doesn't have to be you. Regardless of whose expression you capture, you must be careful where you mount the camera in the name of safety. Common sense dictates not mounting the camera on the ride itself.

>> **Shoot photos on Burst:** When shooting movies, you can start recording before the ride takes off, but still photography is more challenging. So instead of trying to shoot single frames, it's best to set the camera on Burst. It can capture up to 30 pictures per second.

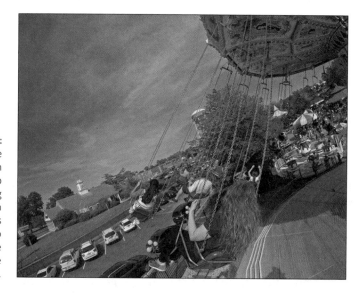

FIGURE 6-3:
By securing the camera with the Head Strap and setting the camera on Burst, it was possible to enjoy the ride and capture this still image.

Exaggerate the ride experience

Like the fresh taste of a piece of bubble gum, the average roller coaster ride lasts around two minutes. And while you always wish both lasted longer, it's doubtful your audience feels the same way about your footage. Perhaps the axiom, *less is more*, acts more like the rule when it comes to how much you show the viewer. Shoot the entire experience, but just show a sliver of the action in the movie.

Here are some suggestions:

>> **Time-Lapse:** Even the most moderate interval setting for a time-lapse can make the action appear 15 times faster than normal. That 40-mph ride can appear as if it's moving at 600 miles per hour, rendering it like hyper-drive.

>> **Slow Motion:** What is more ironic than reducing the super-fast activity of a ride moving 40 miles per hour to one that creeps at a snail's pace. When using this mode, you want to shoot at the highest possible frame rate. And if you shoot at 720p, you can use a frame rate of 240 fps.

>> **Play in reverse:** While you can't do it while shooting, it's certainly possible during playback. It makes for a fun viewing experience when you capture someone diving into the pool head first to coming out of the water feet first to the diving board. Or a busy street scene filled with pedestrians walking backwards.

Mastering each attraction with the right panache

Common sense dictates that your approach to capturing the thrill of a heart-stopping ride is not the same as shooting something more graceful. Rollercoasters and carousels are as distinctly different as oil and vinegar, and so are the techniques for effectively capturing them. Both collectively make your movie interesting, yet are completely different in every way, so each requires a different approach for capture.

Having fun on the roller coaster

When it comes to shooting a roller coaster, GoPro lets you relive the oohs and ahs of the deep drops, sharp turns, and your own falsetto screams. Capturing those brief moments are as simple as wearing the camera on the ride and pressing record to recreate a subjective perspective of the thrill. Sitting in the front of the ride provides an unobstructed view, as seen in Figure 6-4, but that's not to say you can't get great footage from the middle or even the rear.

Let's look at the different kinds of shots.

>> **POV:** Show the ride as you see it by wearing the camera on your chest or mount it close to your own perspective using a Head Strap, Chesty, or the Strap. (Use it on your arm, wrist, or leg.) You can show a subjective view, people raising arms in front of you, or looking upwards.

>> **Selfie:** Turn the camera around and allow the viewer to read the action from your expression, including the shrieks and screams.

>> **Working the angles:** Just because you're not on the ride doesn't mean you should put the camera away. Capturing the ride as a bystander lets you create an objective wide shot that works out for editing. The wide, medium, close-up approach for shot sequence works well, especially when the goal is editing a cohesive package.

When on the rides, there are some other issues to consider:

>> **Being careful:** Unfortunately, it's not always safe to bring your camera on a roller coaster or even always allowed by officials, so you must proceed with caution. If you can bring the camera on the ride, be sure it's firmly mounted and does not fly away. You can lose it, break it, or worse, hurt someone.

>> **Abrupt movement:** The rides move very fast and sometimes come to a screeching halt. Literally, you've heard that sound before. So, make sure the camera is secure or it can be knocked out of your hand. If that happens, losing the camera is not the worst thing that can happen; you can hurt someone, too.

>> **Privacy issues:** I'm going to go out on a limb here, but most people don't like being part of a movie they were not asked to be in. That goes double when they're at their most visually vulnerable, replete with bad hair and angry scowl. It's better to record people that you know — friends and family — to avoid any issues. Of course, you can always ask for contact information and get permission too.

>> **Shoot at a higher frame rate:** Shooting in 1080p with a frame rate of at least 60 fps will help assure the action is crisp.

FIGURE 6-4:
The Head Strap provides a clear perspective at the top of this roller coaster.

Shooting water rides

Whether sliding down on a raft, a log-like Flintstones car, or with your own body, water rides are like rollercoasters under really wet conditions. Capture your point of view as you're screaming joyfully — or panicky — all the way down. It's pretty much the same idea as shooting on a roller coaster, with one caveat: the water part. Electronics are allergic to H2O and that makes it challenging at times to see what you're seeing since you can't use your app or have access to the camera, even if there's a screen. But these problems are easily fixed when you take heed of the following.

>> **Secure the camera:** Holding the camera under normal circumstances is a tricky endeavor. Moving makes it harder, and doing it under wet circumstances makes it even trickier. Try to wear the camera, and if you can't, hold it tight.

>> **Keep the lens clean:** Water droplets on the lens are an occupational hazard, and can rob the image of sharpness or image quality. So, give it a wipe every so often.

>> **Have faith:** You can't use the app (unless you want to short-circuit your smartphone), so just point the camera in the right direction and hope for the best.

Capturing the carousel experience

The carousel does not provide quite the same thrill as a roller coaster — unless you find individually painted ponies thrilling — but it's still one of the most photographed places in an amusement park (see Figure 6-5). Due partially to the timeless elegance of each carousel, not to mention being the perfect vehicle to capture small children and everyone else that doesn't like big rides.

MAKING LONG LINES WORK FOR YOU

Theme park attractions and long lines go together like hot dogs and a stomachache. Both go hand in hand, and oddly enough, waiting in line is something that we secretly admire. Say what? Yes, it's true, numerous studies have shown the longer we wait for something the more we appreciate the outcome. Anyway, that makes the waiting in line a big part of the thrill, so why not capture it as part of the movie.

Here are a few aspects to consider:

>> **Wear the camera:** Wearing your GoPro as the ride goes round and round and up and down makes for an interesting movie. And you're doing nothing more than wearing the camera as an accessory.

>> **Move with the ride:** The nature of a carousel means that you're always on the horse in back and the horse in front. You will never catch up to the horse in front or lose your lead to the horse behind you. But the action outside of the ride, as well as the up and down nature of the ponies does change allowing you to capture action without leaving your seat, er saddle. If you're standing and walking, then all bets are off.

>> **Focus on the horse:** That's meant both figuratively and literally. It's not always a horse; sometimes it's a tiger or another exotic animal. While you can shoot other aspects, the painted horse, for this discussion, is the main attraction. Their unique colors and adornments make each one visually unique, so when you add a little motion . . . voilà!

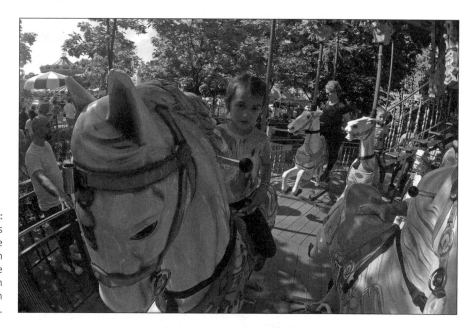

FIGURE 6-5:
Thanks to its ultra-wide view, you can capture some great shots on a carousel with your GoPro.

Round and round on the Ferris wheel

Colorful, circular, and colossal (at times), the Ferris wheel is one of the most iconic symbols of an amusement park. Maybe it's not as thrilling as other action

rides — unless, of course, if you're afraid of heights — but it does make for visually interesting movies and pictures (see Figure 6-6).

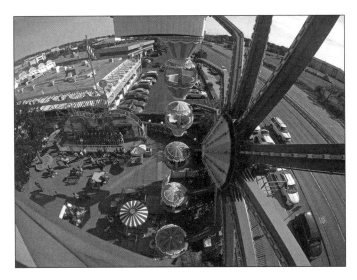

Consider the following:

>> **Long exposure still image:** All it takes is a two-second exposure while the ride is in motion to produce beautiful streaks of color. Try to make sure you fill the frame with the entire ride, but that should be no problem with your GoPro.

>> **Time-Lapse:** Position the camera nearby and set an interval of a half-second or more to record the ride's rotation as colorful streaks. Don't be shy capturing the ride from afar.

>> **Movie:** Capture the ride from a distance or shoot from your perspective on the ride itself.

Recording Sporting Events

Shooting sports takes on a different life when capturing action scenes with your GoPro. Unlike shooting from a distance with a DSLR and a long lens, the GoPro requires far more intimacy with the subject; in other words, you need to be very close. That means sitting in Section 5 Row 20 of an arena or stadium will more than likely yield better shots of people's heads than any sort of decipherable action.

That means with few exceptions, it's not very good for capturing organized sporting events. Conversely, it can work beautifully with the not so organized variety. Activities like a pick-up basketball game, volleyball at the beach, or whiffle ball at a family picnic can produce content for your own version of Sports Center, or something viral on YouTube.

Bringing your camera to a baseball or football game can have a lot of restrictions, yet there are no rules prohibiting you from wearing a camera at a pick-up game with your friends to get some cool footage. You don't even have to concentrate on the game, as you can just shoot random action that makes for impressive movie clips, or just horse around (see Figure 6-7).

Here are some examples of capturing sporting events with your GoPro:

>> **Whiffle ball:** That entry-level game with the plastic yellow bat and tricky vented ball can make for pretty cool movies and pictures, especially since the ball curves like no other and a hard-hit ball doesn't travel very far. Wear the camera with a Chesty or on a Head Strap while pitching, fielding, or hitting. And speaking of the latter, you can mount the camera on the bat using a handlebar mount to capture the bat and ball making contact from inches away.

>> **Basketball:** It's a pretty rough sport to wear the camera, but that doesn't mean cool action shots are off the table. Everybody loves ball tricks (see Figure 6-7). Maybe you want to mount the camera on the backboard, or stand underneath it to capture that "nothing but net" feeling, as shown previously in Figure 6-1.

>> **Football:** It's strongly advised not to wear a camera during the game, unless you want to be flagged for unnecessary roughness to the camera. But that doesn't stop you from capturing action from the sidelines. Whether it's a friendly game of two-hand touch or a hard-hitting game of smashmouth football, mount the camera on a goalpost or position it inches from the field to get up close and personal. For practice situations, you can use the helmet mount or the Strap on your arm or wrist to follow the action or put it on your leg to capture a kick.

>> **Bowling:** Despite the stellar physique of bowlers, league bowling can be an exhilarating sport. All kidding aside, it's still a fun activity to capture in a variety of ways. You can wear the Chesty and capture the release of the ball on the lane or the Strap on your arm to show that perspective.

>> **Golf:** Watching golf on television rarely lives up to the excitement of actually playing. Regardless of the emotional toll it takes on you, or more accurately the clubs, you can capture some pretty cool stuff with your GoPro in a variety of ways, including wearing the camera in some way, mounting it directly on the

club, or positioning it nearby to capture teeing off or making a putt (see Figure 6-8).

» **Volleyball:** Create exciting imagery playing volleyball the next time you're at the beach or a family picnic. Mount the camera to the post, position it high above the game, or wear it (at your own risk) to capture some fun action, especially if you're playing on the beach.

FIGURE 6-7: Sometimes it's as much fun to capture things like taking the ball for a spin.

FIGURE 6-8: Shooting through the basket makes an otherwise boring composition look more interesting.

Photo courtesy of GoPro, Inc.

GoPro and the Water

Since a powerful waterproof camera sounds like something out of a fairytale, let's begin by saying once upon a time most cameras were deathly allergic to water. And while you could also use an expensive waterproof housing on your video camera or DSLR, all it took was a little moisture for your equipment to be ruined. But GoPro with its waterproof housing doesn't shrink or melt. In fact, GoPro and water go together better than movie theater popcorn and imitation butter.

Using GoPro at the pool

The endless possibilities for capturing great movies and pictures around the backyard watering hole could make Forest Gump's mouth spit out a litany of similes. Whether it's as serious as capturing junior's practice for an upcoming swim meet, the spontaneity of a bonkers pool party, or the serenity of an underwater portrait, GoPro should be in demand around the pool.

Here's what you can do:

>> **Capture action in the pool:** Not that long ago bringing a camera to the pool could be misconstrued as a sign that there was a new camera in your future. But with GoPro you can easily record the frolicking and splashing, in and around the pool area.

>> **Mount it to yourself:** Wear the camera on your head, your chest, or hold it while walking around the pool, swim under the water, or hold the camera for practical control. If you choose the latter, make sure that the camera can float, either by mounting to The Handler or having a Floaty on it.

>> **Shoot the subject hitting the surface:** Capture someone breaking the plane of the water as they jump or dive in. Position yourself near the point of entry, even under the water.

>> **Capture underwater activity:** Whether you're capturing a surrealistic portrait of your significant other, your daughter holding her nose under the water for the first time, children swimming underwater (see Figure 6-9), or a unique portrait, you can create beautiful images beneath the surface.

FIGURE 6-9:
Kids having fun beneath the surface of the water are no problem for GoPro.

Shooting water sports

Marco Polo takes on new meaning when GoPro is in the pool showing the chase. The counting, swimming, and the calling out of the name of the game all make for a fun movie at the end of the day. The same holds true for other exhilarating water sports, such as volleyball, basketball, or underwater races. Basically, anything you can play in the water that's competitive is a good match for GoPro.

While many of these activities are distinctly different, here's what you should consider:

» **Visualize what you want:** There's an old saying that goes "You can't get what you want, until you know what you want." That applies to many situations you will capture with your GoPro, especially here. Think about how you want the audience to see your movie, and capture it with that intent.

» **Make sure the camera can float:** Seems like a no-brainer, but you would be surprised. All it takes is a Floaty or the Floating Hand Grip to keep your runaway camera on the surface.

» **Don't be afraid to get under the water:** Some of the coolest scenes are captured below the surface. Just make sure your housing is watertight.

Take GoPro to the beach

GoPro cozies up as nicely at the beach as a blanket and an umbrella. It's small, lightweight, and fits anywhere, so it's not a burden to lug around. And the housing

protects the camera by keeping out water, sand, and other debris, making it easily accessible to capture movies and stills in places where you had to be more careful before.

Here are some things to keep in mind when you bring your GoPro camera to the beach:

>> **Fun on the sand:** Throwing a Frisbee around, running in surf, making sandcastles, playing volleyball, and anything else you do at the beach are perfect situations to capture, without fear of sand or water damage.

>> **Wave jumping:** Wear the camera as you negotiate each wave with awkward precision. Just be careful you don't drop the camera or it doesn't break free; otherwise it will end up in Davey Jones's locker.

>> **Underwater scenes:** Going underwater to make movies or photographs of the seascape is easy with your GoPro. Just make sure you have something that allows the camera to float, or it will be gone forever.

>> **Surfing:** There's a special mount designed specifically for your board, shown in Figure 6-10, so that you can hang ten while yelling "cowabunga," or screaming at a wave, or sometimes for your life. See Chapter 2 for more information on this special mount.

>> **Body surfing:** Wear it while riding the board or mount the camera to the board so you can capture the experience.

FIGURE 6-10:
You can easily mount your GoPro with the surfboard mount.

Photo courtesy of GoPro, Inc.

Using GoPro on a personal watercraft

The personal watercraft resembles the offspring of a motorcycle and a powerboat. Known more familiarly by a bunch of brand names like Sea-Doo, Wave Runner, or Jet Ski, these water scooters are thrilling to ride and just as exciting to capture with your GoPro.

Here's what you can do:

>> **Mount on the vessel:** Depending on the model, you can use the appropriate mount to provide a subjective view of breaking waves. Just use common sense and place it in where it doesn't interfere with your safety or anyone else's.

>> **Wear it:** Probably the best way to capture those special moments on the water is to wear the camera. Put on the Chesty for a subjective view for commandeering the vessel. It does have a slightly downward view, acceptable under certain conditions. You can also use the Head Strap, though there's a chance it can fly off your head, leaving you strapped for a camera. And if it happens there, it's even more of a risk while handholding — unless your goal is losing the camera rather than capturing thrilling footage.

Movies on a boat, movies in the moat

Whether you're navigating a kayak through marshlands, capturing the thrill of an outrigger canoe hitting that massive wave, or zipping around the bay in a motorboat, your GoPro is up for the challenge, transforming nautical time into compelling movies and photographs (see Figure 6-11).

Here are some ideas for positioning the camera:

>> **Mount it:** Depending on the boat, there are numerous places you can mount the camera. These include any smooth (and clean) surface for the suction cup, various bar mounts, or the more permanent adhesive mounts.

>> **Hold it:** It's a bit risky, especially when hanging the camera over the edge of the boat, but you can control the composition more precisely than stationary mounts. Make sure you're using some flotation accessories to be on the safe side. And the safe side for a camera that falls in the water is the side above the surface. Tethering the camera to the vessel, or even yourself, can also help.

>> **Wear it:** Channel your inner Leonardo DiCaprio as you stand on the bow screaming "Kink of the oiled," or something like it with the camera on your body, preferably with the Chesty.

FIGURE 6-11:
Point-of-view
shot.

Making fishing interesting

Regardless of your reason – you know, food or sport — angling over a watering hole takes on new meaning when attaching your GoPro to your fishing pole. Using the Sportsman mount lets you capture those great moments on the water from a poles-eye view (see Figure 6-12). Now you can finally record that moment when you reel in the big one. The only problem is that you can't exaggerate the size of the one that got away, unless you got it on video.

Consider the following when capturing your day on the water.

>> **Mount the camera:** Put GoPro on your fishing pole using the Sportsman mount, so you can capture the pole at work.

>> **Wear the camera on your head:** Record the experience like your eyes would see. You know, stuff like casting, reeling, or reeling in the big one.

>> **Use an extension pole:** It's the fish's version of the selfie stick. Hold the camera over the action, almost like you would a net for a unique view.

FIGURE 6-12:
GoPro lets
you get up
close and
personal on
the high seas.

Photo courtesy of GoPro, Inc.

All Kinds of Bicycling

When it comes to one of the most accessible places for capturing action, it's hard to imagine a better combination than a GoPro and a bicycle, other than sunscreen and a scorching hot day at the beach. Whether you're navigating a mountain trail, going on a scenic tour, or riding one of those city rentals, bicycling is one of the more popular activities you can capture with your GoPro, and that's meant in both the literal and figurative sense. And unlike vanilla ice cream, none of this has to be too bland. There's a bunch of situations to capture with various mounts and techniques that can pepper the imagery. Don't worry if the bike isn't powered by you because you can substitute many of these shots on a motorcycle or ATV.

Let's consider some of the cool ways to use your GoPro while peddling around:

» **Mount it on handlebars:** Several choices are possible, including the standard handlebar mount, or the new Pro Handlebar mount. That one allows you to rotate the camera 360 degrees for unlimited capture options; facing forward, it provides a subjective perspective. Or you could turn it around, and show the viewer your expression and all that you pass. (See Figure 6-13)

» **Point it downward:** Regardless if you wear the camera on your chest or have it mounted on a frame, you can show the ride from the perspective of the front wheel turning, pedals cranking, or terrain the bike has passed.

» **Use the helmet mount:** Allows the viewer to experience the ride at an angle of view much closer to your perspective, and it's also safer than using the Head Strap for both you and the camera. (See Figure 6-13.)

FIGURE 6-13:
Share the rider's perspective with the helmet mount.

Photo courtesy of GoPro, Inc.

Taking Flight with Your Karma Drone

Aboard the Karma drone, your GoPro can soar over whatever corner of the world you call your own, allowing you to capture a rarely seen perspective for your movies and still photos. It's like giving Peter Pan a camera and asking him to capture the rooftops of your town, only you're doing it with a remote control and don't have to deal with his boyish tantrums. The Karma — or any other drone that holds a GoPro — lets you see places you may not venture toward, and from a perspective you're not accustomed, without ever putting you in harm's way. But it's important to understand how to operate it and the local ordinances to keep Karma, yourself, and others safe.

Practice makes perfect

While your Karma drone can capture impressive video from extreme heights without putting you at risk, the same cannot be said for your Karma. Simply put, the physical reality of what goes up must come down applies and works here, unless, of course, it comes down too quickly or perhaps veers off course into a wall.

It's such a downer when you have to take your drone home in pieces. That's why practice is so important.

Consider the following:

>> **Read the instructions:** When you take your drone out of the box, resist the urge to start flying until you understand how to use it. Instead, charge the vessel and remote and read the instructions.

>> **Find a flat, spacious place:** The best way to get comfortable with taking off and landing is to practice. Choose a park or open field for those early missions.

>> **Stay away from trees:** Trees are the drone's natural enemy. Flying too close to a tree never puts you on the winning end, as your drone can get stuck on a branch, or lose a rotor. That's why you should look for an open area when you're first getting started.

>> **Fly on a calm day:** All it takes is a wind gust to take your drone off course and slam it into something hard (resulting in damage) or send it far, far away (and lose it).

>> **Start off slow:** Practice take-offs and landings, gradually going higher and farther. Afterwards you can practice how to move and control the camera.

>> **Stay on top of industry education:** Visit the Academy of Model Aeronautics: http://www.modelaircraft.org/

Fun places for your Karma missions

Once you're feeling confident to fly, you can have fun with your Karma drone. Here are some ideas for missions you can try:

>> **Take it to the beach:** The shoreline usually provides a great place for flying your Karma drone for several reasons. The wide-open space means you can fly in an unobstructed airspace, free of trees and buildings. But more important, the shore is a beautiful place to shoot the sea, surf, and sunbathers. Just be aware, some people may find a GoPro flying overhead to be intrusive.

>> **Shoot a real estate scene:** Whether you're a real estate agent capturing that unique view for your next sale, a homeowner looking to add interesting visuals to your home listing, or simply want to create a visual record of a piece of property, flying the Karma drone overhead will help you show an impressive view.

>> **Capture action sports:** Have fun at your next company softball game, beach volleyball match, or surfing competition. These are just a few of the events you can capture from overhead. Just be careful to not fly too close to the action.

>> **Record something you can't normally see:** For all those times you were curious of what was on the other side of a wall, the scene beyond a ridge, or over a bridge, you can now satisfy your curiosity with your drone.

>> **Shoot a firework display:** Flying your Karma above the bursts provides a perspective that was rarely possible a few years ago. Just be aware of any ordinances before you take off.

Chapter **7**
Mastering the Light

L ight defines how we record the world and communicate ideas through movies. But not just any light will do, so don't expect it to transform your GoPro movie into anything spectacular unless it's appropriate for the scene. Have you ever been in an old house that uses dingy fluorescent tubes for bathroom illumination? If so, you know that the light makes you look like an alien — not just any alien, but a sick one. Compare that with your appearance in a mirror adorned with an array of soft tungsten bulbs. Now, that's better.

It's important to think of light much in the same way that a painter thinks of paint. She doesn't throw it on haphazardly (unless her name is Jackson Pollock). Instead, she applies color very deliberately, creating both form and detail. Great lighting shares this idea and provides an intoxicating mystique to a scene.

Understanding the intricacies and physics of light can help you master it. This chapter is all about light.

Seeing the Color and Temperature of Light

Ever wonder why the picture of your cat on the living-room couch had a yellow cast or what caused Uncle Freddie to look so blue that he looked like he needed some resuscitation? Funny things can happen when the color isn't quite right. Sometimes, we can live with it; at other times, it's a challenge. Though many

scenes captured on a GoPro thrive on excitement, the color should nonetheless appear natural.

The good news: Odd color isn't a flaw in the camera. The bad news: The camera wasn't set properly to capture the color temperature of the light source or the automatic white balance was fooled. Then there's the beautiful news: Some scenes have a wide range of color temperature that render the image unexpectedly stunning (see Figure 7-1).

Taking color temperature

Our brains can differentiate color, but we may not notice when a shadow looks a little blue or when there's a limited spectrum of color. When you capture a scene with a camera, however, colors become quite apparent, because different light sources have their own ways of producing color.

If you view a piece of white paper under lights ranging from an indoor light bulb to the midday sun, you still see it as white. That's simply a function of your visual memory. The camera will record it as white, too, but it may render it with a blue or orange tinge, because the color temperature of the light may differ from what the camera is set to record.

TECHNICAL
STUFF

Celsius and Fahrenheit temperatures help you determine what to wear when you leave the house; Kelvin temperatures (K), however, measure light. Kelvin color temperatures range from candlelight at 1800K to overcast sky at 11000K.

Table 7-1 lists color temperatures in Kelvins for a few common light sources.

TABLE 7-1

Color Temperatures

Light Source	Temperature in Kelvins (K)
Candlelight	1800K
Rising or setting sun	2200–2800K
Incandescent household bulb	2800K
Tungsten light	3200K
Daylight	5500K
Sun on overcast day	6000–8000K
Shade	7000K
Cloudy day	8000–10,000K

Understanding white balance

White balance refers to setting the camera to record light at its proper color temperature. Simply put, a camera renders a white piece of paper as white when its white balance is set properly for a specific type of illumination. Many cameras, including the GoPro, adjust to the proper setting automatically, but unlike with Mother Nature, automatic settings are often fooled.

One way to counteract disparity in color is to set white balance on the camera to match a specific situation. I cover this topic in more detail in "Setting White Balance" later in this chapter.

Shooting Under Different Light Sources

We humans see light as the antidote to darkness, but we're often oblivious to its physical properties, such as direction, harshness, and color temperature. Our visual memory kicks in, and the only criterion is seeing what we need to see.

A camera, however, has no visual memory. Instead, it relies on its settings. Like Mr. Spock from *Star Trek*, it deals with color and exposure in a logical way.

But even when you set the GoPro on automatic and let it adjust to each circumstance, success isn't guaranteed. Sometimes, a scene reproduces with a color cast, which may not match other scenes. You may have a bluish tint on one shot and a cyan cast on another.

Although the GoPro has a fairly intuitive automatic white balance (see "Setting White Balance" later in this chapter), an important part of mastering GoPro moviemaking is understanding the behaviors of different kinds of light.

Sunlight

The primary source of light on the planet resides an average distance of 93 million miles away. The sun provides summer pleasure, vitamin D, and sometimes redistributed energy, and did I mention it's also the recorded image's best friend.

When you're making movies outdoors, the quality of sunlight changes continuously throughout the day with regard to both intensity and color. If you were to start shooting at daybreak, for example, you'd reap the benefits of soft morning light, often referred to as the *Golden Hour.* for its flattering illumination. That means early morning light renders much warmer than the daylight setting on your GoPro (5500 K; see "Taking color temperature," earlier in this chapter), so it reproduces as an orange glow on the subject. It's also coming from just above the horizon, so it's not lighting the subject from overhead.

Even though light still flatters the subject a couple of hours into the morning, the quality of illumination begins to transform as the sun gets higher. High noon puts the sun directly overhead, producing far less warmth and harsher illumination.

Some days, the clouds roll in, making the afternoon overcast. That type of light isn't great for the beach but not too bad for shooting a movie, thanks to the nicely diffused illumination. It lacks the warmth of early morning light, but you could tweak it in postproduction.

Later in the day, when the sun breaks through the clouds, the color balance of the scene takes on the warmth of early morning, but in the reverse direction (see Figure 7-2).

Clearly, shooting outdoors covers a wide range of color temperatures. It's vital that you make manual adjustments when necessary, as I discuss in "Bathing in sunlight" later in this chapter.

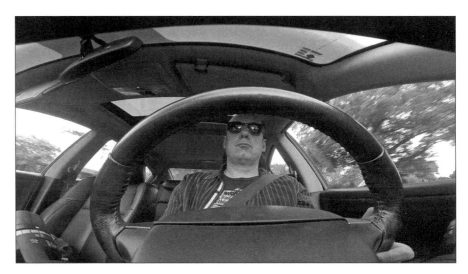

FIGURE 7-2:
Beautiful light
from late-
afternoon sun.

Household lights

When it comes to indoor moviemaking, most of the time you're going to shoot under household lighting conditions. But the game has changed with the incandescent light bulb we all knew, loved, and occasionally burned our fingers on being phased out. In its place, more economical light forms are taking over. Some share similarities with formerly bulbous light sources, while others have their own qualities.

CFL bulbs

Until very recently, most lamps used incandescent bulbs (discussed later in this chapter), but these days, you're more likely to see compact fluorescent light (CFL) bulbs than many other types of illumination, including illuminated signs, like in Figure 7-3.

CFLs are so common now that you can find them almost everywhere, but they have many variations, which makes it hard to nail down the exact color temperature of each one. Because they produce light differently from incandescent bulbs, they're not very predictable when it comes to shooting your movie. Instead of heating a filament to burn brightly, they produce light through a jolt of electricity that excites vapor in the tube, sharing behavior with their taller cousin, the fluorescent tube.

But ingenuity is a wonderful thing. Because these lights are so popular and cheap to operate, they've been engineered to create various light settings, including a full spectrum of color. That makes them great for lighting television and movie sets.

FIGURE 7-3:
CFL bulbs
inside bring
this translucent
red sign to life.

LED bulbs

Watches, scoreboards, and televisions use it, and now so does the lighting in your home. The LED lamp is quickly becoming one of the most efficient forms of artificial light on the planet. Consisting of an array of light emitting diodes, they collectively form illumination in places where bulbs used to reside.

An interesting quality about some of these light forms is that the same bulb can create any color you like, and can be controlled from your smartphone or device. They screw into lamps and fixtures, and can be combined to make any combinations of colors you choose.

On the bright side (pun intended), LED lighting offers the most control over the light. Conversely, it is more expensive and does not provide a high light output.

Halogen bulbs

A true incandescent light source, these lamps offer a high output and naturally produce a full spectrum of color that generally matches tungsten.

Halogen bulbs are found in many places, including automotive headlamps, projector bulbs, and studio lighting. While they usually don't resemble a traditional household bulb, some types now include a screw base for use in lamp and fixture sockets.

These lamps have a wide variety of uses and come in various sizes and types. On the downside, they get very hot and are sometimes used for heating purposes. Ever hear of a halogen oven?

Incandescent bulbs

Incandescent light bulbs are traditional light bulbs, the ones that appear above cartoon characters' heads whenever they have a great idea. Brightness varies from 25-watt appliance bulbs to the 60-, 75-, and 100-watt bulbs used in reading lamps. Flood lighting can go to 150 watts, but generally anything equivalent to 65 watts is more common.

Currently, incandescent bulbs are being phased out, but people have stocked up on them. Incandescent illumination is shown in Figure 7-4.

FIGURE 7-4:
While you should never stick your GoPro in a heated oven, this simulated photograph shows illumination from an incandescent bulb. Do not try this at home.

Fluorescent lights

Tubes of light seem like perfect ways to deliver illumination. These long, bright sticks are efficient, effective, and used everywhere from basements and garages to factories and offices. They make light through a jolt of electricity exciting vapor in the tube. While generally not ideal for shooting a movie, there are numerous types engineered to produce a full spectrum of color. Some are even used for television and movie lighting. Here's what you need to know:

» **Daylight-balanced tubes:** While comparatively lower in output than an incandescent bulb, they offer mass illumination. Sometimes four separate tubes can produce the same output, albeit by using a wider, more collective approach.

» **Mixed lighting makes a good picture:** Look at any office building and notice the variations in color cast. Lighting your movie with tungsten and allowing the

variations of fluorescent light in the background produces a complementary cast that works to your advantage.

>> **Not a harsh bone in its, the subject's body:** Because illumination comes from a wide bank of soft lamps, it produces a nice soft illumination. As a result, it hides minor blemishes, making many actors fans of it.

>> **No heat buildup:** There's a reason these are also known as "cool lights." Trust me, they're a welcome alternative, especially when using a multiple light tungsten setup in the studio or location area. Fluorescent illumination doesn't create excess heat, and you can touch the bulbs.

Candlelight

If the sun is the Big Kahuna, candlelight is the little guy. It's the warmest and least powerful light source (below 2000 K; refer to "Taking color temperature," earlier in this chapter) range, and by itself, it can barely cover a foot. But candlelight is still light. A group of candles can illuminate a whole scene, lending it a warm and cozy feeling. Because the GoPro gets very close, it can work nicely for candlelit scenes.

Neon lights

Iconic neon signs such as "Bar" are glass sculptures with illuminated colored light running through their tubes. Neon is reminiscent of the night, and can render the scene with a cool tone, if not for its dominant color.

Outdoor lights (HID)

Lighting up the night takes a lot of power, and that can get expensive for whoever pays the bill. So, the goal in illuminating massive spaces is producing the most light for the least money. Many government agencies and businesses use a special kind of outdoor illumination: high-intensity discharge (HID) lights.

Like CFLs (see "CFL bulbs," earlier in this chapter), HID lights excite a gas inside a glass tube, producing cheap, bright light. They come in three varieties:

>> **Sodium vapor:** What you regard as a streetlight, lighting experts and city designers know as a sodium-vapor lamp on a pole. Look closely, and you'll notice that its light has a yellowish cast (see Figure 7-5).

FIGURE 7-5:
Sodium-
vapor street
lamps leave
a dominant
color cast.

» **Mercury vapor:** Mercury-vapor lamps are far less flattering to most subjects than sodium-vapor lamps are, because they produce greenish illumination from exciting mercury gas. This color makes them problematic when it comes to video. When it comes to producing the most economical illumination, these guys are great for parking lots, garages, and even some school gymnasiums. On average, they have a color temperature of about 4200 K (see "Taking color temperature," earlier in this chapter).

» **Metal halide:** Like the other HID lamps, metal-halide lamps produce light by exciting weird gases, but unlike those lamps, they also produce a full spectrum of color. And the reason for their hybrid nature? Metal-halide lamps are used to light many outdoor stadiums, and nobody wants to see anything but the richest, most saturated color when watching football on a big screen TV.

Setting White Balance

If you're feeling adventurous or simply want to control the color temperature of a scene on your GoPro, feel free to change the White Balance setting. By default, your GoPro is set to Auto, but you have other options, including these:

» **Auto:** Adjusts automatically to the color temperature of the light source.

» **3000K:** Works well for capturing indoor scenes.

» **5500K:** Lets you manually balance color outdoors.

>> **6500K:** Matches the color temperature of moderately overcast skies and some forms of fluorescent lighting.

>> **Camera RAW:** Records a RAW file so you can adjust the color temperature during the postproduction process (see Figure 7-6).

Here's how you can change the White Balance setting:

1. **Press the Power/Mode button to scroll through the menus until you get to the Settings menu.**

 The Settings menu's icon looks like a wrench.

2. **Press the Shutter/Select button to select Settings.**

3. **Make sure Protune is on.**

 Otherwise the White Balance menu will not be visible.

4. **Scroll until you get to capture settings.**

 Enter it by pressing the Shutter/Select button.

5. **Go to the White Balance option.**

6. **Use the Shutter/Select to select one of the following options: Auto, 3000K, 5500K, 6500K, or Camera Raw, and press the Power/Mode button to set it.**

Working with the Light You Have

Because many action sequences take place outdoors, you need the sun for illumination. That big, flaming ball of fire in the sky offers bright, diverse, and complimentary illumination. It not only flatters the subject, but it's also free. But that doesn't mean there isn't a slight price to pay. It's a passive light form that leaves you with no control over it, and you just must accept its direction of light, the shadow it creates, or its light quality. Seems like a fair price to pay when you consider what you get in return.

One day, the light renders warmly against a rich blue sky, and the next day it's completely different. Sometimes the background sky renders palely; other times it's completely overcast. The sun is always in the sky, but that stuff in between — you know the clouds and haze — can affect what the sun can do on a predictable basis.

Consider the following:

>> **Watch out for lens flare:** Because the GoPro is so wide, there's a greater possibility for lens flare. That means you need to be careful.

>> **Try to use sunlight from a lower angle:** This creates the most flattering illumination, and it's generally warmer too.

>> **Avoid overhead light:** When the sun is beating straight down on the subject, it's not flattering and creates harsh shadows.

>> **Take advantage of an overcast day:** Direct sunlight is sometimes harsh on the subject because it skims across the face and creates shadow and texture. Most people don't like it. Clouds come between the sun and the subject and act as a diffuser, presenting the subject in a more flattering illumination, as seen in Figure 7-7. Just watch out for white patches of sky.

Bathing in sunlight

TIP

Here are a few ways to make the most of sunlight:

>> **Work the angles.** I don't mean working the angles in a grifter sort of way; rather, I mean catching sunlight from different angles.

>> **Shoot early or late.** Sunlight becomes more intense as the sun rises higher in the sky, and color temperature increases as the day goes on. A sunny-day color temperature is about 5500K (see "Taking color temperature," earlier in this chapter) when the sun reaches its highest point. The temperature gets warmer as dusk approaches.

FIGURE 7-7:
An overcast day provides even illumination for this hipster head, and can put you ahead of the competition.

Whenever possible, it's best to shoot your movie early in the morning or late in the afternoon. At those times, the sun is at an angle that produces the most flattering illumination and the warmest tone (refer to Figure 7-8).

>> **Take advantage of clouds.** Although it can be beautiful, direct sunlight can also produce harsh illumination. Most people don't like being photographed in full sunlight. But cloud cover between the sun and the subject works like a giant diffuser, bathing subjects in more-flattering light.

>> **Avoid shooting at noon.** *High Noon* is a great title for a movie but not a great time to shoot it. When the sun is beating straight down on the subject, it's not flattering and creates harsh shadows.

FIGURE 7-8:
Shot from an overhead position late in the afternoon, this construction site emphasizes soft color and even illumination.

Managing artificial illumination

When the sun decides to call it a day, the nightscape comes to life, and individual forms of artificial lighting don't play by the same set of rules as the sun. There are many types of artificial light, each with its own behavior (see "Shooting Under Different Light Sources," earlier in this chapter). Here are a few potential problems of shooting under artificial light:

WARNING

>> **Annoying color casts:** Not all light sources produce a full spectrum of color, especially HID lamps (see "Outdoor lights [HID]," earlier in this chapter), which you're likely to find on a city street or country road. Depending on the way the light source produces light, the scene can render with a yellowish or cyan tinge.

The good news is that a meticulous white-balance setting can eliminate a color cast; the bad news is that it may deplete the scene of all color. HID lights produce a single color, so when you correct the bad color, no others are left.

>> **Unpredictable results:** Sometimes, you don't notice the effect of color or contrast on your smartphone's screen until it's too late.

>> **Harsh shadows:** Contrasty, splotchy light creates shadows that can wreak havoc. When you adjust for these shadows, the highlights may blow out. Fix the highlights, and the middle tones become shadowy.

In the following sections, I show you how to solve problems with several types of light sources.

Working with incandescent bulbs

It's possible to use an array of incandescent bulbs to light your movie, but their effectiveness depends on a variety of factors, including wattage, placement, and positioning. Some tips on working with incandescent bulbs follow.

>> **Move it from the subject.** It's hard to get more basic than simply moving the light away, especially if it's a lamp.

>> **Reduce its brightness.** If it has a dimmer, turn it down. Other options include using a neutral density gel filter over your GoPro or trying a lower-wattage bulb.

>> **Remember that fall-off happens quickly:** When the subject is relatively close (but not too close) to the light source, you can capture adequate exposure. But the range of light doesn't go very far.

>> **Watch for hot spots.** Because the camera covers such a wide angle, it's nearly impossible to keep the actual light out of the frame. Monitor it from the GoPro App to compose the scene so the light is either out of the picture or doesn't ruin the scene.

Coping with CFLs

Here's what you need to know about which CFLs can work to your advantage and which ones to avoid:

>> **Hot it's not:** Fluorescent illumination is considered a cool light form because it doesn't create excess heat. Not only does this mean you can touch the bulbs (if you were so inclined), but also they keep the room from getting unbearably hot. That makes illuminating the subject from a nearby CFL far more bearable.

>> **Be careful of the color:** While many CFL bulbs provide the characteristics of a traditional household bulb, some behave more like economical fluorescent tubes. That means a dim greenish cast that looks terrible when recorded. Use your eyes to help judge the quality of light.

>> **Hot spots need not apply:** While lighting found around the home is not incredibly bright, it can still produce spectral hot spots (bright light reflections) either because the light source is in the scene, reflecting on a bright surface, or flaring into the lens. It's imperative to use your smartphone to monitor the scene when using GoPro indoors.

Making the best of fluorescence

Old school fluorescents produce a sickly green light, but when combined on the scene with light sources of other color temperature, it suddenly becomes just another part of the scene. Look at any office building and notice the variations in color cast. Consider the following:

>> **Try to work with daylight-balanced:** While far less bright that an incandescent light bulb, illumination from a mass array of fluorescent tubes produces adequate lighting by using a wider, more collective approach.

>> **Take advantage of mixed light:** Lighting your movie with tungsten and allowing the variations of fluorescent light in the background produce a complementary cast that works to your advantage.

>> **Take a white balance:** Or at least see how your GoPro treats it on the automatic setting. Fluorescent lighting differs with color output; even when the lighting looks good to the eye, it may not reproduce as naturally as you may like.

Capturing candlelight

Take the following pointers into consideration when you work with candlelight:

>> **Be careful.** It's worth repeating that a candle is a fire, and fire can burn.

>> **The subject is light.** A candle is one of the few light sources that you can keep in a scene without hoping that people think you're just being "ironic." Candles make great props as well as lighting the scene. For a table scene, measure the exposure from the candle, and don't worry too much if the subject is a bit underexposed.

>> **There's strength in numbers.** A single candle usually isn't enough to light a scene, but a group of them becomes a force to reckon with. Use a candelabra or multiple candleholders to create soft, warm illumination.

Loving the way that neon glows

Here are a few ways to work with neon:

>> **Use a wide range of exposures.** Neon light is quite flexible when it comes to exposure. Underexpose it to get rich, saturated color. Overexpose it to open the ambient portions of the scene without losing much color from the lamp.

>> **Establish the location.** Think about neon as a scene-setter. Just about any neon light can establish a scene, including a sign for a restaurant, hotel, or bowling alley.

>> **Take advantage of reflections.** These colorful lights aren't overly bright, but they reflect their rich colors on nearby surfaces. The effect is exponentially powerful when a neon sign is reflected on a rainy sidewalk.

Handling HID lights

HID light is great for finding your car keys in a parking lot or looking at city landmarks at night, but it's terrible for making movies.

Now, I said *terrible*, not *impossible*, because there are ways to take advantage of HIDs. Here are some ways to make this type of light work for you:

>> **A little goes a long way.** Instead of trying to fully correct the color, just reduce it slightly. You'll still have a color cast, but it won't be overwhelming anymore. The footage can pass for a street scene, especially when you have supplemental light coming from stores, neon signs, or the taillights of passing cars.

>> **Shoot at twilight.** Twilight still has ambient light and a variety of colors, including a purplish sky that looks great when you position your subject against it (see Figure 7-9).

TECHNICAL
STUFF

Because a sodium-vapor lamp's illumination is created by excited gas, there's nothing left to do after you correct the color. So, if you take a white balance of the scene, use a blue filter to neutralize the yellow cast, or attempt to correct it in postproduction, all that would remain is a monochromatic rendering of the subject. Unlike an incandescent light source that can be color corrected thanks to its full spectrum of color, these light forms only produce a single color. It you had to place a color temperature on this type of lamp, it would be comparable to tungsten, making it around 3000K.

TIP

It's a good idea to take a white balance under metal-halide light. Depending on the specific type of lamp, color temperature can range from 3000K to 6000K or higher (see "Taking color temperature," earlier in this chapter). Check and reset the white balance often.

FIGURE 7-9:
The color cast of sodium vapor illumination is countered by the coolness of twilight.

Creating Your Own Light

Because natural light (the sun) isn't always around, and artificial light leaves you in a passive role, bring your own light to the scene. The pros have done that since the early days, because using their own lights allows them to actively control light direction, intensity, and color temperature. Now you can do the same.

Lighting a scene can be as simple as using a single bulb and reflector or as elaborate as employing a light kit with soft boxes, umbrellas, stands, and booms. As long as you have some way of lighting the scene and can keep the lights out of view from your GoPro, feel free to light it up.

Basic lighting

Lighting a scene means using the right materials in the right way. The way you light your scene can help establish what you're trying to say without the audience's noticing a thing. Viewers absorb the movie as a whole, with lighting, action, and sound quality working together to sustain their attention.

Here are the basic lights you might use:

>> **Key light:** As the name implies, the *key light* is the main source of light in a scene. Whether that light is the sun, an outdoor lamp, or your light kit, its main job is to illuminate the subject. If you place the main light at a 45-degree angle from the subject, half of the subject renders in shadow, which can be quite dramatic.

>> **Fill light:** The *fill light* illuminates the subject from the side not affected by the main light. Depending on the subject, you can position the fill light at a higher or lower angle than the subject to fill in the shadow areas. The fill light can also be a reflector that redirects illumination from the main light. When you're shooting outdoors, the fill light may be a large white reflector bouncing sunlight back on the subject.

Just make sure that the fill light doesn't overpower the main light.

REMEMBER

>> **Back light (or hair light):** With the front of the subject adequately covered, you use *back light* to add depth to the scene and separate the subject from the background. Position this light high and off to the side, at a 45-degree angle from the subject.

Tungsten lighting

Tungsten lights are used for professional lighting in the studio and on location. This type of bulb produces light by heating the tungsten filament inside until it glows (see Figure 7-7). Studio tungsten bulbs can go as high as 1,000 watts and generally produce a color temperature of 3200 K (see "Taking color temperature," earlier in this chapter).

Tungsten lighting comes in many forms, including the icon giant lights used on movie sets. Some tungsten lights use a glass lens called a Fresnel (developed for use in lighthouses) that maximizes the light's potential. Studio lighting uses a combination of Fresnel lenses and reflectors to concentrate light on the subject. These lights produce a full spectrum of color like the sun and can be moved wherever they're needed.

Nonconventional lighting

Conforming to conventional lighting is a fundamental concept of moviemaking. But what about using nonconventional lighting? You can improvise with just about anything that emits light, such as the following:

» **Work lights:** You may have seen work-light kits at home-improvement superstores. The lights use some form of tungsten bulbs; many kits have stands and reflectors. The light is harsh but easy to smooth out by finding a creative way to diffuse it. The kits are cheap — a bonus if you're on a limited budget.

» **Flashlight or lantern:** These light sources aren't as unbelievable or impractical as you may think. They're self-contained, low-intensity light kits that you can use in a jam or for some creative effect.

» **Television screen:** If the subject is close to a television set and the GoPro is close to both, it's hard to imagine a softer, more interesting light source than the TV screen. Just tune the set to a nonbroadcast channel and position the subject close to the screen.

» **Glow sticks:** They're not bright enough for illuminating a scene, but they often work in situations in which the subject is light. Not only do they provide illumination, but their intense, saturated color makes for a great subject too.

TIP

TAMING TUNGSTEN BULBS

If a tungsten light source is too harsh for your GoPro movie, consider the following options:

- **Move it away from the subject.** It's hard to get more basic than simply moving the light away.

- **Reduce its brightness.** If the light has a dimmer, turn it down, or use a lower-wattage lamp.

- **Soften the light.** Put the light in a soft box to get close so you can bathe the subject in bright but flattering light.

- **Reflect the light.** You can turn the light around and bounce it into a reflective umbrella. If you're in a jam with the budget or don't have an umbrella, use a piece of diffusion material over the light source instead.

- **Focus the light.** Narrow down how much of the light illuminates the subject.

- **Use a filter.** Use a neutral-density gel filter to cut down a couple of stops of light.

Using Light Effectively

Like many things in life, shooting under the right lighting conditions depends on the time of day, your ability to think on your feet, and recognizing the opportunity. It's important to understand how light behaves so you're ready to effectively capture the subject. Here's how to use light effectively.

Wait for the right light

The sun flatters subjects early in the morning and early in the evening; in the middle of the day, it's not as effective. It's best to shoot with your GoPro either in the early morning or later afternoon, as shown in Figure 7-10.

Once the sun goes down you have twilight — that narrow span of time between sundown and dusk. The sun is below the horizon but still emits some light providing a "sweet spot" thanks to its rich blue or purple background. But twilight lasts only 20 minutes or so, so you have to act fast.

If you have time, wait for the right light. You have only a short window of time to make the shot work.

FIGURE 7-10:
Perfect lighting for a late afternoon beach run.

Work with the light you have

Color casts aren't intrinsically bad, and sometimes, they have a place. The normally unflattering cast of a mercury-vapor lamp can emulate an otherworldly experience, for example, just as a street scene lit with sodium-vapor can lend warmth to a subject. (I cover both types of lighting in "Outdoor lights [HID]," earlier in this chapter.)

When the sun goes down, artificial light dominates the scene. Sometimes it does so in an unflattering way, with each light source producing a dominant color of illumination. Separately, this artificial light is problematic because it produces a single-color cast. But when you combine artificial light sources, they collectively show various colors. Put artificial light against a twilight sky, and you have something unique and often beautiful.

Use colored gels

Gels work wonders when you want to adjust the color of a scene, do something creative, or make a statement. You can use a colored gel over a light to spice up the background.

Avoid light pollution

Pollution doesn't apply just to dirty beaches and belching factory pipes; it also refers to the interplay among lights in a scene. One light can spill to the coverage area of the next, producing hot spots, color variations, and odd shadows. In addition, it's likely to create lens flare (see the nearby sidebar) because the GoPro captures such a wide view.

In a perfect world, having the light at your back is the ideal way to use a GoPro, but it's not always possible to do so. That's why it's important to strategically place your camera and monitor the scene before recording to prevent light pollution.

Light the scene efficiently

Sometimes, a portion of the light source doesn't reach the subject, either because it strays out of the way due to improper bouncing or isn't bright enough. Make sure that the light is properly directed to the subject and close enough to be effective.

LENS-FLARE ALERT

Although it's common for light from an unintended light source to shine into your lens, it's even more common with the GoPro, due to its wide lens. Lens flare occurs when the axis of the lens gets too close to a light source. Sometimes, lens flare acts as an artistic device; more often, it makes you look like you're not observant enough. The figure within this sidebar shows lens flare from the afternoon light. Here are a few ways to deal with lens flare:

- **Remain alert.** Look at the light in the scene from the camera's perspective, and double-check it in the GoPro App on your smartphone.

- **Adjust the camera's position.** Because you can't use a lens hood or matte box with a GoPro (its angle of view is too wide), if you can't move the light, your only option is to reposition the camera.

- **Accept it.** Sometimes, you have no choice but to accept lens flare. It might even complement your movie. When you're shooting a street scene at night, for example, flare from the lights of passing cars seems natural.

Deal with problematic ambient light

Whether it's a window leaking bright light or a glaring streetlamp, stray light can ruin your shot. Combat it by repositioning the camera or blocking the offending light with a card, sheet, or anything else that prevents it from reaching your subject.

Chapter **8**

Of Sound Movie and Body

I f you showed a group of viewers two movie clips — one a high-definition (HD) video with slightly distorted audio quality and the other a standard-definition (SD) video with clear sound — and asked them which video is better quality, chances are that they'd pick the SD version. That's because the better your movie sounds, the more an audience will appreciate it.

Sound completes the sensory experience of a film, so always make sure that your movies sound great. That's easier said than done with the GoPro, though, because it doesn't always capture sound effectively. Maybe you didn't place it in the right location to capture the right sounds, or perhaps the limitations of the built-in microphone came back to haunt you. Lots of things can make audio capture on a GoPro less than perfect.

Although the GoPro can't handle every audio situation out of the box, a wide range of accessories can help you capture superior sound.

Capturing Sound on the Scene

The GoPro allows you to use the same range of microphones as any other camcorder, though some mikes require an adapter that plugs into the camera

or mixer and captures audio directly on the camera's memory card. DSLRs and some consumer-level camcorders generally use a 3.5mm (mini-plug), not much different from the one on your headphones, whereas more advanced models use the XLR input (that's the bigger one with the prongs).

You can also use an audio recorder, which bypasses the GoPro's memory card and captures sound as a separate file. Later you can match with the video in your editing program (see Part 3). If you have a professional-quality microphone that uses an XLR connection, you can use an adapter.

All microphones and audio recorders have advantages and drawbacks, as you see in the following sections.

Using a microphone

When you think of shooting a GoPro movie, capturing sound with a microphone is not the first thing that comes to mind. Most people start with the microphone that's built into the camera, but some move on to other microphone types when they need to capture sound in a special way. It is especially important with scenes that depend on sound for a full sensory experience. Whether it's a pool party or the din of an outdoor scene as shown in Figure 8-1, it's equally essential that the viewer hears the action as much as seeing it.

FIGURE 8-1:
The sound from this outdoor casino is as important as the visual aspect.

Capturing sound with the on-camera microphone

Whenever you record video on your GoPro, the camera captures both video and audio. That is, sound and picture come together in a single file on your memory card.

Thanks to advanced audio processing on the HERO5, you can capture left and right stereo audio channels on your GoPro. it provides better results when conditions are perfect: That's when the subject is near the camera and there's little, if any, ambient noise. Unfortunately, conditions are rarely perfect. (See Figure 8-2.)

FIGURE 8-2:
The GoPro's
microphone.

On-camera microphones like the GoPro's have several drawbacks:

>> They pick up all kinds of ambient sounds near the camera. Everything from barking dogs and screaming kids to planes passing overhead is recorded on your audio track.

>> Even when those elements don't rear their ugly heads, the sound quality of the camera's microphone can lack depth and range, based on its proximity to the source.

>> The GoPro is designed to capture unique visuals, not necessarily to record audio. Audio is a secondary feature. When the best source of sound comes from the side of your GoPro, there's not much you can do about it.

On-camera microphones were never intended for serious recording. They were added as a cheap way to capture sound to go with video. Use the GoPro's mike to capture sound for reference, and use it when it's the only game in town.

ADAPTING YOUR GOPRO TO ANY MICROPHONE

You will notice that your GoPro does not have a connection for either type of microphone. No need to worry. You can buy an inexpensive accessory (see Figure 8-1) that plugs into the mini USB connection on the camera. You can plug in a mini-plug microphone, as well as an adapter to use an XLR connection. GoPro 3.5mm mic adapter, for example, lets you attach an external microphone to the camera.

Adding a microphone

Like just your new iPhone, the HERO 3.5mm mini-plug connector for internal audio is a thing of the past. But that's no problem with the Pro 3.5mm Mic Adapter. It expands the potential for high-quality audio capture. Compatible with a wide range of external 3.5mm microphones, it enables stereo mic and line input for external audio sources like an audio recorder or mixer. Microphones come in various types and price ranges, one of which may be perfect for your needs and budget.

External microphones have their own sets of issues, but they capture better audio than the GoPro's built-in mike. Here are several popular types of microphones:

>> **Shotgun:** This long, narrow microphone (see Figure 8-3) picks up audio directly where you point it, but not necessarily close to it. Basic models are attached to professional camcorders; dedicated versions are used in television studios and on boom poles at movie shoots and red-carpet events. Think of the shotgun mike as being the audio version of a telephoto lens.

FIGURE 8-3:
Shotgun
microphone.

- » **Stick/Directional:** Perhaps the most recognizable microphone on the planet. It's the type that singers use on stage, comedians use in clubs, and television news reporters hold in front of interview subjects, held close to the mouth to isolate ambient sound. The stick/directional type of microphone covers a wide range of microphone types that you hold with your hand in front of the subject, or in front of yourself. These mikes are usually tethered to the camera by an XLR cable, though some inexpensive models use a 3.5mm connection cable. It's ideal to use when interviewing a subject or singing into the camera.

- » **Lavalier:** Also known as a lapel microphone, it's commonly used during television interviews. The tiny device clips to the subject's clothing near his face and is wired either directly to the camera or to a transmitter on the subject. When used correctly, this microphone provides great audio and isn't visually obtrusive. When it's used improperly, the audio is a rustling, muffled mess.

- » **Camera-mounted:** Camera-mounted mikes are ideal for picking up natural sounds in the scene, such as the whoosh of a babbling brook or the pleasant sounds of a horse farm. They also work well for interviewing people when they're close enough to the camera — say, 4 to 7 feet away.

- » **Boom:** Basically, it's a shotgun microphone connected to a pole so you can capture sound farther away from the camera.

- » **Wireless:** Sometimes, you're just better off using a wireless microphone. Instead of tethering the camera to a cable, connect the microphone to a transmitter and a wireless receiver on the camera. A wireless mike allows you to move independently of the camera if you're within range of its receiver, but connecting one to your GoPro requires an advanced understanding of setting it up properly and staying in range.

CAPTURING AUDIO FROM DISTANT SUBJECTS

If the subject is far from the camera, you can get the microphone closer by mounting it to a pole and holding it over the subject. Using a shotgun microphone tethered to the GoPro on a handheld rack mount provides a definite improvement over your GoPro's built-in microphone. Just be careful to keep it out of the shot.

GoPro has a very wide view, so if the microphone encroaches on the frame, it's going to appear in the final shot. Another issue is that distant sounds don't record as cleanly as sounds closer to the microphone. The microphone's narrow band of capture limits some added noise, but unwanted sound can still be a problem.

MOUNTING A MIKE ON A GOPRO

Unlike a traditional camcorder, the GoPro doesn't have an accessory mount that lets you attach an accessory microphone to the top of the camera, so you have to get creative. Here are some ideas:

- **Use a rack mount.** If you're going to hold your GoPro while recording sound, consider mounting the camera on a rack *(or tray?)*. It helps to use the tripod mount to do it because most racks depend on the tripod socket.

- **Mount the GoPro on yourself.** Use a headband or chest-harness mount for the camera, while you hold the microphone near the subject's face.

- **Tether the cable.** Mount the camera wherever you need it, and tether the microphone cable to the camera or portable audio recorder.

Choosing the right mic for the job

Here are some common shooting situations and the right microphone to use in each situation:

>> **Interviewing a moving subject: stick microphone.** The trick is to get the microphone close enough to a subject on the move without knocking out his teeth. Make sure that the microphone is no more than 9 inches from the subject.

Be consistent about how far away you hold the mike. If you move closer or pull away, you can alter the audio level, which is like raising or lowering the volume — only worse. If you're not sure you can hold a constant position, have your sound person hold a boom microphone over the subject.

» **Capturing natural sound: on-camera microphone.** When you're recording natural sound with an on-camera microphone, it's important to get as close to the subject as possible. This can be a challenge when the audio source is at a different distance from the subject, so you may have to compromise between audio and video (see Figure 8-4).

» **Shooting stationary talking subjects: lavalier microphone.** When you have a stationary subject, you can control the audio portion of your recording much better than you can in other situations. Because the subject isn't moving (or at least isn't going to move far), it's best to use a lavalier microphone to ensure that you capture sound at a consistent distance, as shown in Figure 8-5. Due to the wide view of the camera, it's imperative to keep the wires out of the scene or go wireless.

» **Shooting a movie scene: boom microphone.** If you're shooting a feature film, you're most likely capturing the audio on a separate recorder (see the next section), so camera-to-subject distance isn't an issue. The microphone and audio recorder can be much closer than the camera. The same can apply for your GoPro movie. Just make sure that the sound person holds the boom microphone appropriately. That means held from a consistent distance over the subject, and out of camera range.

FIGURE 8-4:
From casual conversation to the game itself, there are a variety of sounds near and far for Sunday afternoon baseball.

FIGURE 8-5:
Lavalier
microphone.

Using a digital audio recorder

Using a separate device to capture audio may seem to be complicated, but it's much simpler than you'd think. Also, it involves minimal risk with a great reward: optimal audio.

A digital audio recorder (see Figure 8-6) captures sound independently of the GoPro. Add the audio recording to the video in postproduction by matching it to the audio track captured by the camera, by using a plug-in for your editing software, or by using a separate sound application.

Here are some pointers for using a digital audio recorder:

>> **Capture sound on the GoPro too.** It's essential to record a reference track to match the better-quality audio that the recorder captures. Later, you can discard the weaker track when editing in a more advanced program such as Final Cut Pro or Adobe Premiere. (To aid in syncing the tracks, use a "scene clapper" or clap your hands several times.)

>> **Pick the proper audio format.** Digital audio recorders offer a wide range of audio format choices, but not all of them are right for movies. Choose a WAV or AIFF file. You can capture sound in MP3 format too, but the audio quality won't be very good. (Be sure to consult the documentation of your editing software to ensure the media is compatible.)

>> **Record on two or four channels.** A digital audio recorder lets you decide the number of channels you want to record and the audio format. Select four-channel recording if you want more control at various levels; then mix the sound down later. (You will need four separate mics and four separate cables to four separate inputs.)

>> **Fine-tune your audio levels.** Make sure that audio levels are within range (that is, not peaking and creating distorted sound) by looking at the meters before you start recording. (For more information, see "Maintaining proper levels," later in this chapter.)

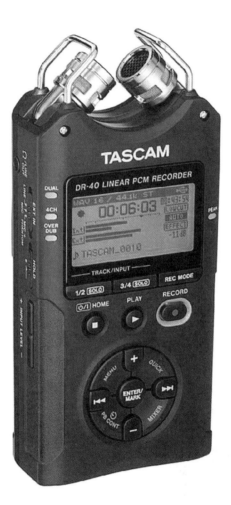

FIGURE 8-6:
Digital audio recorder.

Using the Frame

While the HERO5 and Session models already use the Frame (they're already waterproof), previous GoPro models require this accessory. The Frame, shown in Figure 8-7, provides a viable alternative to the waterproof case and captures cleaner audio because the microphone is directly picking up sound as opposed to being covered by the camera's protective case. Thanks to its open design, this

important accessory allows you to attach the camera to your favorite GoPro mount. But that's not all it can do; other benefits include:

>> **Access to camera ports:** You can change media card, offload data, and charge the camera without taking it out of the case.

>> **Easily Accessorize:** Free of the cumbersome case, you can attach an LCD Touch BacPac to monitor the scene as well as the Battery BacPac for longer capture.

>> **Sharper optics:** Because there's not an extra piece of glass, less chance exists for lens fog or debris.

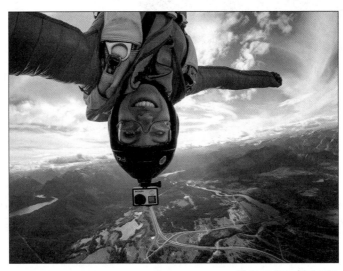

FIGURE 8-7: The Frame in action.

Photo courtesy of GoPro, Inc.

Preventing Audio Problems

In capturing audio, some elements are clearly out of your power. What matters is taking care of the ones that you can control. Sometimes, that's as simple as being aware of ambient noise on the scene. At other times, it means using a specific microphone technique.

Working around background noise

The most common audio problems involve unwanted background noise. No matter where you are, something can ruin your audio capture. In urban areas, you may pick up honking horns, screeching truck brakes, or emergency-vehicle sirens. In the country, the problem may be tree branches rustling, crickets chirping, or animals making various sounds.

The microphone doesn't discriminate when it comes to sound, so it picks up what you want to record *and* an assortment of unwanted noises that can distract attention from the primary audio. It's your job to reduce as much background noise as possible.

To reduce background noise, try the following things:

>> **Use your ears.** Your ears are made for more than just keeping your sunglasses from falling off your face. They're designed to pick up lots of different sounds. Before you press the Shutter/Select button to start recording, listen for any potential problems. If everything sounds good, listen for noise patterns so you can shoot around traffic or wind gusts.

>> **Stay away from noisy locations.** Airports, train stations, and high-traffic areas are obvious places to avoid, but chattering crowds and music blaring from passing cars also present challenges to recording audio. Whenever possible, position the microphone away from noisy locations.

Maintaining proper levels

Maintaining proper audio levels isn't possible because you can't see the meters on your GoPro, especially because it's mounted somewhere far away, or maybe too close, like your forehead. That's why it's important to use a separate audio recorder (see "Using a digital audio recorder," earlier in this chapter) when sound quality is high on your list. Watch its meters and use headphones to monitor the sound (see "Working with Other Sound Equipment," later in this chapter).

Audio should peak no higher than 12 decibels (dB). Otherwise, you'll get *clipping*: irreversible distortion caused by high audio levels. There's no sense in capturing audio if it's going to clip. Before rolling, ask actors or interviewees to speak their loudest lines to avoid recording distorted audio.

Coping with wind

TIP

Using a separate microphone offers clear advantages over using the GoPro's on-camera microphone, but it may not be free of problems. Shooting on location puts you at the mercy of forces outside your control. Regardless of what kind of equipment you have or what you know about audio, the second you step outside a controlled environment, you're at the mercy of sound-related issues. Howling wind (or even just a whimpering one) can wreak havoc on a scene. Gusts can impede sound or render it unusable. Better-quality microphones reduce some wind-related problems, but only some.

The good news is that you can solve many sound-related dilemmas by using the proper techniques and accessories. Consider these coping strategies for shooting outdoors on a windy day:

>> **Put a windscreen over a stick microphone.** A windscreen looks like a little hat for your microphone. It cuts down on the whistle of the wind (as well as heavy breathing sounds, if your subject is winded).

>> **Put a wind muff on your boom microphone.** From a distance, a boom microphone with a wind muff looks like a comatose squirrel dangling on a pole over the subject. But this woolly accessory can deal with some of the worst conditions and reduce noise by nearly 10 dB. The big problem is keeping it out of your shot.

>> **Use a blimp.** A blimp comes in handy when conditions are tough, such as when you're recording in a howling wind. This accessory is a big hollow tube that fits around the microphone and creates a pocket of stillness around it by absorbing wind vibrations.

TIP

>> **Get creative:** In a pinch, shelter your microphone from the wind using whatever means you have handy: a cupped hand, shielding with your jacket, put a sock on it, or whatever; otherwise, your sound will be wind-blown.

Staying close to the subject

If you're a fan of the classic television sitcom *Seinfeld*, you may be familiar with the episode "The Puffy Shirt," in which Jerry was asked to wear a puffy shirt by a low-talking fashion designer. Because he didn't hear what the low talker was asking him to do, he ended up wearing the shirt during a television appearance. He should have gotten closer to hear what she was saying.

The same applies to using a microphone. The closer the microphone is to the subject, the better the audience can understand his words, and the less likely you are to have extraneous noise polluting the audio track.

It's hard *not* to have the subject close to you when you're shooting with GoPro. If you're not using the GoPro's on-camera microphone as your primary audio source, use a shotgun microphone or a wireless model closer to the subject.

TIP

You may want to use a *pop screen*, which is a circular foam accessory stretched across frame that clips in front of a microphone. Besides looking cool, this inexpensive attachment reduces *plosive* noises — the "pop" sounds in words beginning with *b*, *p*, or *t*. If you don't use a pop screen, the subject's plosives may be the vocal equivalents of fingernails on a chalkboard.

Working with Headphones

It's always a good idea to use headphones to monitor audio. You can not only hear when the sound overmodulates (that's a fancy way of saying it's distorted), but also listen for unwanted sounds and distortion.

Following are a few common types of headphones:

>> **Earbuds:** The headphones you use with iOS devices can work with your DSLR. The audio quality is acceptable.

>> **Ear pads:** These small, inexpensive, over-the-ear headphones are adequate, but they don't isolate ambient sound.

>> **Clip-ons:** Clip-on headphones clip directly to your ears. They can come in handy, especially when you can use a clip-on that's clipped on one ear.

>> **Full size:** Full-size headphones have large cups that cover your ears. These headphones are best for listening to music while relaxing in an easy chair — not for monitoring audio.

WARNING

Noise-canceling headphones aren't recommended, because you need to pay attention to ambient sound to hear if it may affect audio capture.

3

Movies Are Made in Postproduction

Understand workstation requirements.

Master the basics of GoPro Studio Edit.

Make a GoPro-style video with templates.

Add transitions and titles.

Export your movie for various uses.

Chapter **9**

Equipping Your Edit Station

echnology has come so far that "editing suite" often refers to your table of choice at your favorite coffee place with your laptop computer. You can literally put a movie together with headphones on while sipping your latte. You can sip a cappuccino when downloading footage from your camera and immediately start editing your movie. All it takes is a machine with enough horsepower — most consumer models have it these days — to run GoPro Studio Edit, or your favorite editing app.

Not all computers are created equal; some are clearly a little more robust when it comes to efficiently handling all that you throw at them. Often that difference comes down to having a faster processor and an abundance of RAM.

Picking a Computer Platform

The rivalry between Macs and PCs used to have the same intensity as debates between Yankees and Mets fans or Ohio State and Michigan followers. Although the sports rivalries are still intense, the one between Macs and PCs has softened a bit.

Both operating systems can help you achieve your goals; they just happen to go about the process differently. Chances are that the computer you already own can meet your video editing needs.

Choosing a Macintosh

Walk out of an Apple Store with a Mac, and you can start editing your movie not long after you take it out of the box, because iMovie is loaded on every Mac.

Mac models

Currently, you can choose among these models:

- **» MacBook Pro:** This powerful laptop lets you edit anywhere. It comes in two screen sizes and a variety of configurations, including Retina Display. It includes a SuperDrive for reading and burning media discs. Thunderbolt and USB 3 inputs allow you to connect to just about anything.

- **» MacBook Air:** This lightweight version of the MacBook, the Air sheds some weight and thickness by leaving out a conventional hard drive. It has less processor speed than a MacBook Pro, but it's still adequate for video editing, especially when it's connected to a fast external hard drive (Figure 9-1).

- **» MacBook:** Somewhere between the Air and Pro models lies the MacBook. It uses the latest generation of Intel Core processor. You can also choose a variety of colors. A possible drawback with this model is its single USB-C port that shares both power and data transfer.

- **» iMac series:** This popular all-in-one desktop computer acts as an edit station right out of the box. Like the MacBook Pro (see the previous item), it has Thunderbolt

connectors and USB 3 inputs. It comes in two screen sizes — 21.5-inch and 27-inch, as shown in Figure 9-2 — and comes in a variety of configurations.

>> **Mac Pro:** The Big Kahuna of the Macintosh line, this tower computer offers enough raw power to edit a feature film with special effects, as well as process high-quality CGI animation. It's not light on the pocket, and the monitor and other peripherals are separate purchases, so for anyone who's just breaking into the field, it may be overkill. But it's a durable workhorse for serious moviemaking.

>> **Mac mini:** The Mac mini is the powerful tiny version of the Mac Pro. As with the Pro, you add the monitor, keyboard, and mouse of your choice.

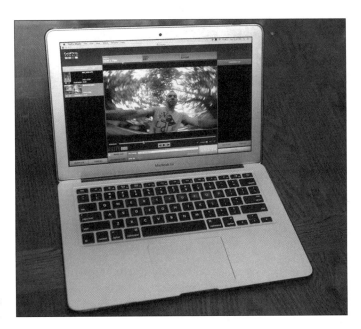

FIGURE 9-1:
MacBook Air.

Minimum editing requirements for a Mac

For optimum video editing, choose a Mac with these specs or better:

>> Intel Dual Core processor

>> Mac OS X 10.9 (Mavericks) or later

>> 4GB of RAM

>> Display resolution of 1280 x 768 pixels

>> 5,400 rpm internal hard drive; 7200 rpm is preferable

>> External hard drive with Thunderbolt, USB 3.0, or eSATA connectivity

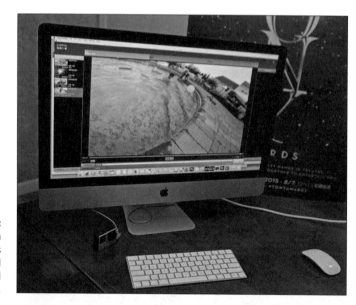

FIGURE 9-2:
iMac 27-inch
model provides
a great deal
of screen real
estate.

Setting Up Windows

At entry level, Windows PCs are cheaper than Macs, though cost is significantly affected by component quality. These days, PCs have enough initial power to edit video, but they may not include a fast-enough hard drive or a complete set of connection types.

PC models

Numerous manufacturers make PCs — including Dell, Toshiba, Hewlett-Packard (HP), and Sony — and each manufacturer makes several lines that use a variety of components. Even when you isolate your choice to laptops, you still should consider differing screen sizes, processors, and connectivity arrays.

PC models come in the following types:

>> **Desktop:** Better desktop PCs feature fast multicore processors, sound boards, multiple hard drives, and high-speed inputs.

>> **Laptop:** Some models excel at high-definition (HD) video editing; others fall short. Check the specs for running GoPro before committing to a laptop. Standout models include the HP Envy and the Dell 7000 series.

>> **All-in-one:** All-in-one PCs offer fast processing, HDMI connectivity, and large screens. Many models support video editing, including the Dell 7000 Series and the HP Touchsmart.

Minimum editing requirements for a PC

For best video editing performance, choose a Windows PC with these specs or better:

» Intel Core 2 Duo processor

» Windows 7

» 4GB of RAM

» Graphics card that supports OpenGL 1.2 or better

» Display resolution of 1280 x 800 pixels

» 5,400-rpm internal hard drive; 7200 rpm is preferable

» External drive with USB 3.0 or eSATA connectivity

» QuickTime 7.6 or later

Understanding Workstation Requirements

When it comes to editing video, some computers are clearly better suited than others. Here's what you need for your moviemaking workstation.

Picking a newer computer

Often, older computers are more replaceable than upgradable. An older iMac that doesn't include a Thunderbolt connection, or at least a FireWire 800 connection, for example, won't be usable with a fast external hard disk. Neither will a Windows PC with a slow graphics card or a processor that can't run the latest operating system.

Shooting for more-than-minimum speed

Editing HD video is serious business, so your computer's processor had better be up for the challenge. Whether you're using a new machine or an old one, be sure it exceeds the minimum requirements to run your editing software (see "Picking Software That Suits Your Needs" later in this chapter).

CASHING IN ON THE CACHE

The cache is perhaps the most-overlooked component in high-speed computing. Every time you do something on your computer, the processor gathers instructions to honor the request. The processor can execute actions faster than memory can, so it uses various levels of cache to accomplish tasks. Cache is a funny thing in that you don't always notice when it's there, but you know when it's not there.

Here's how cache helps in editing video:

- **Level 1 (L1) cache:** This type of cache speeds the editing process, but only in short bursts. It works harder when the processor needs a little help and then goes back to working normally. Like eating a chocolate bar when you're hungry, using Level 1 cache is satisfying but not meant to replace the meal.

- **Level 2 (L2) cache:** At this level, a little more memory is available to crunch the data, but performance at this level is slightly slower than Level 1 cache.

- **Level 3 (L3) cache:** This level has more memory than Level 1 and Level 2 combined. Processing is slower than at those levels but significantly faster than RAM. A processor with an adequate L3 cache performs significantly faster than a computer with more RAM.

WARNING

A processor has much in common with a drummer in a rock band: Each needs to keep up to do the job. When you capture 30 frames per second, the processor must play 30 individual frames per second (fps) without missing a beat. Processing a continuous video signal is an arduous task, and any hitch or glitch can seriously slow the process or even drop frames.

Using a large monitor

If you have a desktop computer, get the biggest screen you can afford. With a laptop, you're a bit limited, but try to get at least a 15-inch screen.

Lots of RAM

Your computer can't live without random access memory (RAM), and you can never have enough of the stuff. It feeds your processor-hungry video editing software while updating your Facebook status. The more RAM you have, the better, and because HD movie files require a lot of memory, buy as much as you can afford. Fortunately, RAM is relatively cheap.

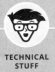
KNOW YOUR DRIVES

Not all hard drives are created equal. Here are a few types of drives you're already using or can add to your system:

- **Internal drives:** The internal hard drive is the one that's already in your desktop or laptop computer. A basic one runs at 5,400 rpm, though some inexpensive computers use drives that run at 4,500 rpm.

- **External drives:** External hard drives are available in various flavors. Benefits include compatibility with various computers and faster access speed than internal drives can offer. Some external drives are self-powered to accommodate on-the-go editing needs.

- **RAID arrays:** A RAID (Random Array of Independent Disks) array is a group of hard drives connected to act as a single unit for increased performance and stability.

- **Solid State:** While it saves data like a normal spinning hard drive, unlike a normal hard drive, solid state drives have no moving parts, magnetic coating, or spinning platters. Instead, the data is stored on interconnected flash memory chips. And they don't need power to retain data. These drives are faster and more stable than a standard hard drive, but are also more expensive and hold less data.

- **Fusion:** Somewhere between a standard moving hard drive and a solid-state drive lies the fusion drive. With this hybrid drive, developed by Apple, the operating system keeps the most accessed files on the flash storage side for faster access. Less frequently used items reside on the hard drive.

Benefits of a faster graphics card

Think of the graphics card as a specialist hired by the processor to reproduce the image and redraw the screen 30 times per second. Today, video is recorded and played back at 60 fps — and 120 fps and higher rates loom on the horizon. Your graphics card has its work cut out for it. Many computers built over the past couple of years are more than adequate to run GoPro Studio Edit.

Accessorizing Your Station

Accessorizing your outfits makes good fashion sense, and so does adding accessories to your editing workstation. If you have room on your desk and in your budget, add a second monitor and some comfortable peripherals.

Connecting an extra monitor

Your video footage and your video editing tools reside on the same monitor, so it's a good idea to connect another monitor to separate the editing tools from the actual video (see Figure 9-3). Also, adding a high-quality monitor helps with video quality control.

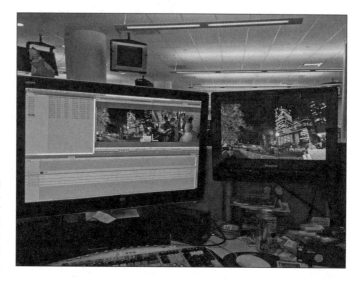

FIGURE 9-3:
Professional-quality monitor connected to a Mac Pro running Final Cut Studio 2.

The hardest part about connecting a monitor is making sure that you have the proper connectors. Even if your computer doesn't have a dedicated video connection, you can connect another monitor via USB or Thunderbolt.

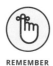

REMEMBER

Set up the extra monitor as an extension or mirror of your main monitor, per your needs:

>> **Extending the monitor** adds more real estate by continuing the monitor on the other monitor. This arrangement is perfect for adding space to separate your editing tools from the video player. Extending gives you more room and allows you to multitask without overpopulating your screen.

>> **Mirroring the monitor** is exactly what it sounds like. This technique is great for working on your main monitor while showing your work to an audience on the other monitor.

Adding a monitor to a Mac

To set up an additional monitor on a Mac, make sure you have the right connector, and enjoy dual-screen bliss. Here's how:

1. **Connect the second monitor to the Mac, using the appropriate connector.**

 Use one of the following:

 - *Thunderbolt cable:* Transfers both data and a display signal.
 - *VGA adapter:* Lets you connect any standard analog monitor, projector, or LCD screen that uses a VGA connector.
 - *DVI adapter:* Allows you to connect a monitor that has a DVI connector.
 - *Mini monitor port to VGA adapter:* Lets you connect a second monitor to any Macintosh with a Thunderbolt port.

2. **Turn the monitor on.**

3. **Choose System Preferences from the Apple menu.**

4. **Select Monitors in the System Preferences window.**

 If you don't see it, select Detect Monitors.

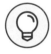

TIP

5. **Adjust the resolution, colors, and refresh rate as desired.**

 If your Mac is running the Mavericks operating system, simply choose Best for Monitor.

6. **Specify how you want to use the second screen.**

 The default setting extends the screen between the two monitors. Rearrange the orientation of the monitors by dragging one over the other and clicking the Arrangement button. If you want both monitors to show the same screen image, select the Mirror Monitors check box.

Adding a second monitor to a PC

Using another monitor with your Windows PC is simple. Follow these steps:

1. **Turn off the computer, if it isn't already off.**

2. **Connect the second monitor via the DVI or VGA port.**

3. **Turn the computer and the second monitor on.**

 The Windows operating system looks for both monitors. Don't be alarmed if the new monitor doesn't turn on.

4. **Activate the second monitor.**

To do this:

a. *Right-click any spot on the screen, and choose Screen Resolution from the shortcut menu.*

b. *Click the Settings tab of the Properties dialog box, which displays two boxes to represent the two monitors.*

c. *Right-click the second monitor, and choose Attached from the shortcut menu.*

d. *Click Apply in the resulting dialog box.*

After some churning, the second monitor should come on.

5. **Specify what you want the monitors to do.**

If you want to extend the video across the two monitors, for example, select the second monitor and select Extend these Displays.

Adding ergonomic peripherals

Be sure to pick the keyboard and mouse that work for you. Some manufacturers make keyboards designed for specific nonlinear editing programs, such as Apple Final Cut X and Adobe Premiere CS.

Keyboarding bliss

Maybe it's not as much fun as snowboarding — especially if you love strapping a board to your feet and negotiating a snowy hill — but there's something incredibly pleasurable about using the right keyboard. Whether you like one that has a specific action or helps with your repetitive-stress injury, it's key (pun intended) to select the right one.

Although the keyboard that came with your computer does the job, you may want to upgrade to one of the following:

» **Dedicated editing keyboard:** With color-coded keys and written instructions, this keyboard familiarizes you with editing shortcuts. Also, it looks cool on your desk.

» **Ergonomic keyboard:** An ergonomic keyboard is designed to provide a more natural feel when typing and to reduce injury.

» **Wireless keyboard:** A wireless keyboard frees a USB connection on your computer and allows you to move the keyboard without tangling cables.

Sometimes a mouse is not a rodent

This popular peripheral got its name because it resembled a mouse with a tail. These days, you'd be hard-pressed to find a mouse with a tail: Most modern mice are wireless. Some pointing devices aren't even mice; they're trackpads or trackballs.

TECHNICAL
STUFF

For video editing, it's common to use a shuttle control. As an active part of the video editing process, it guides you through the program interface and the time-line with relative ease.

Picking Software That Suits Your Needs

Many novices think that their unedited video footage stands on its own. It's possible to understand an unedited clip of some specific action, but that case is more the exception than the rule. But more often, raw footage doesn't satisfy anyone but the person who shot it.

For that reason, it's important to edit your footage with a nonlinear editing program. Which one? You have a lot of programs to choose among, and all of them do pretty much the same thing, so you may want to base your decision on your needs and budget.

WARNING

Occasionally, problems arise when you use video editing software on an older computer, depending on how old the computer is and what version of the operating system it uses. Check the system requirements of the software you're considering.

Trying free software

You can download GoPro Studio Edit *gratis,* but you may already have a pretty decent moviemaking program on your Mac or Windows PC.

GoPro Studio Edit

For many of your needs, you may not have to go further than GoPro Studio Edit (see Chapter 11 for more information). The software is free to download — and more important, it's designed to work with GoPro cameras.

GoPro Studio Edit is packed with features, including a series of templates that allow you to produce GoPro-style videos by just adding your video to appropriate places. I discuss this software in more detail in Chapter 10.

GoPro Studio Edit doesn't discriminate and works well with both Windows PCs and Macs. Computers running Windows XP, Vista, Windows 8 Pro, Windows 8 Enterprise, and Windows RT can all run the software. So can any Mac running OS X 10.6.3 or later.

iMovie

Standard issue on Macintosh computers for more than a decade, iMovie (see Figure 9-4) is a popular choice among amateur video editors. It offers many special effects and fully integrates with Mac programs such as iTunes and iPhoto. Although the software is easy to use and loaded with functions and themes, some people may find it limited for advanced editing.

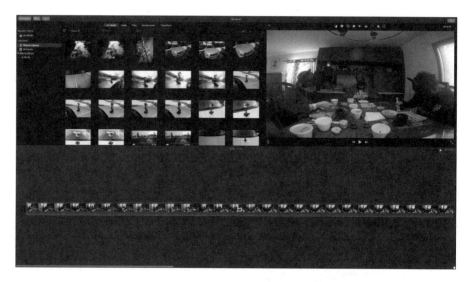

FIGURE 9-4:
iMovie
interface.

Windows Movie Maker

Included on most Windows PCs, this powerful little program lets you make movies easily. It's intuitive to use and includes many fun effects.

Purchasing software

GoPro Studio Edit provides a great starting point for creating your movie, but it's not the only game in town. More elaborate programs are available that go beyond GoPro Studio Edit.

Final Cut Pro

Considered by many people to be the de facto standard for nonlinear editing, Final Cut Pro appeals to the prosumer market. Robust, powerful, and filled with every imaginable function, this video editing program lets you do anything your creative heart can dream up. It captures or transfers video files in just about any format and exports them with a great deal of flexibility.

REMEMBER

On the down side, Final Cut Pro works only on Macs.

Adobe Premiere Pro CC

One of the oldest nonlinear editing programs on the market, Premiere has a devoted following. It helps you edit professional-quality movies, and it integrates nicely with the Adobe programs After Effects and Photoshop. Native DSLR editing presets in the newest version make it ideal for creative GoPro moviemaking. The software runs smoothly on both Macs and Windows PCs. Just make sure that your workstation has enough RAM and a decent graphics card.

Adobe Premiere Elements

This abridged version of Premiere Pro (see the preceding section) is not only affordable, but also powerful. Version 14 includes a wide range of new features. It behaves the same way on a Macintosh as it does on a Windows PC.

Sony Vegas Pro Movie Studio

If you're looking for a PC video editing application that lets you edit pro-quality movies, there are worse choices than Vegas. Designed for the professional on the go, it includes a healthy selection of effects and 3-D capability to boot. When you get the knack of the software, you can use it to crank out quality material. It comes in a variety of configurations and ranges in cost from affordable to pricey.

Pinnacle Studio HD

REMEMBER

Another name synonymous with video editing, this consumer-level program offers a nice set of features. Don't expect it to have lots of bells and whistles, but what it does have ensures that you can make a successful movie. It's quite complex for an inexpensive program.

Macintosh users need not apply; Pinnacle Studio HD is strictly a Windows program.

Chapter **10**

Getting to Know GoPro Studio Edit

D epending on when you grew up, the home movies of your childhood (or perhaps videos of your child) may have something in common: The camera captured too much for the movie to maintain its pizzazz. Sometimes, it took too long for the action to happen; at other times, the camera kept recording after the interesting stuff was long gone. Or maybe, there just wasn't a whole lot of interesting content. Forget about the reason, though, because the result is the same: People are reluctant to watch long and boring movies.

The problem isn't necessarily shooting too much footage. Often, when you leave the camera running, you capture amazing activity. You never want to shoot less — maybe more wisely, but never less. As Tarzan might say, "Shooting lot of footage, good. Playing all that footage at family party, bad."

Editing your movie before showing it to anyone is always a good idea. By assembling the best pieces into a shorter, more concise movie, you not only hold your audience's attention, but also can create a narrative that keeps them watching.

Using an intuitive editing program like GoPro Studio Edit provides some power to transform your clips into a cohesive, well-edited movie. When you've shot the footage, it's time to get to work. Unlike mowing the lawn or cleaning the gutters, this task is more creative and thought-provoking.

For the section on GoPro Studio Edit, a Macintosh computer was used. Versions for both platforms are similar in operation.

Why Use GoPro Studio Edit?

It's unlikely that anyone ever said, "Hey, I want to spend more money than necessary for some video editing software." That's like asking the Internal Revenue Service whether you can pay more taxes than you owe. But that's often what happens when beginners buy software that's too advanced.

These days, many affordable consumer programs are available, as mentioned in Chapter 9, but there's something nice about a free program. It's even nicer when that program is powerful and intuitive too. That's what you can expect from GoPro Studio Edit, which makes it easy to create professional-quality videos from your GoPro content. By providing features that specifically address that type of camera, the program lets you add effects and titles to your movie, as well as add voiceovers, music, and sound effects.

In addition, it includes a series of templates (influenced by popular GoPro videos) that accelerate the process of transforming your clips into an incredible movie.

TIP

Although GoPro is up to the task of working as a stand-alone program, you can also integrate it with other, more powerful nonlinear editing programs such as Apple's Final Cut Pro and Adobe Premiere.

Seeing what's special about the program

Besides being free, GoPro Studio Edit offers the right amount of versatility. Here are some advantages of using this program:

>> Intuitive working environment

>> Nice selection of special-effects features

>> Easy integration of clips recorded at different resolutions and frame rates with no visual loss of quality

>> Variety of templates

>> Capability to export a high-quality master file with up to 4K resolution for broadcast or archival purposes

>> Capability to export projects as H.264 MP4 files at up to 1080p resolution for sharing on sites such as YouTube and Vimeo.

Getting the software on your computer

Editing your GoPro footage for free is just a few clicks away when you download the software from the GoPro site.

Besides the free version, two paid versions of the software are available: GoPro Studio Edit Premium and GoPro Studio Edit Professional.

Before you get the software, make sure that your computer meets the minimum requirements mentioned in Chapter 9. If your computer is good to go, you're ready to start downloading. Follow these steps:

1. **Go to** `http://gopro.com`, **click the Products link, and navigate to the software page.**

2. **Choose your operating system from the drop-down menu.**

3. **Enter your email address.**

4. **Click the Download button.**

5. **When the .dmg (Mac) or .exe (Windows) file finishes downloading to your computer, double-click it to open the installer.**

6. **Double-click the installer icon.**

7. **Follow the installation wizard's prompts.**

Breaking Down the Interface

GoPro Studio Edit 2 offers a new, user-friendly interface with lots of controls and features.

Navigating the player window

The player window (see Figure 10-1) provides three panes:

» **Import & Convert:** This pane is where you import your files into the program and convert source files to the CineForm format. (I discuss CineForm in Chapter 12.)

» **Edit:** In this pane, you put the movie together, doing everything from trimming clips to adding effects, titles, and music.

» **Export:** This pane provides the necessary tools to convert your movie to a self-playing movie file.

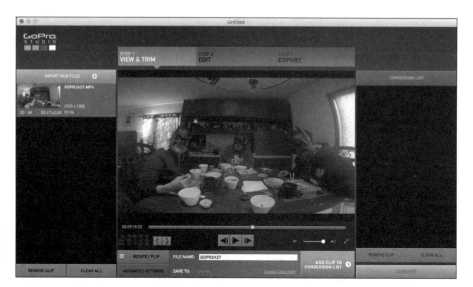

FIGURE 10-1:
The three
panes of the
player window.

The window's function depends on what you're working with in the program:

>> **Individual clips in the Media Bin:** Click a clip in the Media Bin, and it loads it
in the player. Press the play button to view it. You can trim the clip by setting in
and out points (see Figure 10-2).

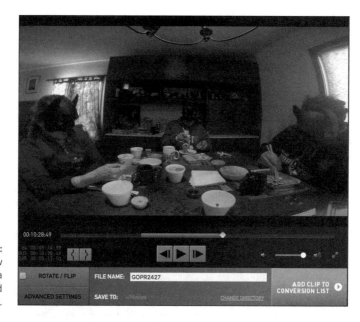

FIGURE 10-2:
Player window
showing a
clip with in and
out points.

>> **Clips on the Storyboard:** If you click the Storyboard, the clips play in order.

>> **Individual clip on the Storyboard:** More than likely, your Storyboard is populated with clips. Double-click a clip to play it. You can also trim a clip.

Deciphering the menus

Navigating the features of GoPro Studio Edit is like driving to a friend's house a few towns away, as opposed to navigating bigger, more complicated programs, which is like driving cross-country. You still should know the lay of the land, though. In this section, I cover the menus and their commands. The Mac and PC versions are similar in operation, although the Mac version has more operations under the menus.

File menu

The commands on this menu let you create a project, import content, and save the project:

>> **New Project:** As you might expect, this command creates a new project.

>> **Open Project:** This command lets you navigate to a project you've already started.

>> **Open Recent Project:** This command displays a submenu of projects you've already started.

>> **Match Stereo Pair (Mac only):** This command combines multiple audio channels into a single stereo file.

>> **Import Media (Mac only):** Choose this command to locate and import into GoPro Studio Edit.

>> **Load GoPro Template:** This command allows you to select a template for your movie.

>> **Close:** This command does exactly what it says to the file you have open.

>> **Save Project:** This command saves your project and prompts you for a filename if you're saving it for the first time.

>> **Save Project As:** The Save Project As command, which lets you change the project name when saving, comes in handy when you want to have an alternative project name.

>> **Revert to Saved (Mac only):** Choose this command if you've made a lot of wild changes since the last time you saved the project and want to get back to that point.

Edit menu

The commands in this menu include many of those that you normally find on Edit menus. They are

» **Undo:** This command lets you reverse your last 50 actions. You could choose the menu command 50 times, or press ⌘+Z (Mac) or Ctrl+Z (Windows) 50 times and then erase those steps.

» **Redo:** Just in case you've undone too much, this command allows you to start bringing everything back.

» **Cut (Mac only):** The Cut command removes a Storyboard element and copies it to the clipboard, just in case you change your mind.

» **Copy:** This command lets you copy an element for future use and holds it in the clipboard.

» **Paste:** The Paste command moves a copied or cut element to a new place.

» **Clear Storyboard:** This command clears the Storyboard of all content.

» **Reset All:** Choose this command to clear any changes you made in the clip on the Storyboard.

View menu (Mac Only)

Things get a little more interesting on the View menu:

» **Enter Full Screen:** The floating screen takes over the entire screen when you choose this command.

» **Play/Pause:** This command is a toggle, allowing you to play and pause a clip wherever it resides: the Import Bin, Media Bin, or Storyboard.

» **Stop:** Stop stops the movie.

» **Fast Rewind:** This command rewinds clips quickly, allowing you to look for a specific point in the footage.

» **Fast Forward:** This command does the same thing as Fast Rewind, only in reverse.

» **Previous Edit Point:** This command moves the Storyboard time indicator to the last clip on the Storyboard.

» **Next Edit Point:** This command moves the Storyboard time indicator to the next clip on the Storyboard.

- **Mark In:** Choose this command to set the point where the clip should begin before trimming.

- **Mark Out:** Choose this command to set the point where the clip should end before trimming.

- **Step Reverse:** This command moves backward through the Storyboard or selected clip.

- **Step Forward:** This command moves forward through the Storyboard or selected clip.

- **Split:** Choose this command to divide the selected clip.

- **Loop Playback:** This command makes the Storyboard or selected clip repeat until you intervene.

Share menu (Mac only)

Sparse in choices, the Share menu offers two choices for exporting your movie or still image:

- **Export Movie:** Lets you export the movie. The resulting Export Movie dialog box provides resolution and format options (see Chapter 11).

- **Export Still:** Allows you to export a still frame from the movie in three file sizes, as well as in the native format.

Window menu (Mac only)

The Window menu contains commands that have to do with the program window and its relationship to the computer screen:

- **Minimize:** This command hides GoPro Studio Edit so you can see other open programs on your computer.

- **Zoom:** This command fills the screen with the program.

- **Show Conversion Details:** This command shows the conversion setting of the selected clip.

- **Bring All to Front:** If you're running other applications while you're editing in GoPro Studio Edit, this command allows you to bring GoPro to the front.

Help menu

Rounding out the menus is Help:

- » **Search (Mac only):** Choose this command, and type a topic you're trying to find information on.

- » **GoPro Studio Manual:** This command accesses the manual.

- » **Online Support:** This command launches web-based help.

- » **Tutorial:** Choose this command to find the appropriate tutorial for what you're doing, such as Import, Edit, or Export.

- » **Device Window:** This command lets you update your GoPro camera and other accessories.

Bringing in Media

I'm sure you're familiar with the fable of rubbing a magic lamp and having a genie pop up to grant you three wishes. There's no genie in GoPro Studio Edit, but the first time you try to import content, a tutorial on importing pops up (see Figure 10-3).

FIGURE 10-3: The Import tutorial.

Alternatively, you can choose this tutorial from the Help menu.

With or without a tutorial, it's easy to import your GoPro footage and any other elements you want to add.

Importing media from your GoPro

Downloading image and movie files from your GoPro is easy. Just plug the camera into the computer's USB port. Then you can do the following:

» **Import files through GoPro Studio Edit.** Click the Import New Files button at the top of the player window's Import & Convert pane. An import dialog box opens. Select the DCIM folder, and click Open. You can also access the folder where the movie resides and choose the files you want, if you don't feel like opening the entire batch.

» **Pull the files off the camera.** Navigate to the DCIM folder and drag the files from the camera to the desktop.

» **Use another app.** Mac users can easily open files through iPhoto or iMovie. On a PC, you can grab files from Movie Maker or Photo.

Importing other media files

If you want to add footage from other sources to your GoPro movie, you can easily import clips from your camcorder or another camera. Just connect that device to your computer via the USB port, click the Import New Files button at the top of the Import & Convert pane, use the Import New Files dialog box to navigate to the media you want to import, and click Open. This process works for audio files, too.

Using GoPro Edit Templates

At one point or another, a co-worker or friend may have pulled you aside to show you some cool GoPro video online. Guess what? Now you can make your own. GoPro Studio Edit offers templates based on the most popular GoPro videos to transform your footage into another exciting GoPro video.

The program comes with four templates (see Figure 10-4):

» **Dubstep Baby:** Slow-motion video and dubstep music can transform your baby video into a hip clip.

>> **Laser Cats:** There's no shortage of cat-video fans on the Internet, so it seems like a no-brainer to combine your cat with GoPro video and a cool layout. All you need to do is drop in your own cat video, and away you go.

>> **Ocotillo Desert Lines:** The action-movie template lets you add your own exciting video to produce a nicely constructed segment.

>> **Pool Party with the Niños:** Replace this family with your family for an impressive movie.

Other templates are available online. To download more templates for free, go to `http://gopro.com/studio-templates-download?referral=studio_app&version`.

Just follow these steps to create a video by using a GoPro template:

1. **Choose File ⇨ Load Edit Template.**

 The Browse Edit Templates dialog box opens.

2. **Select a template.**

 The template you choose populates the Storyboard, providing sample video clips, music, and titles. Each template lists the title, artist and song, a brief description, duration, number of clips used, and tempo.

3. **Replace the content of the template with your own.**

 Just drag the new footage to the target on the clip in the Storyboard. Repeat it for other clips you want to include.

4. **Save and export your movie.**

Implementing an Efficient Workflow

Everyone has different needs, but some basic practices will make your time using GoPro Studio Edit swift and productive.

Customizing your workspace

GoPro Studio Edit doesn't offer a lot of preferences or settings, so you can't customize for all your needs. Think of it as being like the computer at the office that everyone shares: It works well, but you wouldn't dare use your vacation pictures as a screen saver. Well, it's the same thing when using GoPro Studio Edit. You can't adjust the size of your bins and windows or create your own keyboard shortcuts, but that doesn't mean you can't use it as an effective tool.

Organizing projects and files

It's essential to organize your movie content to make the process go as smoothly as possible. Here are a few things you can do:

» **Group your visual assets.** Put all the visuals you want to use in your movies inside a folder so you can access them easily.

» **Create a project folder.** This folder keeps your GoPro movies in the same place. It differs from your visual-assets folder, which acts more like a storage area.

» **Name your folders consistently.** Using a coherent naming convention for folders will help you find footage six months from now.

» **Import only what you need.** There's no sense in filling the program with excessive footage, especially if you have no intention of using it. Keep things lean and mean.

Setting preferences

If having the fewest preferences were a competition, GoPro Studio Edit would be a finalist. The Preferences dialog box (see Figure 10-5) offers a limited number of options:

» **Use Time of Day for Timecode:** This option takes the time of day from the source file and writes it into the time-code track of the converted file.

» **Use Reel Name in Destination:** This option lets you name the clip that you're converting.

» **Auto-Start Conversions:** This option automatically starts converting files when they're added to the Conversion List (see Chapter 11).

» **AutoSave Is On:** When this option is selected, the project is saved automatically at the intervals you set, which range from 30 seconds to 60 minutes.

FIGURE 10-5:
The GoPro
Studio
Preferences
dialog box.

Delving Deeper into GoPro Studio Edit

Every section of the program windows contains its own controls. In this section, I review them to help you master the program.

Navigating the player window's controls

GoPro Studio Edit is like the Swiss Army knife of video editing programs. It's a bit scaled down when compared to programs like Final Cut Pro and Adobe Premiere, but it still provides you enough tools to get the job done, minus the small saw and fold-out scissors. The program's features and functions center around the player window, which has three states that show different features depending on what you're doing in the program. Here is a brief description.

Import & Convert pane

The Import & Convert pane (also known as the Import Room; see Figure 10-6) is where you import your movie clips, trim the footage, and choose advanced conversion settings.

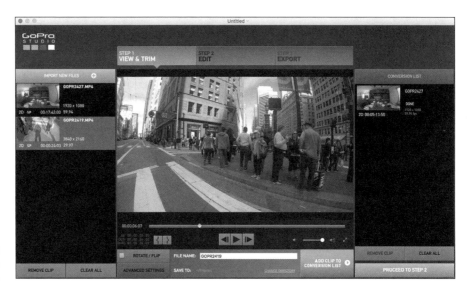

FIGURE 10-6: The Import & Convert pane.

Following are brief descriptions of the pane's controls:

- >> **Import:** Click this button to bring media into the program. (Alternatively, choose File ⇨ Import.)

- >> **Import Bin:** The Import Bin holds the media you've imported for the project.

- >> **Playback slider:** This slider shows the progress of the clip or movie, both in the position of playhead and the time code.

- >> **Playhead:** This diamond-shaped icon shows the progress of the clip playing. Drag it to scroll through the clip.

» **Remove Clip:** Click this button to delete a clip from the Import Bin.

» **Clear All:** Click this button to remove all clips from the Import Bin.

» **Rotate/Flip:** Click this button to rotate or flip the selected clip.

» **Advanced Conversion settings:** These controls let you modify the image size, frame rate, and quality. In addition, you can speed the clip or apply a motion blur.

» **Trim Point:** Click this button to set in and out points to trim your source file.

» **Filename text box:** Enter the name of each clip here.

» **Playback controls:** These controls let you play the clip, as well as play it frame-by-frame in forward or reverse.

» **Change Directory:** Click this button to change the directory in which the clip will be saved.

» **Add to Conversion List:** Click this button to add the file in the player to the Conversion List.

» **Convert All:** Click this button to convert everything in the Import Bin.

» **Full Screen:** Click this button to make GoPro Studio Edit fill the screen. Press the Escape key on your keyboard, and it reverts to the floating window.

» **Volume controls:** These controls allow you to adjust the volume.

Edit pane

The Edit pane (see Figure 10-7) is where you take the edit to the next level. You can add effects, music, and titles, as well as combine multiple videos on a Storyboard. Access it by clicking the second tab at the top of the player window.

Here are the controls in this pane:

» **Add Media:** Click this button to add converted media files to your project for editing.

» **Add Title:** Click this button to bring up a box where you can type a title and adjust its font, size, and style.

» **Media Bin:** This area contains the converted media clips.

» **Remove Clip:** Click this button to delete clips from the Media Bin.

» **Storyboard time indicator:** This control shows the duration of the movie as it plays.

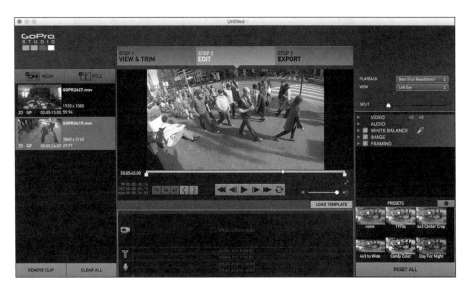

FIGURE 10-7:
The Edit pane.

>> **Volume controls:** Use these controls to adjust the volume.

>> **Trim, Split, and Clip Navigation controls:** Use these tools to work on the clip.

>> **Playback controls:** Use these tools to play the movie, scroll through the footage, and make frame-by-frame adjustments in forward and reverse.

>> **Load Template:** Click this button to load one of the GoPro templates (refer to "Using GoPro Edit Templates" earlier in this chapter).

>> **Global Playback controls:** These tools apply playback and view settings to the entire movie, as opposed to a single clip.

>> **Video & Audio Playback controls:** These tools let you change a single clip rather than the entire movie.

>> **Color Correction, Framing, and 3D controls:** These nested controls let you adjust white balance, exposure, cropping, and other settings.

>> **Presets:** These controls let you apply image effects to your clips.

>> **Reset All Settings:** Click this button to revert to the last-saved state after you change a clip.

Export pane

You use the Export pane (see Figure 10-8) when your movie is complete. This pane offers only a few controls, which allow you to name the file, choose an export format, and save your movie in the appropriate folder.

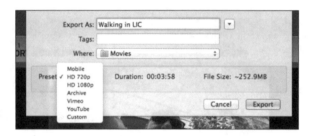

FIGURE 10-8:
The Export
pane.

Making transitions

GoPro Studio Edit offers only one transition: a *dissolve*, where one scene slowly transforms into another. If you have two clips, you can add a dissolve. There's no menu command for this feature, and it's rather subtle, so if you blink, you can miss it.

To add a transition, follow these steps:

1. **Click the Edit pane to select it and display your Storyboard.**

2. **Click the Add Transition icon between two clips.**

 This icon is a tiny plus sign (+) resting on the yellow line between the clips (see Figure 10-9). The playhead does not have to be on the clip.

FIGURE 10-9:
To create a
dissolve, click
the + sign.

3. **Set the duration of the dissolve.**

 When you click the + sign, you see a narrow box outlined in yellow that stretches across the two clips you set the dissolve.

4. **Click the Dissolve icon to select it.**

5. **Move the playhead to the desired out point on the playback slider.**

6. **Click the Mark Out button to shorten the duration of the dissolve.**

Working with audio

Great audio depends on many factors, some of which take place during the editing phase. GoPro Studio Edit offers you a fair amount of control of audio. You can fix noise, add a sound effect, or record a voiceover track.

To access the audio controls, select a clip in the Storyboard and then click the Audio control on the right side of the Edit pane. The control panel shown in Figure 10-10 opens, giving you access to the following settings:

>> **Level dB:** This slider allows you to change the volume level of the clip during playback. You can increase the level for clips with lower audio and decrease it for clips that are too loud or distorted. If you need to reset the levels, just click Level dB.

>> **Fade In:** This slider gradually raises audio level from silence.

>> **Fade Out:** This slider gradually lowers the audio level to silence.

>> **Completely Disable Audio from Video Clip:** Click the Audio Mute button on the clip's thumbnail.

FIGURE 10-10:
The Audio control panel.

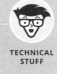

TECHNICAL STUFF

MAKE SURE YOU HAVE ENOUGH FRAMES

For the dissolve to work, you must have enough frames at the end of the first clip as well as at the start of the second one; otherwise, there's nothing to dissolve. If you plan to add dissolves, be sure the clip has the necessary frames. Also, the length of the dissolve cannot exceed the duration of the shortest clip. So, if your first clip has an extra minute of footage that you trimmed in the Storyboard, but the second clip only has ten extra frames, then that's the longest you can make the dissolve.

Using a second video display

You can use a second video monitor with GoPro Studio Edit. If you have one connected to your computer, the program recognizes it. Control this function through the Global Settings panel of the Edit pane (see Figure 10–11).

GoPro Studio Edit makes it easy to edit 3D video, especially when it comes to including a second monitor. You can still view your normal 2D files, but many of the options are for monitoring a 3D movie.

Following are brief descriptions of the options:

>> **None:** The default setting means you aren't using a second monitor.

>> **Left Eye:** This option shows the left-eye side of a 3D clip.

 When you're working with 2D clips, always choose the Left Eye option for playback on a second monitor. If you don't have a secondary monitor, choose None.

>> **Right Eye:** This option shows only the right-eye side of a 3D clip.

>> **Anaglyph:** There are several Anaglyph settings:

 - *Red/Cyan* shows the left and right eye tinted for viewing with red and cyan 3D glasses.

 - *Red/Cyan/BW* shows the left and right eye in black-and-white and tinted for viewing with red/cyan 3D glasses.

 - *Red/Cyan/Optimized* shows the left and right eye tinted for optimal viewing with red/cyan 3D glasses.

 - *Amber/Blue* shows the left and right eye tinted for viewing with amber/blue 3D glasses.

 - *Amber/Blue/BW* shows the left and right eye in black-and-white and tinted for viewing with amber/blue 3D glasses.

 - *Green/Magenta* shows the left and right eye tinted for viewing with green/magenta 3D glasses.

 - *Green/Magenta/BW* shows the left and right eye in black-and-white and tinted for viewing with green/magenta 3D glasses.

FIGURE 10-11:
The Global
Settings panel.

>> **Line Interleaved:** This option shows the left and right eye by alternating between horizontal lines and is used for certain polarized, passive 3D displays and polarized glasses.

>> **Side-by-Side:** This option, for 3D monitors, shows side-by-side 3D mode on a second monitor.

>> **Over-Under:** This option, used on 3D monitors, stacks the left and right eye and scales them vertically into one frame.

IN THIS CHAPTER

» **Creating a project**

» **Importing media**

» **Assembling the clips**

» **Getting audio levels right**

» **Using titles**

Chapter **11**

Editing with GoPro Studio Edit

Have you ever wondered why your favorite movies ended up being your favorites? Maybe you liked the subject matter or an actor, but often it's because the movie was tightly structured and nicely paced.

Regardless of how well a movie is planned and shot, success comes from the editing process. Whether it's a studio blockbuster, a quaint indie film, or a student project, a well-edited movie compels viewers to escape into the world created onscreen. Conversely, a carelessly arranged film evokes negative emotions. Side effects may include drowsiness, indifference, and nausea.

Making compelling movies sounds like a monumental task, but it's entirely possible to succeed when you adhere to the fundamentals. This chapter covers the basics of editing a movie in GoPro Studio Edit.

Creating Your Movie Project

Gathering all the assets for your movie can mean anything from putting the video, photos, and music in a folder ahead of time to downloading the day's shoot into GoPro Studio Edit. First, though, you must create and save a new project. Next,

you transfer your footage from the camera to your computer. Then it's time to bring the footage into GoPro Studio Edit.

Starting a new project

To create a new project, follow these steps:

1. **Launch GoPro Studio Edit.**

 If you're using the program for the first time, a tutorial pops up, offering some basic information on how to get files into the program. You can follow it if you want, but importing is simple, so feel free to click the Skip Tutorial button.

 When you start GoPro, you can get right to work because it creates a project by default.

2. **Choose File⇨New Project.**

 A new, blank project opens (see Figure 11-1).

3. **Choose File⇨Save Project to save the project.**

 Alternatively, press ⌘+S (Mac) or Ctrl+S (Windows).

4. **Navigate to your desired save folder.**

5. **Type a name for your project in the Filename text box.**

6. **Click the Save button.**

 The project is saved with the .gcs file extension.

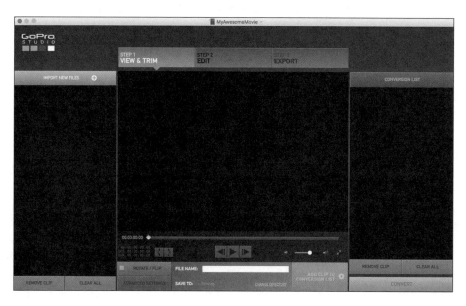

FIGURE 11-1:
A new project.

Importing video files

After you create and name the project, you can fill it with content. To import a video file, follow these steps:

1. **Click the Import New Files button on the left side of the project window (refer to Figure 11-1).**

2. **Navigate to the folder that contains the files you want to import.**

3. **Select the desired file, and click Open.**

 The file loads in the Import Bin.

 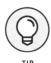

 You can import an entire folder of clips at the same time by navigating to where it resides on your computer and dragging the folder from a window to the Import Bin.

Importing and converting GoPro media

If you want to edit footage from your GoPro camera, you need to convert it to the CineForm *codec* (a program that compresses and decompresses files) before you can edit it into GoPro Studio Edit. That's because GoPro files are so compressed, converting them to CineForm is the only way to get them to play without lagging or dropping frame.

To import and convert GoPro footage for use in GoPro Studio Edit, follow these steps:

1. **Click the Import & Convert work area selection button in GoPro Studio Edit.**

2. **Click the Import New Files button in the top-left corner of the project window (refer to Figure 11-1).**

 The footage loads in the Import Bin.

3. **Click the Add Clip to Conversion List button in the bottom-right corner of the player window.**

4. **Click the Convert button (Convert All on a PC) in the bottom-right corner of the project window.**

 Conversion takes a few moments, depending on the length of the file and what you have under the hood of your computer. When conversion is complete, the file appears in the Conversion List pane (see Figure 11-2).

FIGURE 11-2:
Converted files
show up in the
Conversion
List.

Adjusting fish-eye distortion

Capturing footage with the GoPro's ultra-wide-lens may have charm, but (as with eating chocolate cake or watching television) moderation is important. The ultra-wide distortion produced by the lens can be interesting (see Figure 11-3), but a little less distortion sometimes makes it look better.

Here's how to make the fish-eye effect less extreme after you import footage into GoPro Studio Edit:

1. **Select the clip in the Conversion List pane (refer to Figure 11-3).**

2. **Click the Advanced Settings button in the bottom-left corner of the player window.**

3. **In the Advanced Settings dialog box, select Remove Fisheye.**

4. **Click OK.**

 After you convert the clip, the image has less distortion (see Figure 11-4).

Viewing file information

When you import files, they appear as thumbnails in the Import Bin on the left side of the project window. Each thumbnail also contains some helpful file details (see Figure 11-5).

FIGURE 11-3:
Fish-eye
distortion.

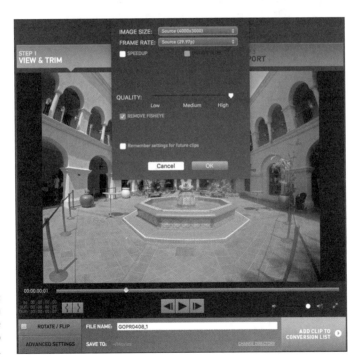

FIGURE 11-4:
You can
easily make
adjustments to
limit distortion.

These details include

>> **Filename:** You can change the name when you convert the file, if that's how you set your preferences (see Chapter 10).

>> **Image size:** Knowing the resolution comes in handy when you shoot in both high definition (HD) and 4K.

>> **Frame rate:** The frame rate of the clip is helpful when you have multiple clips with different settings.

>> **2D or 3D:** This item is self-explanatory.

>> **Video or Time-Lapse icon:** This icon is informative when you shoot the same scene both ways.

>> **Duration:** It's always nice to know the running time of a clip.

Viewing clips

You can select files in the Import Bin by clicking them. Press the up- and down-arrow keys on your keyboard to cycle through clips, or drag the playhead on the playback slider. You can play a clip by clicking it or by highlighting it and then clicking the Play button. Click the Step Forward and Step Backwards buttons to step through a clip one frame at a time.

REMEMBER

When you're previewing your files, don't be surprised if you see choppy video. Choppy video is normal because the files are not yet converted to the CineForm codec. Depending on camera settings and the computer you're using to edit the movie, the effect will vary. But this is only for viewing; you cannot edit the clip until you convert it. You can, however, set in and out points so you only convert the parts of the clip you want to use.

Deleting clips

More than likely, you won't want to use every clip you import. To remove a clip, select it and then click the Remove Clip button in the bottom-left corner of the Import Bin (refer to Figure 11-1), or select the clip and then press the Delete key on your keyboard.

To remove all clips at the same time, click the Clear All button in the bottom-right corner of the Import Bin.

Putting the Pieces Together in the Edit Pane

Video editing is like assembling a jigsaw puzzle; there are lots of pieces, and it's up to you to make them fit. But movie editing requires far more creativity. If you don't have the right piece, you have to go out and shoot it, come back to the project, and add it in the proper place.

You view, arrange, rearrange, and enhance your clips in the Edit pane of the player window. When you first click this pane, you're given the option to use a blank template or an existing GoPro template for your project. For now, begin by using a blank template. See Chapter 10 for more about templates.

Setting in and out points

To keep your audience interested in your movie, you need to show them the prime parts of each clip, so it's important to make sure that you remove the excess frames by setting in and out points. There's no sense in trying to convert a five-minute clip when all you need is 30 seconds of it for your movie.

Setting in and out points is also helpful in reducing the size of the converted file, and it eliminates any unwanted portions of the initial recording from being

included in the converted file. It's like trimming the fat from your chicken cutlets, but you won't need to wash your hands when you're done.

GoPro Studio Edit offers a variety of ways to isolate the desired part of the clip:

>> Set in and out points with a menu command. You can do this only on a Mac (see Chapter 10).

>> Drag points on the playback slider (see Figure 11-6).

>> Use the Split Clip tool. It looks like a razor blade and divides the section where you place the playhead.

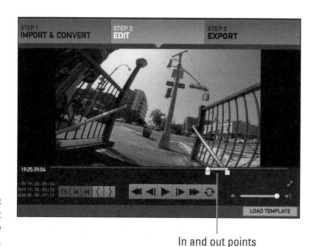

FIGURE 11-6: In and out points on the playback slider.

In and out points

Here's how to set in and out points:

1. **Select the clip in the Import Bin.**

2. **Move the playhead on the playback slider to the desired start point of the clip, and click the Mark In button to cut everything before that point.**

3. **Move the playhead on the playback slider to the desired endpoint of the clip, and click the Mark Out button to cut everything after that point.**

4. **Find other cuts on the same clip.**

 After you click the Add Clip to Conversion List button, you can grab other sections from the original clip by resetting the in and out points and clicking the Add Clip to Conversion List button. This adds it to the Conversion List bin.

This comes in handy when you have a long continuous clip with different elements you want for your movie.

5. **Repeat Steps 1–4 to set more in and out points.**

Dragging clips to the Storyboard

After importing your clips, setting in and out points, and converting to the Cine-Form codec, you can drag them from the Import Bin to the Storyboard. The clips play in order from left to right, so be sure you drag them to the proper place.

Assembling Clips in the Storyboard

After gathering your clips, and setting the in and out points, it's time to arrange them on the Storyboard. Located below the player window, this is the place where you decide the order the clips play, thus combining multiple clips into a single video. The Storyboard consists of one video track, two audio tracks, and two title tracks (see Figure 11-7).

FIGURE 11-7:
Storyboard shows video thumbnails and space for audio and title tracks.

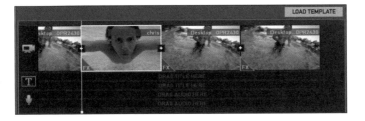

Populating the Storyboard is as simple as dragging clips from the Media Bin (which occupies the same place as the Import Bin when you're in the Edit pane) into the Storyboard. Although you can drag clips around to change their order, it's more efficient to build the movie in sequential order when the clips are in the Storyboard. You can always modify the order of clips later.

REMEMBER

It's a good idea to save your work often, especially after making a change or adding some interesting element. The program has an autosave function, adjustable to intervals of 2–30 seconds. You can also turn it off, but that means you will need to save manually. Choose GoPro Studio ⇨ Preferences.

Adding clips

Here's how to add a clip to the Storyboard:

1. **Find the desired clip in the Media Bin.**

2. **Drag it to the Storyboard.**

 As you drag, a green vertical line indicates the spot where the clip will be inserted.

3. **Release the mouse button to drop the clip.**

4. **Repeat Steps 1–3 to add more clips.**

5. **Save the project by choosing File ⇨ Save.**

Clips use the same thumbnail in the Media Bin and the Storyboard, but clip information changes slightly in the Storyboard.

A yellow border around the thumbnail indicates a selected clip (refer to Figure 11-7). Other information includes

» **Filename:** The filename is based on how you set preferences, mentioned in Chapter 10.

» **Delete a clip:** Poof! It's gone. By dragging this triangle on the lower left of the thumbnail off the top, as seen in Figure 11-8, you remove all applied effects such as color, framing, and exposure.

» **Mute button:** Click this button to toggle audio for the selected clip.

Cropping images

The Framing controls, found in the Video Playback settings, allow you to change the composition of your clips. This feature comes in handy when you want to isolate a portion of the scene or crop a distracting element. Depending on the amount of area you crop and the resolution of the source footage, you will lose some detail. If you shot the footage in 4K, however, you can crop a good portion of the image and still have more than enough resolution when saving the file in HD.

Just select the clip you want to alter on the Storyboard, go to the Video Playback settings area, and then click the down arrow next to Framing to display the Framing controls (see Figure 11-9).

Special effects deletion indicator Video Playback settings area

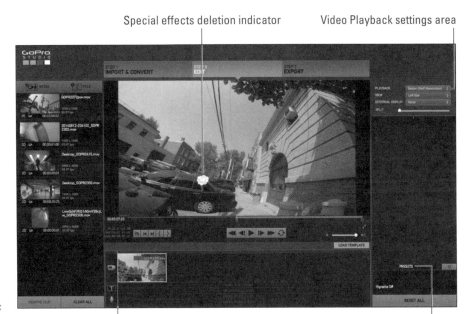

FIGURE 11-8:
Deleting
special effects.

Storyboard time indicator Presets

FIGURE 11-9:
The Framing
controls allow
you to adjust
and position
an image to
your liking.

Here's what each Framing control does:

>> **Zoom:** Use this slider to make the image larger or smaller.

>> **Horizontal:** Use this slider to move the image left or right. This feature works best with a cropped image so that the frame remains filled. An uncropped image shows black at either end.

>> **Vertical:** Use this slider to move the image up or down. This feature works best with a cropped image so that the frame remains filled. An uncropped image shows black at the top or bottom.

>> **Rotation:** Use this slider to rotate the clip. A cropped image maintains a full frame.

>> **H.Zoom:** When you're mixing 4x3 and 16x9 video sources, use this slider to adjust the horizontal scaling of the image. 4x3 looks like the aspect ratio of your old television set; 16x9 resembles the current wide screen.

>> **H.Dynamic:** Use this slider to adjust the horizontal stretch point of the image. This control, which is best used in tandem with the H.Zoom control, helps preserve the normal appearance of people who have been stretched by 4x3-to-16x9 conversion.

>> **Keyframes:** These controls allow you to create different frame sizes in the same clip so you can zoom, pan, and rotate while the clip is playing.

>> **Flip:** Select the Horizontal or Vertical check box to enable horizontal or vertical flipping of the image. Select both of these options if you shot your scene upside-down and want to correct it.

Splitting clips

Sometimes, you want to split a large clip and insert a new clip between its parts. Splitting a clip is as easy as cutting a piece of pie. Just follow these steps:

1. **Select the clip you want to split.**

 Move the playhead or the Storyboard time indicator (depending if you're working from the player or Storyboard, respectively) to the location where you want to insert the new clip.

2. **Click the Split button to split the clip.**

 If you position the playhead on the first frame of a clip, clicking the Split button cuts the clip in half.

TIP

3. **Drag a new clip between the two split clips.**

Fine-tuning clips

You can fine-tune clips in several ways:

» **Rearrange clips.** To rearrange the order of clips, drag them in the Storyboard. A green line appears as you drag a clip, indicating a new location for the clip.

» **Delete a clip.** Select it on the Storyboard and drag it up and get it a poof! The little cloud lets you know it disappeared (refer to Figure 11-8). Or just select it and press the Delete key.

» **Trim a clip.** When you're fine-tuning your edit, you may want to shave a few seconds off a clip to make the movie smoother. Just reset the in and out points (refer to "Setting in and out points" earlier in this chapter), and you're good to go.

Adjusting white balance

The White Balance controls let you alter the color of the scene to either correct or enhance the way you remembered the scene. Although GoPro captures color fairly accurately, sometimes you need to enhance the scene, and this feature does the trick. Just click the little triangle next to the White Balance choice on the right side of the window. The feature consists of a couple sliders, an eyedropper, and key-frame adjustments. Click the movie clip you want to enhance in the Storyboard, and make your adjustments.

You can change the color by doing one of the following:

» **Temperature slider:** Move the slider to adjust the color temperature of the clip, ranging from cool to warm. You can also adjust temperature using the step controls just to the right of the slider.

» **Tint slider:** Move the slider to adjust the tint, ranging from cool to warm. You can also adjust tint using the step controls just to the right of the slider.

» **Eye Dropper:** When you use the eyedropper to click on something white (or something that's supposed to be white) in the frame, it adjusts the overall color. So, if the area you click on was a little blue, the correction will neutralize the blue and warm up the image.

» **Keyframes:** You can change color as the clip plays by setting keyframes at various points. Move the playhead to a desired area, and click the + button. Change the White Balance, or more appropriately, the color in the image. It will play until you set another keyframe and make another change. Every time you repeat this, it will change the tone at that point in the clip.

Adjusting tones with the Image feature

You can make tonal adjustments to your movie clip to make it look just right. Just click the little triangle next to the Image choice on the right side of the window. The feature consists of several sliders and keyframe adjustments. Click the movie clip you want to enhance in the Storyboard, and make your adjustments.

Here's what the controls do:

>> **Exposure:** Basically, it allows you to make the movie clip lighter or darker.

>> **Contrast:** Adds or decreases image contrast.

>> **Saturation:** Enhances color in the image, or can take it away. This is a cool effect for stylizing your movie.

>> **Sharpness:** Adds, or takes away, sharpness in the image.

>> **Keyframes:** You can make the color change to your specifications in a movie clip by setting keyframes at various points. Each time you set a keyframe, it makes a change to the color (in this case) from that point on (or until you set another keyframe). Move the playhead to a desired area, and click the + button. Make another tonal adjustment, and it will play until you set another keyframe and make another change. Every time you repeat this, it will change the tone at that point in the clip.

TECHNICAL STUFF

APPLYING THE "KEN BURNS" EFFECT

You can add motion to an otherwise-static video by using the *Ken Burns effect, named* after the award-winning creator of such films as *The Civil War, Baseball,* and *Jazz.* Burns mastered the technique of making still photos appear to move onscreen by zooming, panning, and rotating them.

Here's how you can apply this effect:

1. **Select a clip in the Storyboard.**

2. **Display the Framing controls (refer to Figure 11-9).**

3. **Place the playhead on the part of the clip you want to change.**

4. **Click the + button to add a framing keyframe to the clip.**

5. **Make the desired changes.**

 Use the Zoom slider to make the clip larger, for example, or you can change any of the other settings.

6. **Repeat Steps 1–5 for all clips you want to change.**

7. **Save the project.**

A few tips won't hurt:

- **Pace the movement.** Never zoom in or out of a scene too quickly or too slowly.

- **Make sure that the movement has a purpose.** Don't make an image larger haphazardly; do it intentionally. Let the zoom or the pan show viewers what they should be looking at.

- **Pan properly.** A *pan* is a camera movement from left to right. If you pan video that you've already shot, you get a black area that gets larger as you move, as in the top figure below. Instead, crop the image so that you have enough image real estate to keep the frame full, as in the bottom figure below.

- **Crop the image.** If you rotate the image, be sure to crop it enough so you don't show the black on the edge or corners.

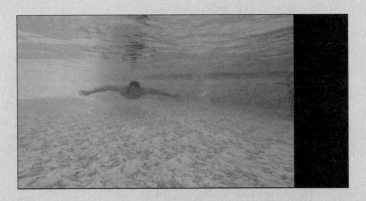

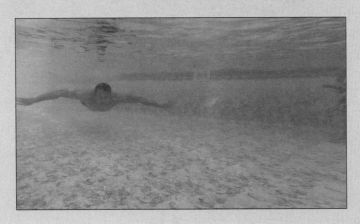

Working with presets

GoPro Studio Edit lets you stylize your video with a series of preset effects, found on the bottom-right side of the window. Using these presets is quick and easy, and can help your movie make a statement. All you must do is select a clip on the Storyboard and then click an effect. If you don't like it, click the Reset All button, on the bottom right, or click and drag the FX triangle on the clip to make it go away.

Using existing presets

You can use the following presets:

>> **None:** Restores all default settings.

>> **Protune:** Makes a flat clip look punchier by increasing saturation and contrast. (For more on Protune, see Chapter 4.)

>> **1970s:** Applies a warm color filter that simulates film shot in the '70s (see Figure 11-10).

FIGURE 11-10: This sunflower picture takes on a retro look with the 1970s filter applied to it.

>> **4X3 Center Crop:** Zooms in on a clip shot at a 4:3 aspect ratio while cropping the top and bottom portions of the image.

>> **4X3 to Wide:** Applies a combination of framing adjustments to transform a clip shot in 4:3 aspect ratio to a 16:9 image.

- **»** **Candy Color:** Applies a highly saturated color effect to the clip.

- **»** **Day for Night:** Makes a scene shot during the day look as though it was shot at night.

- **»** **Hot Day:** Creates a warm color effect that simulates being close to the sun.

- **»** **Night Vision:** Makes the video look as though it was shot through night-vision goggles by applying a green tint (see Figure 11-11).

- **»** **Sepia:** Applies a brownish, unsaturated filter to create a sepia effect (See Figure 11-12).

- **»** **Vignette Large:** Blurs the edges of the frame, as in an old photograph.

- **»** **Vignette Medium:** Provides a subtler vignette effect.

- **»** **Vignette Off:** Turns vignette off on the image.

FIGURE 11-11:
This cool effect makes your movie look like *The Blair Witch Project.*

Making your own presets

On the off chance that you're not crazy about GoPro Studio Edit's presets (see the preceding section), you can make your own. The process is simple. Just follow these steps:

1. **Select a clip in the Storyboard.**

2. **Use the White Balance, Image, and Framing controls to create the look you want for the video.**

FIGURE 11-12:
The Sepia filter
provides a
timeless look.

3. **Click the little gear icon next to Preset Title to open the Manage Presets window.**

4. **Click the + button, type a new preset name, and check the setting you want to save.**

5. **Click OK.**

Adding slow motion and reverse

Sometimes there's nothing like slow motion for getting your point across, especially if you want to emphasize a situation that normally plays out too fast. Maybe you performed a jump on a BMX bike and it plays too fast to appreciate. Other times, you want to render the clip in reverse to capture a world gone backwards. A great example is a clip of someone jumping out of the water and onto the diving board. Whatever you choose, GoPro Studio Edit makes it easy to accomplish. Just click on the little triangle next to the Video choice on the right side of the window. The feature consists of a couple sliders that control speed and fade. There's also a check box for reverse.

Here's what the controls do:

» **Speed:** Adjusts the duration of the clip from 1 percent to 1,000 percent. That allows you to slow down the clip, as well as speed it up.

» **Fade In:** Fades the clip from black. You can choose the duration using the slider or text entry box on the right side of the slider.

» **Fade Out:** Fades the clip to black.

Managing Audio Matters

GoPro Studio Edit uses Storyboard editing as opposed to a timeline, so editing a movie is a matter of assembling trimmed clips to play in order. The program offers some flexibility when it comes to audio, adding up to two additional tracks for sound effects, background music, or voiceovers.

When you use a GoPro edit template, the soundtrack uses one of the tracks, so you're left with only one.

Because audio plays such a big part in a movie, it's important to treat it with some TLC, fine-tuning the levels of your clips, laying down the right music for the soundtrack, and maybe adding a voiceover.

REMEMBER

GoPro Studio Edit currently supports the following audio formats: MP3, M4A, WAV, and AIFF.

Adding an audio track

Nothing gives your footage a real movie feel like adding a soundtrack, and GoPro Studio Edit makes that easy to do. You can also include a voiceover. The only limitation is that you can add only two tracks.

Audio is like video in that you must import it into GoPro Studio Edit. Follow these steps:

1. **Click the Add Media button at the top of the Media Bin.**

2. **In the resulting dialog box, browse to your audio file, select it, and click Open.**

 A thumbnail of a microphone on a music staff appears in the bin.

3. **Drag the file to the Storyboard.**

 As you drag, a green box indicates the spot where the file will be inserted, making it easier for you to line up the audio file with other portions of your Storyboard.

 Dragging an audio file on top of an existing video clip causes the audio file to start at the same time as that video clip.

4. **Revise the file if necessary.**

 After placing an audio file, you can rearrange it by dragging it to a new location. You can also change its duration by dragging its edges.

Correcting an audio track

Because you capture audio under a variety of circumstances, sometimes audio levels are inconsistent. GoPro Studio Edit makes problems easy to fix. The Audio Setting features include a few controls for adjusting audio levels and fading sound in and out.

>> **Level dB:** Allows you to change the volume level of the clip during playback. You can increase the level for soft clips and decrease it for loud or distorted clips.

>> **Fade In:** Gradually raises the audio level from silence.

>> **Fade Out:** Gradually lowers the audio level to silence.

Working with Titles

Great video, clear audio, nice layout, and a rocking soundtrack . . . check, check, check, and check. You need just one more thing to make a great movie: a title. You can use two tracks for titles, which can be superimposed over clips or appear directly above them on the Storyboard. And don't forget the closing credits to give a shout-out to everyone that helped with the movie.

To add a title to your movie, follow these steps:

1. **Click the Add Title button at the top of the Media Bin in the Edit Pane.**

 A title thumbnail appears in the Media Bin.

2. **Drag the thumbnail to a title track in the Storyboard.**

 As you drag, a green box indicates the spot where the title will be inserted, which makes it easier for you to line up the title with other portions of your Storyboard.

3. **Double-click the thumbnail.**

 A dialog box appears on the right side of the project window.

4. **Type the title.**

5. **Adjust the font, size, and other details.**

Chapter **12**

Presenting Your Movie

W hether your movie consists of a few clips from the GoPro you mounted on a lawn mower, an elaborate edit of your backyard-pool Olympics, or a short movie of your dramatic friends, it's time to kick it out of GoPro Studio Edit and get it out into the world.

Will you upload it to a video-sharing website? Send it out as a live stream? Go old-school and burn it to a Blu-ray DVD? You have many possibilities to consider.

Maybe you're not even looking to make an exclusively GoPro movie; instead, you want to incorporate some GoPro footage into a bigger movie project. That's no problem, because the process of using the program, and ultimately exporting your edit, remains the same.

After that, it's a matter of showing it to the world.

Converting Your Movie Files for Export

Although GoPro Studio Edit (see Chapter 11) provides some options for exporting your movie, it offers limited choices. Although many may work for your needs, you can export your movie from GoPro Studio Edit and use a conversion program to create a file that meets your specific needs.

Conversion programs do more than make video files viewable in another file format: They also allow you to customize resolution, quality settings, audio settings, bit rate, and other settings. Convert your uncompressed file to an MP4 file, for example, or transform an AVI file to an FLV file for embedding in a web page. Whatever you choose to do, the software does the work.

MPEG Streamclip

If you're looking to convert your movie to another format with lots of options and don't feel like spending a lot of money, check out MPEG Streamclip. It's powerful, it's free, and it handles multiple formats and sizes. It also is available for both Macintosh and Windows.

Because it's designed exclusively for exporting and encoding files in a variety of formats, MPEG Streamclip gets the job done quickly. It supports the following formats:

AC3 AVI AVR AIFF DAT DV M1A M1V M2P M2T M2V MMV MOD MOV MP2 MP4 MPA MPEG MPV PS REC TS VID VOB VRO

You can download it at www.squared5.com.

Other conversion programs

If you need a little more horsepower for converting your files, here are a couple of reasonably priced programs.

>> **AVS Video Converter (Windows only):** This program handles an extensive list of video file types (including Blu-ray) and provides a wide array of tools and effects. At this writing, a subscription to the software ranges from $39 to $59. You can download a trial version at www.avs4you.com.

>> **Xilisoft Video Converter Ultimate (Windows and Macintosh):** This conversion program handles most file types and supports a variety of mobile devices, music players, and gaming platforms. The program costs around $50. You can download a trial version at www.xilisoft.com.

Getting That Movie Out There

When you've put your movie together, applied every possible effect that GoPro Studio Edit has to offer, performed any necessary conversions (see the preceding section), and saved it, you're ready to export it.

REMEMBER

After you export a movie, you no longer need editing software to play it, because the file becomes self-playing. You can watch it on any computer, mobile device, and even your big screen television.

Choosing export options

Sometimes, you have a definitive plan for the movie, so it's simple to pick the export settings you need for it. At other times, the process is a little more complicated. You may have used a low-quality setting, only to find out that what looks good on a smartphone looks bad on a video-sharing website and atrocious on a big-screen television set. To make the right choices about everything from resolution to playback bit rate, you need to have informed opinions.

You have two ways to export and share: You can export your movie, either by clicking the tab of the Export work area, or by using the pull-down menu. On a Mac, go to Share⇨Export Movie. You'll see the choices for sharing, as shown in Figure 12-1. On a PC, go to File⇨Export movie.

FIGURE 12-1:
The Export dialog with the pull-down menu on a Mac.

GoPro Studio Edit provides many ways to export your files. Following are the program's export options:

» **Mobile:** Sizes your video appropriately for viewing on smartphones and other mobile devices.

» **HD 720p:** Exports a high-definition (HD) movie file.

» **HD 1080p:** Exports a full HD movie.

» **Archive:** Exports the file with the CineForm codec.

» **Vimeo:** Exports the file in full HD for sharing on the Vimeo website.

» **YouTube:** Exports the file in resolutions up to full HD for sharing on YouTube.

» **Custom:** Lets you create your own versions of some of the preceding options.

VIDEO SETTINGS DEFINED

Here are some of the video settings you'll use when exporting video:

- **Bit rate:** By definition it refers to the number of bits displayed over a period of time, usually one second. But you will know it as a number that provides the most video quality the higher it goes. The problem is that as bit rate climbs, so does the file size, hence the reason there are so many for you to choose.

- **H264:** One of the most common video compression formats, it saves the video file in a smaller file with very little loss of quality.

- **CineForm:** The native file format for working with GoPro files.

- **Source Frame Rate:** The frames per second the video was captured in.

- **Exported Frame Rate:** Regardless of how many frames per second you captured the footage in, GoPro Studio Edit will export most files at 29.97 frames per second, but depending on the preset, you can get 59.94 frames per second.

- **Resolution:** It's the number of pixels that you captured the movie file in. If you captured in HD, it would have a resolution of 1920x1080. 4K video is double that, while NTSC covers 720x480.

The following sections take a deeper look at GoPro Studio Edit's export options to help you find the one that's right for you.

Mobile

This option is the perfect choice for exporting a movie that you want to play smoothly on a mobile phone — the kind of thing you want to send via email or show as a work in progress. You never want this version of a file to be the only export of a movie unless you don't really care about it. Here are the settings:

>> **Resolution:** No matter what resolution you used to shoot the movie, this setting changes it to 640x360p (pixels).

>> **Compression:** This setting applies the H.264 compression format.

>> **Bit Rate:** This setting is 1.5MB per second — a very low rate, so both video and audio quality will suffer. But because the file is intended to be viewed only on a mobile phone, the quality will suffice.

>> **Exported Frame Rate:** The file will have a maximum frame rate of 29.97 frames per second (fps).

HD 720p

This option creates a smaller HD file that provides the perfect compromise between quality and file size. Think of it as HD light — something that plays online with excellent quality. Here are the settings:

>> **Resolution:** No matter what resolution you used to shoot the movie, this setting changes it to 1280x720p.

>> **Compression:** This setting applies the H.264 compression format.

>> **Bit Rate:** This setting varies with the frame rate at which you captured the footage. Footage captured at a frame rate higher than 29.97 fps gets a healthy bit rate of 15MB per second; anything with a lower frame rate has a bit rate of 7MB per second.

>> **Exported Frame Rate:** This setting varies based on native resolution but goes no higher than 59.94 fps.

HD 1080p

This option is the default for export and provides the greatest quality. It's perfect for playing your movie on a big screen or burning it to DVD. If you want to upload your movie to a video–sharing site or send it to a friend to watch on a smartphone, however, it's a bit much. Here are the settings:

>> **Resolution:** No matter what resolution you used to shoot the movie, this setting changes it to 1920x1080p.

>> **Resolution:** No matter what resolution you used to shoot the movie, this setting changes it to 1920x1080p. Be careful if your original GoPro capture setting is lower; otherwise the result is a net loss of resolution.

>> **Compression:** This setting applies the H.264 compression format.

>> **Bit Rate:** This setting produces an optimum-quality bit rate of 15MB per second, which creates a great experience for the viewer as well as an enormous file. YouTube has a handy "grid" of settings for bit and frame rates at `https://support.google.com/youtube/answer/1722171?hl=en`.

Where to Go from Here

Now you're ready for action. Give the pages a quick flip and scan a section or two that you know you'll need later. Please remember, this is *your* book — your

weapon against the computer nerds who've inflicted this whole complicated computer concept on you. Please circle any paragraphs you find useful, highlight key concepts, add your own sticky notes, and doodle in the margins next to the complicated stuff.

REMEMBER

The more you mark up your book, the easier it will be for you to find all the good stuff again.

Archive

This export option retains the program's original codec by creating a CineForm file with a user-selectable quality level. This option is your best choice if you want to export a high-quality master file for broadcast or archival purposes. Here are the settings:

>> **Resolution:** This setting preserves the resolution at which you shot the movie.

>> **Compression:** This setting applies the CineForm codec. On a Windows PC, you can choose a CineForm AVI or MOV format.

>> **Bit Rate:** This setting doesn't apply a numerical bit rate; it allows you to choose Low, Medium, or High.

>> **Exported Frame Rate:** This setting applies the native frame rate of each clip.

Vimeo

Choose this option for movies that you want to export to the Vimeo video-sharing site. Here are the settings:

>> **Resolution:** This setting applies native resolution up to 1080p. Files with resolution higher than 1080p are center-cropped and scaled to 1080p.

>> **Compression:** This setting applies the H.264 compression format.

>> **Bit Rate:** This setting varies with resolution, applying a bit rate of 15MB per second to files with resolution of 1080p or higher. For clips with resolution below 1080p, the setting applies a lower bit rate of 7MB per second.

>> **Exported Frame Rate:** This setting is native to the frame rate of each clip but never higher than 29.97 fps.

YouTube

Choose this option for movies that you want to export to the YouTube video-sharing site. Here are the settings:

>> **Resolution:** This setting applies native resolution up to 1080p. Files with resolution higher than 1080p are center-cropped and scaled to 1080p.

>> **Compression:** This setting applies the H.264 compression format.

>> **Bit Rate:** This setting varies with resolution, applying a bit rate of 8MB per second for files with resolution of 1080p files or higher. For clips with resolution below 1080p, the setting applies a lower bit rate of 5MB per second.

>> **Exported Frame Rate:** This setting applies the native frame rate of each clip and supports rates of up to 59.94 fps.

Custom

If you don't find the other export settings to be to your liking, you can build your own, choosing the format, frame size, frame rate, and quality settings. The Custom dialog (see Figure 12-2) allows you to customize your movie for export as follows:

>> **Resolution:** You can select a resolution up to 1920x1080p.

>> **Compression:** Choose H.264 or CineForm compression.

>> **Bit Rate:** Use a slider to set a bit rate of 1MB to 50MB per second. CineForm uses a slider between low and high.

>> **Exported Frame Rate:** This setting applies the native frame rate of each clip and supports rates of up to 59.94 fps.

FIGURE 12-2:
Custom dialog
options.

Exporting your movie on a Mac

The Export pane of the player window is where you export your movie in the desired format and with the desired settings.

Exporting is quite simple. Follow these steps:

1. **Choose Share⇨ Export Movie or click the Export pane.**

 The dialog shown in Figure 12-3 appears.

FIGURE 12-3:
The Export dialog.

2. **Type a name for your file in the Export As text box.**

3. **Choose a preset from the Presets drop-down menu.**

4. **Click Export.**

 Within a few moments, a self-playing movie is ready.

Exporting your movie in Windows

Because the Mac and Windows version of GoPro Studio Edit differ somewhat, the process is slightly different when exporting your movie.

1. **Click Export or choose File ➪ Export.**

2. **Type a name for your file in the Export As text box.**

3. **Choose your preset.**

 On the lower right of the dialog, you find the Presets drop-down menu.

4. **Click Export.**

 Within a few moments (or many, depending on the file size), a self-playing movie is ready.

REMEMBER

After you export your movie file, be sure to watch it for quality control. Make sure that the file format and size you applied look as good as possible. If you don't like it, trash it and export another copy that meets your approval.

Sharing and Sharing Alike

Sharing movie files in the era of the hit television series *Mad Men* was very different than we do it today. Back then, would-be moviemakers made copies of their silent 8mm film reels to send to family, friends, and film competitions. That spirit remains alive today, except instead of a physical movie, you're sending a virtual one. It's also not going to just one person, but many — maybe even millions.

Here are some of the ways you can share your movie:

>> Upload it to video-sharing sites.

>> Share it on social media.

>> Share it on mobile devices.

>> Send it via email.

Movie files are big, and HD makes them bigger, so it's important to strike the right blend between file size and quality. Ideally, you compressed yours enough to upload on the Internet. Although each video-sharing site has different specifications, it's possible to upload a HD movie that's properly encoded.

Sharing your movie on Facebook

The world's largest social media site, with around 1 billion active users, provides a great forum for your video. How many people see your video, of course, depends in part on the size of your Friends list and how many of your friends can get other people to check out the movie. Facebook allows you to upload a video directly from your computer, or you can post a link to YouTube if your video is posted there.

REMEMBER

Be sure that you're using a recent web browser and have Adobe Flash loaded. Adobe Flash is necessary for the movie to play. If you don't have it, chances are you will be prompted to download it. If you already have it, then expect to be asked to update Flash periodically. Your movie should meet the following requirements:

>> The video is no larger than 1,024MB.

>> The video's length doesn't exceed 20 minutes.

>> The video is an MP4 movie file using H.264 compression and the AAC audio format.

>> You made the video yourself or have permission to share it.

Uploading a video to Facebook is relatively easy. Follow these steps:

1. **Navigate to the Facebook home page (www.facebook.com).**

 Make sure you have a Facebook account. If not, create one.

2. **Click the Add Photos/Video link at the top of the page (see Figure 12-4).**

FIGURE 12-4:
The Add
Photos/Video
link.

3. **Click the Add Video pane (see Figure 12-5), click Choose File, and navigate to the desired file.**

FIGURE 12-5:
The Add Video
pane.

4. **Add a description of the movie, if you want (see Figure 12-6).**

5. **Click Post, and grab a cup of coffee.**

6. **Share the movie.**

 Determine who gets to see it. You can share your movie with anyone on Facebook who can find it, your friends, or a group of your friends. Or just yourself.

FIGURE 12-6:
What you type
here is what
viewers
will see.

Sharing your movie on YouTube

YouTube records more than 4 billion video views per day, so your movie has the potential to be viewed by a lot of people — if they know it's available. If you're a little shy about reaching an audience, you can make your movies private and send would-be viewers an invitation to see it. The website supports a variety of file formats and allows some videos to be uploaded in full HD.

Here are a couple of YouTube requirements:

» Video length can't exceed 15 minutes unless you verify your account.

» You made the video yourself or have permission to share it.

Uploading a video to YouTube is relatively easy. Follow these steps:

1. **Navigate to the YouTube home page** (www.youtube.com).

2. **Sign in.**

 Enter your username and password, or your Google login, as shown in Figure 12-7.

FIGURE 12-7: When you attempt to upload a video, you will be prompted to sign in.

3. Click Upload at the top of the page.

After the upload screen, search for the video you want to share.

4. Select the video you want to upload.

5. Add details about the video while it's uploading.

Depending on file size, uploading can take an hour or more. Use this time to name the movie and provide the proper information (see Figure 12-8).

FIGURE 12-8:
The more information you add here, the easier it is for your movie to find an audience.

6. View your movie.

Also, keep an eye on the page views (see Figure 12-9) to see whether you'll have a viral favorite on your hands.

Sharing your movie on Vimeo

Vimeo (an anagram for *movie)* is an alternative to YouTube. Because it supports higher quality, it's a popular place for independent filmmakers to upload, share, and view movies. Another notable difference from YouTube is that all uploaded content must be original and noncommercial.

Vimeo is a much smaller community than YouTube: The site has 35 million registered users and attracts around 170 million unique visitors per month.

Vimeo provides several levels of access: While free to upload video, users are limited to 500MB. An inexpensive Vimeo Plus account allows users a greater weekly upload amount, as well the capability to limit advertisements before the video,

unlimited HD videos, and unlimited creation of channels, groups, and albums. Vimeo PRO provides the highest level of service and offers large storage, third-party video player support, and advanced analytics.

Uploading a video to Vimeo is simple. Follow these steps:

1. **Navigate to the Vimeo login page (`https://vimeo.com`).**

2. **Log in, using your Vimeo or Facebook login details.**

3. **Click the Upload a Video button.**

 The Upload dialog appears (see Figure 12-10). You can click it to navigate to the selected video file, or drag and drop it.

4. **Select the video you want to upload, and click the Upload Selected Videos button.**

 Depending on file size, uploading can take an hour or more.

5. **Name the movie and provide the proper description.**

6. **View your work.**

 You'll notice the sleeker presentation, as seen in Figure 12-11.

FIGURE 12-10:
The upload
dialog.

FIGURE 12-11:
The Vimeo
player occupies
a fair amount
of screen real
estate.

Finding the Best Archiving Solution

There's a great deal of uncertainty about the best way to save digital media files. Technology changes rapidly and is unstable at times. The problem of finding a stable solution is further compounded by imperfections in most of the storage methods at your disposal. This section presents some of the options.

Choosing a file format

The first step in saving your beloved files is choosing the right file format. Here are a few options:

- ➤ **MOV:** Apple created this file format for use in its QuickTime program. It's a versatile format that allows you to save files in both compressed and uncompressed form. Use it when you want a self-playing file that you can also edit in another program without a loss of quality. It's ideal for broadcast.

- ➤ **MP4:** Also created by Apple, this format lets you compress files securely and (depending on the level of compression) with little loss in quality. This format uses the H.264 codec. These files can play back on iOS devices. This format is a perfect blend of quality and size, and can be delivered via email and FTP for broadcast playback.

- ➤ **AVI:** Microsoft's AVI (Audio Video Interweave) format saves files with a variety of compression formats and in several sizes. It doesn't retain aspect-ratio information, however.

- ➤ **CineForm:** CineForm is GoPro's proprietary codec and the one used when you save an archive copy in GoPro Studio Edit. It supports 3D and has been used for many feature films.

Archiving on an external hard drive

External hard drives get faster and cheaper all the time, so they continue to be viable options for backing up your GoPro movies. With HD files occupying about five times the space of standard–definition (SD) files, however, the 2GB drive that you thought could never fill begins gasping for air. HD costs more to save, because the minutes of video per dollar ratio (breaking down capacity with file size) hasn't quite caught up with hard drive capacity. Of course, after you fill it you can move on to the next one.

Also, external hard drives have been known to fail from time to time, and they sometimes corrupt data, stop spinning, or burn out. You should always save important files on various drives and keep your fingers crossed.

Backing up to tape

You can back your files up to tape if you have a camcorder or HD recording deck that uses tape. Professional production houses also back up to tape.

The upside of tape is that your footage can be played back on a television set or computer. You can digitize it by playing it into the program while it's recording.

The downside of tape is that tape is being phased out. Fewer decks for playback will be available over time, so finding someone to digitize your tapes may be difficult.

Using media cards

Using media cards to store files, at least temporarily, has some merit. The prices of the cards are plunging, their capacity is rising, and their access time is increasing. That means you can play back an HD movie with no glitches.

Here are a few tips on using media cards:

>> **Save as storage.** The intention is not necessarily to play video directly from the card, just to save the video file. You load the card, drag the files on it, and then safely eject.

>> **Use a fast card.** If you plan to play video directly from the card, be sure to use a fast-enough card. If you're not sure which speed will work for you, see Chapter 3.

>> **Stick with common formats.** These days, common formats are Compact Flash (CF), Secure Digital (SD), and Memory Stick.

>> **Be ready to transfer.** Because technology changes so rapidly, consider saving your files on newer media from time to time to ward off the evils of dust interfering with transfer or problems with the firmware of the drive or reader.

>> **Keep the cards safe.** If media cards get wet, dusty, or stepped on, their content is lost.

Storing in the Cloud

You no longer have to worry about local media storage when you save in the Cloud. Media files are uploaded to large servers in a techno netherland.

Most Cloud sites offer free basic plans and use secure servers. Not all free plans are easy to use, however, making it hard to upload or find your files. Also, if your files are too big or you need to add space, you're either out of luck or have to pay a subscription fee to upgrade.

Longevity is also a concern. Although some Cloud services are full-fledged online businesses, others aren't as successful. Stay current on site activity, and be prepared to move your files at the first sign that the service is closing.

PROTECTING YOUR INTELLECTUAL PROPERTY

With modern video technology, the good news is you can easily share the movie with millions of potential viewers. That's also the bad news. Because your content can reach so many people some of them may use it without permission.

Here are a few ways to protect your video:

- **Use a watermark.** Sometimes a watermark is distracting, but it may deter content thieves by confirming that the content is yours.

- **Add a bug.** If you don't want to watermark your video, add a *bug* — a large icon in one corner of every frame. (You've probably seen bugs in programs on many television networks, such as ESPN.) Don't worry that the bug will affect sales or other legitimate use. Serious parties will ask you to send them a "clean" version.

- **Share cautiously.** Don't upload your video to just any place that will accept it. Instead, limit the number of sites to which you send movies, and keep a log of where and when you sent movies.

- **Search the web periodically for your movie.** Video pirates may be brazen but not always bright. You'd be surprised by how many users grab someone else's content and repost it under the original filename.

Following are a couple of credible Cloud services:

- ❯❯ **Dropbox:** This file-hosting service makes it easy to send files from one computer and access them on another by using a common folder on the Desktop. You drop files or folders into the Dropbox folder and send invitations to people, allowing them to access your material via an email link. Dropbox offers 2GB of storage space for free.

- ❯❯ **Hightail:** This reliable FTP service (formerly known as YouSendit) allows you to save and share large files. The free version provides 2GB of storage. A professional plan that costs $12.00 per month provides unlimited storage.

4

The Part of Tens

Use your GoPro in fun ways.

Find out how professionals use the GoPro camera.

Avoid the things that can go wrong.

Chapter **13**

Ten Fun Ways to Use Your GoPro

The GoPro brings out your fun side faster than a New York Jets jersey gets your green eyes to pop, if you have green eyes. Anyway, this little wonder lets you take a fresh perspective on the world. You can put it anywhere your heart desires and get some pretty cool stuff. This petite wonder has changed sports and adventure video, because it lets you capture scenes in places where cameras weren't always welcome.

In this chapter, you discover a fresh perspective for creating content, including putting the camera in places that were never "camera-friendly," like in the water or up in the air. You can even attach it to your dog, or goat if you want, and see the world from his point of view. The sky is the limit when finding fun places for your GoPro.

Attach It to Your Bike

Ambitious riders have long been mounting cameras on their handlebars to record compelling video sequences. The GoPro can do the job too, with more options and from a unique perspective. And don't worry about taking your hands off the

handlebars to start and stop the camera, when you can speak verbal commands into the optional Remo voice–activated remote control.

Consider the following possibilities:

>> **Helmet mount:** This mount allows you to attach the GoPro on your bicycle helmet. Wear the camera as you zip down bike paths or mountain trails, giving the viewer a truly authentic rider's-eye view.

On the downside, the GoPro will capture motion from both the bike and the rider.

>> **Pro Handlebar / Seatpost / Pole Mount:** This mount lowers the perspective and keeps the camera steady while providing the bike's point of view. You can swivel this versatile mount 360-degrees for unique perspectives. So, turn it around to get the rider's point of view, as shown in Figure 13-1. Its quick clip makes it easy to attach and remove. And don't worry about the bar size, as it supports different diameters.

>> **Time-Lapse video at night:** Point the camera at yourself and ride through a well-lit area, such as a busy downtown area at twilight. Keep the footage stable with an optional handheld gimbal or mounting on your Seeker backpack for super smooth footage.

FIGURE 13-1:
GoPro on a
roll bar mount.

Take GoPro in the Snow

The GoPro enables a new generation of family documentarians, extreme–sports aficionados, and ambitious filmmakers to cover winter sports and activities with relative ease and little worry about the equipment.

Here are some of the cool ways you can use your GoPro in the cold:

- **Ice skating:** Mount the camera to yourself, using one of the body mounts (headband, helmet, Chesty, and so on), and get a fresh view of a day at the rink.

- **Sledding:** Attach the GoPro to yourself or your sled to capture the sensation of flying down a snowy hill.

- **Snowboarding:** You wear your GoPro with the helmet mount or on your back with the Seeker backpack. It provides three mounting options while carrying your stuff at the same time.

- **Skiing:** Mount the camera on yourself or use the 3-way pole to produce your own exciting ski video. Other options include mounting your GoPro on the Seeker backpack or attaching it on your ski pole with the Pro Handlebar / Seatpost / Pole Mount.

- **Snow tubing:** The helmet or headband mounts work great for this purpose, letting you capture the rush of going down the mountain. Shoot the scenery, or turn the camera around to record your buddy's expression.

- **Put it on a RVC:** Some radio-controlled vehicles are powerful enough to trudge through the snow. For Figure 13-2, one of the adhesive mounts was attached to the vehicle, then the camera was slid into the mount. For stabilized footage, use the Karma Grip gimbal to create amazing footage.

- **Snowman time-lapse:** Mount the GoPro nearby and get to work on Frosty. You can mount the camera to a tree or use the tripod mount. Later, over hot chocolate, watch your hour-long effort in 45 seconds. You can also mount the GoPro on a warm day to capture the hours-long melting process in less than a minute. Use a portable power pack for longer durations.

FIGURE 13-2:
This snow
scene was
captured at
ground level.

Explore Underwater

Maybe you're not an accomplished oceanographer, but you still desire to be the Jacques Cousteau of your local swimming hole. If so, the GoPro is ready, willing, and able to capture your views of the underwater world.

Here are some cool ways to take underwater photos and videos:

>> **Swim with it.** Take the GoPro underwater, and mount it to your body with the Chesty body harness or hold it as you navigate the deep. You can use it while snorkeling, scuba diving, or simply taking a dip in a pool (see Figure 13-3).

>> **Use an extension pole underwater.** By attaching the camera to a pole like 3-way or the Handler and submerging it, you can get great underwater footage at a beach, pool, or lake.

>> **Mount it underwater.** Use an existing mount, or jerry-rig your own; then put it in a pool or a shallow lake.

WARNING

Just be careful that the GoPro doesn't get swept away and become a hazard to others. That's why it's a good idea to use the Floaty Backdoor so the camera can float if it breaks free.

>> **Shoot at the surface.** Catch a rider on a boogie board, your mom on her raft, or the players in a water-polo match. Attach GoPro to your arm or hand with the Strap to capture with ease.

FIGURE 13-3:
Capturing a
selfie under
a big wave at
La Jolla.

>> **Monitor it with your smartphone.** Because most GoPro cameras don't include a viewfinder, and you don't want to get your smartphone wet, you can monitor the footage from the sidelines (in other words, away from the water).

Make the Coolest Selfie

The selfie is quickly becoming one of the most prominent ways to take a portrait. Thanks to the wide-angle view of your GoPro, the camera lets you create some interesting moving or still selfies.

Here are a few pointers for getting the best results:

>> **Make the shot flattering.** More appropriately, keep it from becoming unflattering. The GoPro's wide-angle lens can distort your appearance, and holding it too low and close to your face can make your nose look like a weapon. Instead, hold it at just above eye level, perpendicular to the ground.

>> **Know yourself.** What's your good side? If you know it, make sure that you shoot it.

>> **Make sure that the light works.** Opt for soft directional light, as shown in Figure 13-4. Also, make sure that the background is not busy or too bright.

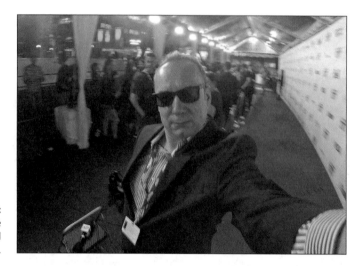

FIGURE 13-4:
A GoPro selfie taken on a red carpet.

>> **Mount the camera on an extension pole.** You can make a fun shot by extending the camera at an angle above you or your group with the GoPro 3-way or the Handler.

>> **Shoot on Burst.** Press the shutter once and get a bunch of shots. This works especially well with group selfies and can improve the chances that everyone has a flattering expression.

>> **Use your smartphone as a monitor.** Here's something a little different: Hold the GoPro and keep your smartphone in view so that you have some idea how the shot will turn out.

Walk through a Crowded Space

Capturing video of walking through a crowd isn't easy with a conventional camera. GoPro changes that situation, thanks to its small dimensions and wide view. You have lots of ways to move through a crowd with a GoPro attached to a headband or chest mount.

Here's how to use these mounts effectively:

>> **Head Strap plus Clip:** The GoPro is almost small enough that you can walk through a crowd with it unnoticed.

Try mounting the camera on your headband and looking behind you. This technique can provide some funny, compelling footage, especially when people get too close to you. You can monitor the scene by watching it on your smartphone.

>> **Chesty (chest harness):** Also known as the Chesty, this mount holds your GoPro at chest height, providing a slightly different perspective. (See Figure 13-5.)

>> **Wristband or Strap:** Both mounts let you grab shots to the side and shoot from the hip by holding the camera low and directly in your path. This technique helps you create some unique GoPro imagery.

FIGURE 13-5: Walking onto the field for the big game provides an interesting perspective.

Take It Out on an ATV

If offroading is your thing, the GoPro can help you capture some great footage from your All Terrain Vehicle. Don't worry about the mud, sweat, and tears; the camera thrives under these conditions and handles them all with dignity.

Check out the following options for using your GoPro on an all-terrain vehicle (ATV):

>> **Mount it on a roll bar.** GoPro makes a mount specifically for this point of view, the Large Tube mount. Mount to handlebar with the Pro Handlebar / Seatpost / Pole mount or use the 360-degree swivel QR base to rotate the camera for new perspectives.

- **>> Put it on the bumper.** This vantage point provides a rugged almost-ground-level view of the terrain, allowing the viewer to experience the excitement. You can also mount the Karma Grip gimbal to your vehicle for super smooth footage. See copy deck.

- **>> Place it on a road course.** If you're traveling a specific road course, put a GoPro at a strategic location to get a unique perspective. (Just be careful that you don't run over it.) Use a tripod or mount to a tree with Large Tube mount.

- **>> Use multiple cameras.** Mount a camera inside the vehicle to show the driver; then mount other cameras on the roll bar, bumper, and even on the course to capture multiple points of view. Control them all at the same time with Smart remote.

Wipe the lens after each take. There's nothing worse than having a great capture and finding goop on the lens.

Shoot the View from the Sky

If you like flying remote-control planes as much as you like making cool videos, you'll love flying your GoPro on a quadcopter. See section about the Karma drone.

Here are a few cool ways to capture airborne video:

- **>> Fly it near fireworks.** If you fly the quadcopter in safe areas (not over a large crowd or near a helicopter, for example), you can take an exciting new approach to filming a firework display.

- **>> Get an overhead shot of the beach.** Flying the GoPro over a beach can create interesting views of the sun and surf.

- **>> Capture your town from above.** It's cool to look at a place you know well from an uncommon view. Capture everything from Main Street to your street for a fun and exciting video.

Abide by the rules. Always keep your quadcopter in your sight. Never fly it around another airborne vehicle or near an airport. And respect other people's privacy.

Get a Dog's-Eye View

If you have a big-enough dog (20–120 lbs.), you can mount the camera on him to get the canine version of a bird's-eye view (see Figure 13-6). You have a few ways to mount the camera, with the best using the GoPro Fetch mount, which is designed specifically for your four-legged pal. Of course, fitting a small chest harness to the dog seems to work well too. It may take a few adjustments to get the harness to fit snugly (and for the dog to get used to it, but that's nothing a few treats can't fix).

When the camera is mounted and on, just let your dog do his thing. The camera is lightweight, and if you mount it properly, it shouldn't cause the dog any discomfort. Also, mount your GoPro to a toy or stick with the handlebar mount for a new perspective of your dog playing or performing tricks.

FIGURE 13-6: Dog's-eye view — well, sort of!

TECHNICAL STUFF

Try to shoot at a frame rate of 60 frames per second (fps) to compensate for the constant motion. Control the camera with Remo or Smart remote seeing as though you can't press the shutter on a moving dog.

Here are some ideas:

>> **Get a dog's view of the dog park.** Watching your dog interact with his canine buddies puts you right in the middle of the action.

>> **Play fetch.** The time-honored game takes on new, exciting meaning when you see exactly what the dog sees.

> » **Take your dog for a swim.** If your dog likes the water, the GoPro is ready for the challenge, providing some interesting footage.

When you're done with the shoot, have a treat ready!

Make a Time-Lapse Movie

It's cool to shoot a bunch of still images to create a time-lapse movie. GoPro makes the process easy, with a special mode dedicated to time-lapse capture. You can speed up the world at the interval of your choosing for fun, or study changing scene over time. Shoot a sequence that shows a parade of commuters walking into the subway or fans filling a stadium, or record an expedited version of your child's Little League game. (Sometimes it's wishful thinking for a game to be that short.)

To make a time-lapse video, you need the following:

> » **Proper settings:** Make sure that your GoPro is turned to Time-Lapse mode and set to the desired interval.

> » **Sturdy mount:** Whichever mount you choose, make sure that it's sturdy and located away from excessive vibration.

> » **Freshly charged battery:** The GoPro's battery doesn't last long, so when you're running the camera for an hour or so, you're at risk of a battery failure. Also, consider using the Portable Power Pack to charge your GoPro during an extended time-lapse.

> » **Something to help pass the time:** Although time-lapse recording produces an exciting effect, creating that recording isn't too exciting. Depending on how long you plan to capture frames, bring along a book and maybe a chair. Come to think of it, bring a beverage and a snack, too.

Capture Your Own Band from the Stage

The GoPro provides an all-access pass to the center of any stage performance. Give the audience a perspective that only the band gets to see by using the removable instrument mount to capture footage right onstage.

Here are some of the places that a GoPro can go during a performance:

>> **Guitar:** Mount the camera on the headstock with the Arm, and position it to show the guitarist's fingers working the frets (see Figure 13-7). Put it on the guitar's body with a gooseneck mount to show the player picking. Turn the GoPro around to capture the rest of the band with your "guitar cam."

FIGURE 13-7:
View of the
frets from the
neck down.

>> **Drums:** If the drummer has enough space to drum, you can put the removable instrument mount anyplace. Use the gooseneck or jaws mount, depending on what you're trying to show.

>> **Keyboards:** Put the camera above the keys to show a close-up and nicely distorted view of the keyboard player's hands.

>> **Microphone stand:** Put the audience right in the middle of the action with a view from the microphone.

Chapter **14**

Ten Professional Uses for GoPro Cameras

D o you make money shooting photos or video? By definition, you're a pro, no matter what your day job is. If you want to gain an edge, adding GoPro to your repertoire can help. Whether you shoot weddings, cover news stories, or create multimedia real estate listings, the GoPro can elevate the quality of the final product.

The camera is already gaining exposure on the pro circuit. Several reality television shows already incorporate GoPro cameras, including the CBS series *Survivor*.

This chapter presents ten professional uses for GoPro cameras.

Professional Photography

The GoPro has found its way into many professional photographers' camera bags. It's fun to use when you're already comfortable with holding a camera, and that near-fish-eye view (I won't bicker over 10 degrees) lets you do some pretty creative stuff with still images and video.

If you're not already using a GoPro in your photography business, here are a few ways you can take advantage of it:

>> **Take ultra-wide-angle pictures.** The GoPro allows you to get close to your subject to create a pleasantly distorted sense of perspective (see Figure 14-1).

FIGURE 14-1:
The GoPro
makes it easy
to capture an
ultra-wide-
angle view of
waterfront
landscape.

>> **Capture time-lapse footage.** Shoot a bunch of still images and play them as a movie, using the time-lapse setting on your GoPro and putting everything together in GoPro Studio Edit (see Chapter 12).

>> **Capture video of yourself taking photographs.** This technique comes in especially handy for in-depth photo essays or commercial shoots.

>> **Mount the camera remotely.** Sometimes it's easier to take the time to mount the camera on a pole or overhead railing than to climb and wait for the shot. After you mount it, you can watch what it's seeing using your smart-phone or device.

>> **Put the GoPro in harm's way.** Some situations make great photographs, but it's too dangerous to capture them directly. Maybe you're covering the running of the bulls at Pamplona or wanting to capture traffic on an interstate highway. Mounting the camera, getting away to a safe distance, and control-ling the camera remotely prevents you from getting run over.

Documentary Filmmaking

TIP

You probably don't want to shoot the entire documentary with a GoPro. Instead, use it as a secondary camera, blending its footage with conventional footage. That way, you give yourself some cool choices for editing. These include:

>> **Tight spaces:** So many times, it's not possible to get a wide enough view with your camcorder, so don't stress about it anymore; just mount a GoPro or two in the room for those situations.

>> **Capture action:** That's what the camera is designed for, and that's how you should use it when shooting scenes for your documentary.

>> **Point-of-view (POV):** A common practice with documentaries is to make the viewers feel like they're part of the scene, as seen in Figure 14-2. It's hard to think of any better way than mounting a GoPro on a headband or harness and walking through a castle, stepping in a battlefield, or maneuvering through a cave.

FIGURE 14-2:
POV footage
from the
inside of a
walk-through
fountain.

Wedding Videography

Depending on how ambitious the bride and groom want their nuptials video to be, the GoPro provides endless possibilities. Thanks to its portability, the camera stays out of the way to capture more natural activity. Most likely, you won't shoot the entire event with GoPro, but you can capture enough cool scenes to make things interesting.

Here are a few cool ideas:

>> **Limo ride:** Mount one or more cameras in the car to document the transportation experience.

>> **Dancing close-up:** Mount the GoPro on a pole or on your head, and get in close on the dance-floor action.

>> **Table views:** Attach the GoPro to an extension pole, hold it above each table, and ask the guests to salute the bride and groom.

>> **Low-angle portrait:** One cool trick is to lie on the ground with the camera facing upward, surrounded by the bridal party standing in a circular embrace. This technique works well for both still photos and videos.

Real Estate Sales

Although it may not sound as exciting as capturing a surfer in a pipeline, there are many good reasons to use a GoPro to capture real estate interiors and exteriors, giving prospective buyers some informative images to consider.

REMEMBER

Most pictures on real estate websites are ineffective images that don't represent the property accurately. Sometimes, they show too little of the property because they weren't shot with a wide-enough lens. Even with a moderately wide-angle lens, you can back up only so far before hitting a wall. The GoPro's lens is so wide that you may have the opposite problem, but it's certainly one you can work with.

Here are some ways to use the GoPro effectively in real estate:

>> **Capture the entire room.** The camera's ultra-wide-angle lens lets you capture a whole room from some tight spots (see Figure 14-3).

>> **Do a walk-through.** When a prospective customer can't visit the property right away or just wants to vet it first, watching a video walk-through can be the next-best thing. Mounting the camera on a headband produces a perspective conducive to what your eyes see when walking through a crowded space.

>> **Go aerial.** Mount a GoPro on a remote-control quadcopter, and fly it over the house to give the viewer a bird's-eye perspective of the property.

Multimedia Reporting

Peek into any multimedia reporter's bag, and you're likely to find a variety of tools: a laptop computer, a smartphone loaded with apps, some sort of camcorder, and perhaps a GoPro camera.

Here are a few ways to use the GoPro on a reporting beat:

>> **Record interviews.** You can capture the audio portion for radio highlights and capture video to accompany the story online.

>> **Capture raw footage.** It's best to capture a scene now and worry later about how you'll use it. Taking raw footage is better than not shooting at all and wishing that you had.

Television News Production

The two roles may seem to be similar, but there's a dramatic difference between the functions of a multimedia reporter and a television producer. The latter relies solely on gathering visual images; the former uses various media to tell the story.

Most news crews use big cameras, but the portable GoPro provides a unique perspective. Even news cameras with expensive wide-angle lenses can't capture as wide a scene as a GoPro can. Also, you can mount a GoPro on a pole above the scene, which you can't do with a news camera; it's way too heavy (and expensive to replace if the pole breaks).

When you're covering television news, here are some ways that the GoPro can work for you:

>> **Get a wide view of a news scene.** Parades, processions, red carpets, and other expansive events are easy to capture when you mount a GoPro nearby (see Figure 14-4).

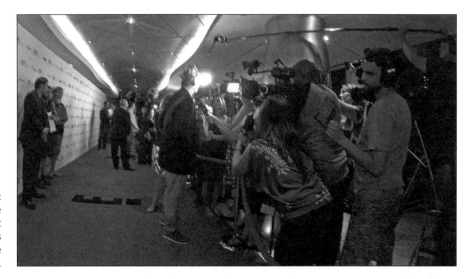

FIGURE 14-4:
View from the red carpet provides a unique cutaway.

>> **Film in tight spaces.** Sometimes, you need to capture news footage from a cramped space. Use a GoPro to fill the frame with all you need.

>> **Create unique visual hooks.** The ultra-wide-angle lens creates footage that integrates nicely with conventional footage for both practical reasons (getting more into the scene) and aesthetic ones (getting a fish-eye view).

Independent Filmmaking

Anyone who ever made a film understands the extended time and high cost of shooting. The GoPro makes a positive difference. Because the camera is so cheap, you can put several of them all over a scene and not have to worry about making alternative takes.

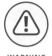

WARNING

You need to use the GoPro sparingly in filmmaking, however, due to its super-wide view. An actor who requests a close-up will think twice about asking for it again when the GoPro makes him look like a bobble head doll.

Home Security

While not its main job, GoPro is perfect for keeping an eye on things. Sure, there are less expensive ways to observe a scene, but GoPro can come through in a pinch. Though it's small, it's not as small as a nannycam, you know, the ones hidden in a stuffed teddy bear. Although not as cute as those peeking bears, GoPro blows away the competition with its superior quality image. Because it's already designed for mounting, there's not the dilemma of "how am I gonna mount my camcorder outside my front door?" With GoPro, you can easily put in anywhere and start observing.

On the downside, the battery doesn't last that long and you have to control it from a nearby smartphone or remote. But it can still work.

Here are some ideas:

>> **Mount it on a pole:** Observe the scene using your smartphone or device. You can control when to record and when to stop.

>> **Put it in the baby's room:** If you don't have a video monitor, the GoPro provides a great solution.

>> **Monitor an entrance or exit:** Whether you're watching the door and want to see who's coming and going, or just need to keep an eye on things. GoPro lets you temporarily place a camera anywhere to observe activity. Plus, it's small enough to fit in cramped spaces.

Traditional Sports Shooters

The GoPro works well for recording sports, whether they're high-school games or local sports events. Regardless of what you plan to use the camera for, capturing great action footage with it is easy.

TIP

Thanks to the camera's durability, coaches in many sports use it to record footage for future reference. Some Little League coaches, for example, use the GoPro as a teaching tool to help young players perfect their mechanics.

Here are a few ideas for recording a few popular sports:

>> **Baseball:** Mount a GoPro on a catcher's mask to get a clear view of a pitch after release. Place a camera in the batting cage to capture footage for later evaluation by players and coaches. Wear a camera on a hat to capture a fielder's perspective.

>> **Basketball:** Try mounting a GoPro (or two) on a glass backboard. You can shoot the full-court game on a conventional camcorder and edit in the backboard shots later, as appropriate.

>> **Swimming:** Mount one or more GoPros in the pool to add an exciting aspect to swim-meet coverage. You can combine this footage with footage captured above the water on another camera.

>> **Skiing:** Capture what a skier sees by putting a GoPro on a ski pole, using a pole mount. Or put the camera on a headband or helmet mount.

Extreme Sports Shooters

Extreme sports make for exciting video. Following are some extreme sports that go well with the GoPro:

>> **Surfing:** Photographers and filmmakers have mounted cameras on surfboards for years, but it did require an expensive waterproof housing and was a bit cumbersome on the board. GoPro is small and out of the way.

>> **Skateboarding:** Use the skateboard mount to get a low-angle view (see Figure 14-5), or mount the camera on a skater's helmet to produce heart-skipping skateboarding video.

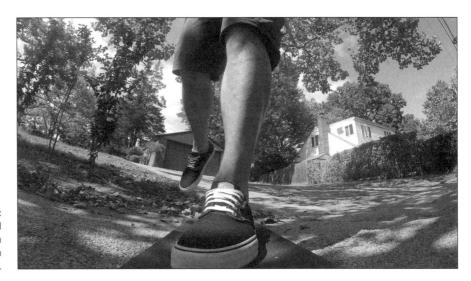

FIGURE 14-5:
Skateboard view of an afternoon stroll.

>> **Skydiving:** Mount the camera on a diver's helmet to capture the free fall and the parachute opening.

TIP

Because of the speeds involved in skydiving, it's a good idea to use a high frame rate — 60 frames per second (fps) or more.

Chapter **15**
Ten Pitfalls to Avoid

Long before they invented cheese in a spray can, situations that were once too dangerous to talk about shooting are now part of the conversation with GoPro. It's amazing how such a small camera has made it possible for you to reveal moments and perspectives that were unheard of a few short years ago. And much like the technology that led to putting cheese in a spray can, it doesn't always mean it's safe, easy, or without problems all the time. Steering clear of the pitfalls is a small price to pay for a camera that goes anywhere and releases the boundaries of what was near impossible a decade ago. Let's look at ten potential issues in no particular order you should avoid.

Not Using the GoPro App

Squinting over your GoPro and poking around the controls every time you want to make a change is a buzz killer. Thanks to its diminutive size and lack of viewfinder (for the most part) using GoPro is not always incredibly intuitive. Add another level of difficulty if you have less than perfect eyesight. It's far beneficial using the GoPro App on your smartphone for controlling the camera and making proper adjustments than reading the tiny nested menus on the camera. Add the fact that you can preview the scene and it's a no-brainer.

Let's recap why you need to use the GoPro App:

>> **Control over the camera:** Provides immediate and clear access to camera functions with no squinting or pressing the wrong command.

>> **Live Preview:** Even if you're using a LCD touch screen, you need to be near the camera to see what's going on, and that's not always practical. Instead, watch the scene form your smartphone and see what the camera sees so you can frame each shot with confidence, as seen in Figure 15-1.

>> **Other benefits:** Besides controlling the camera remotely, the app also lets you view photos and play back movies after you shoot them. You have access to everything shown on your camera's SD card and can manage your files right after you shoot them, avoiding the wait to get back home.

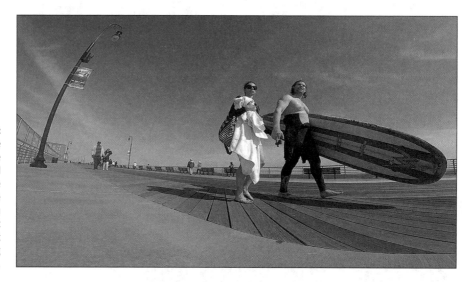

FIGURE 15-1:
Placing the camera on the ground and monitoring the scene from the app allows you get the perfect shot without straining your back.

Pausing When You Didn't Mean It

Immediately after the invention of the record button came the inadvertent action of pressing the button at the wrong time either to pause or record when you meant to do the other. You can reduce the odds of that happening.

TIP

Here's what you can do:

>> **Hands off:** It's a good idea to keep your grubby paws away from the record button, or holding the camera for that matter. Holding while recording increases the risk of inadvertently hitting the button.

>> **Observe the record light:** Some people turn it off, but it's a good idea to leave it on so you have a visual reference.

>> **Watch the counter:** Make it a habit to notice the activity of the counter whether it's on the camera or the GoPro App.

>> **Shut the camera off:** All too often, the camera accidentally records when you're not shooting, leaving you with minutes to hours of recorded gibberish. Powering down decreases the possibility of it happening.

Keeping Your Body Parts Out of the Picture

When wearing a GoPro — or having one nearby — it's sometimes impossible to keep your body parts out of the frame, especially when you're having so much fun. There are times when a limb or two adds dimension to the shot. When? While grasping the handlebars of a mountain bike while zipping through a lush trail, dangling your feet off a bridge before bungee jumping, or extending your arms while spinning a small child (one that belongs to you, please). But sometimes you just want some alone time with the subject, sans limbs. That's not always easy to do, especially with the camera's expansive perspective.

TIP

Here are a few ideas to capture what you want without the extras.

>> **Monitor the scene:** Seems like a no-brainer, but the decision to have your hands and feet in the scene is fine if that's your intention. Watching on your smartphone is one way to control what the camera will record so you can leave out what you choose.

>> **Change the angle of view:** Most newer model GoPro cameras offer several choices, making the angle of view wide enough to capture the scene, yet narrow enough to keep your hands and feet out of it.

>> **Keep your fingers to yourself:** For those times you need to handhold your GoPro don't be surprised that your digits will end up in the frame every now and again (see Figure 15-2). This is bound to happen sometimes, because the camera has no viewfinder and a very wide-angle lens. Unlike those times when you include your arms or legs in the shot, fingers do not look intentional nor do they act as much of a creative visual device, so be extra careful to keep your grubby paws out of the shot.

>> **Don't be afraid of your own shadow:** Still, you should be leery of having it in the frame. Unlike Groundhog Day, there is no reason for your own shadow to end up in the movie or photo. Remember the GoPro has such a wide field of view; you need to be mindful of casting a shadow, especially if the sun is behind your back.

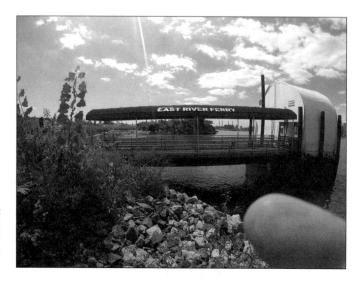

FIGURE 15-2: My finger had an unintended walk-on role in this shot.

Staying Out of Harms Way

Danger, or at least the presence of it, makes using your GoPro more appealing. It's like your sister falling for the bad boy. And just like that situation, it's only impressive when the danger is an illusion and everyone stays safe. Thankfully, the sophisticated set of accessories allows you to take things to the extreme, while keep you out of harms way. Still, it's easy to get caught up in the moment, possibly putting safety in jeopardy.

Here's what you can do to make security your number one priority.

WARNING

>> **Be mindful of danger:** Don't do anything you wouldn't normally do if you didn't have a GoPro. While the camera can capture some incredibly impressive imagery, you don't have to put yourself in peril to accomplish it (see Figure 15-3).

>> **Let the camera do the work:** Just because you position the camera over a waterfall doesn't mean you must stand at the edge. Not when you could strategically use the proper mounts and accessories instead to get close to the action without becoming a casualty.

>> **Make sure the camera is not a weapon:** Just because the camera is so small does not mean it can't hurt someone if it breaks free. Many accidents occur when the camera is not securely mounted, or the mount itself cannot handle the force. The camera can fall and hit someone, or the force can transform it into a dangerous projectile.

FIGURE 15-3: Driving through traffic, this scene was captured from the hood of a car using the Suction Cup mount.

Not Protecting the Camera

As previously mentioned, the camera can break free and end up in a million tiny little pieces, or worse, hurt someone. So, while safety of your friends or strangers comes first, next in line is the well-being of your GoPro. Just because it can go anywhere and do anything, doesn't mean it will come away unscathed. That's why it's important to protect the camera as much as possible.

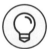

Here are some tips to help ensure your camera stays in place:

>> **Mount the camera securely:** Unlike the question regarding the chicken and the egg, the first order of business is making sure the camera is securely fastened to the mount. Regardless if the camera is mounted to a suction cup or mounted to you – make sure everything is tight. Most of the time the damage to the camera happens when it comes loose and falls (or flies) to the ground with less than favorable results. A second check never hurts, no pun intended.

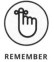

REMEMBER

>> **Understand the risks:** It's obvious that if you mount the Suction Cup mount to a dirty area on your car hood, it can fly and will not bounce like a ball. The same holds true for putting the camera in places where it can fall, be struck by a vehicle, or in some way come on contact with something. So be aware of where you put it.

>> **Tether the camera (when possible):** Sometimes you can save the camera when it breaks free by tethering it. Basically, it's a thin cable or heavy-duty string that prevents the camera from falling or hurting somebody.

>> **Put the camera in a safe place:** Cameras get damaged or stolen when not carefully watched. Many of these situations can easily be avoided with common sense. You know, don't put the camera in the middle of a busy road or leave it unattended. There are lots of other situations, but you get the idea.

Capturing the Scene Too Wide

The problem with ultra-wide-angle lenses is they sometimes capture a more expansive view than desired. Even when relatively close, the main subject can still appear too far away in the frame. Much like sitting on the couch with your dog, the GoPro demands closeness. Extreme closeness! And while your furry kid will draw closer on her own, it's up to you to make sure the camera is positioned near enough to the subject to not make the scene appear "under-lensed." (That's photographer lingo for not being close enough.) That can lead to a very boring composition, something nobody wants to look at for more than a glance.

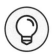

TIP

Try the following to limit this problem:

>> **Get close to the subject:** Put your intimacy issues aside and fill the frame. How close? That depends on the subject and how safe it is to get nearby. Often that means being only a foot or two away, or at least having the subject dominate the frame.

> » **Working the angles:** Sometimes you can make that wide view less boring by changing the angle you position the camera. Even a slight tweak can make the wide composition a little more interesting.

> » **Adding foreground subjects:** Even when you're near the subject, you can still be too far away. For these types of situations, look for an object in the foreground to include in the frame. This can transform a boring scene into something more interesting. (See Figure 15-4.)

FIGURE 15-4:
Framing the shot with the front of the canoe provides depth, and makes the photo more interesting.

Losing Control of Your Drone

Much like a hamburger joint next door to your health club, having your GoPro fly high into the sky is both a blessing and a curse. Every time you launch the drone you run the risk of losing control, and possibly having it fly away never to return, or worse, violently crash into a building. Damaging the camera or losing your mini airship into the abyss is a buzz kill.

TIP

Here are some tips to help keep you airborne.

> » **Start off slowly:** Like learning how to drive a car or a ride a bike, it takes time and practice to successfully fly a drone. Begin the process slowly in an open space, free of poles, wires, and closely-positioned structures. Make small trips at first, then gradually become adventurous with each journey.

>> **Be aware of ordinances:** Just like a San Francisco morning, the regulations for a flying a drone are foggy. That's why it's important to check local ordinances before taking flight; otherwise, you may be intentionally grounded after your maiden voyage.

>> **Stay away from restricted areas:** Some may think of your drone — especially those with cameras attached — as enemy aircraft. That could get you in trouble, so getting your drone shot down may be the least of your worries. Be aware before taking off.

>> **Be mindful of weather conditions:** Wind and rain can affect the flight of your drone and lead to serious problems like water damage, crashing, or both. That's why it's always important to check the weather report before flying.

Getting the Most Out of Audio

GoPro goes practically anyplace and captures almost everything, yet the footage is better seen than heard thanks to those tiny holes on the camera called a microphone. It's better on the new models that include three microphones. Making it worse, older models with a waterproof housing can muffle audio capture. It's like the clarity of speaking to someone with a bucket over your head. Audible, yes, but not incredibly perceptible. The garbled audio captured is acceptable, especially when protecting the camera, but it can be better.

TIP

Here's what you can do to improve audio quality.

>> **Go naked:** Take the camera out of the case to get the microphone out in the open. It will certainly improve the sound quality.

>> **Mount it in the Frame:** Taking the camera out of the case has its advantages, but access to various mounting options does not. That's where the Frame comes in handy. It provides the best of both worlds by keeping the microphone open, yet offers a brace for the camera to freely attach to mounts.

>> **Going with an external microphone:** The built-in microphone provides acceptable audio, but remember, at best, its still a tiny hole on the top of the camera. An external microphone is cumbersome at best, but it's still a great option especially when optimal audio quality is necessary.

>> **Capture audio with a sound recorder:** Record pristine audio with maximum control by using a separate audio recorder. Connect it to a boom microphone, a lavalier, or a directional mike and capture the seen with the best possible quality. When you're editing, just match the tracks with the camera sound for sync, and then delete the camera track.

Keeping the Camera Safe Near Water

Just as it's no secret your monthly cell phone bill is always more than they tell you, the same can be said about using your GoPro in and around the water. Yeah, it's waterproof, but that doesn't mean it's immune to damage. You see, while the camera is waterproof (providing it's in its protective housing), the bad news is it sinks like a stone as soon as you let it go in the water. Seems like a horrible irony, but it doesn't have to end up as a statistic.

Here are some tips for keeping your GoPro camera safe near water:

>> **Keep the camera dry:** Most of the time, the camera is in its waterproof housing, so it's not going to short circuit when you take it in the rain or even shoot with it underwater. That said, if the housing leaks when submerged in water it can damage the camera. Prevention starts with being sure the housing is properly closed, and that the rubber gasket is in place, free of dirt or debris.

A good habit after visually inspecting the O-ring is to run your clean forefinger around it prior to sealing in order to detect hair, sand, or other debris. It only takes a tiny opening to eventually flood the housing. Also, consider purchasing spare O-rings and O-ring grease to have on hand if you notice damage such as a crack or nick.

Gone unchecked, these factors can compromise the integrity of the water-proof case and possibly cause a big problem.

>> **Attach something buoyant to the camera:** If you drop it while in the water, it will sink, and if there's a strong current it may drift out to sea. Remedy this problem by attaching something to the camera that makes it buoyant like the floating Handler, Floaty Backdoor, or a Floaty on the Session, as seen in Figure 15-5.

>> **Keep the lens clean:** Sometimes water droplets on the lens affect the quality of the image, so be sure to clean the lens regularly. There's no worse feeling than having a great shot marred by a droplet.

FIGURE 15-5:
Attach
something
buoyant to the
camera so it
doesn't sink.

Power Outage Cutting the Shoot Short

GoPro captures all kinds of magic, but that only lasts as long as its battery life. One minute you're capturing some compelling action at the beach or in the desert, and the next moment, nothing, because the power runs out. Sometimes the camera runs out of gas because of its limited battery life. But often, it's because the battery did not have a full charge when you started shooting.

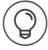

TIP

Here are some tips to help ensure that you don't run out of power:

>> **Make sure the battery is freshly charged:** You should get more than an hour of shooting pleasure from a freshly charged battery. The same can't be said for the charge left over from the last shoot.

>> **Bring an extra battery:** Relatively speaking, GoPro batteries are inexpensive, so it's not a bad idea to carry an extra. And if you need more time, try a Battery BacPac for getting the most life on a single charge.

>> **Carry a Portable Power Pack:** You know, those portable packs that provide extra juice for your cell phone. Well, they also work for your camera. GoPro also makes one specifically for your camera.

Chapter **16**

Ten Ways to Improve Your Moviemaking Skills

A director makes only one movie in his life. Then he breaks it into pieces and makes it again.

— JEAN RENOIR

I suppose being a great filmmaker and descendant of the great impressionist doesn't mean you always speak with a gender-sensitive tongue. But the grand-son of Auguste Renoir, and director of *The Grand Illusion* makes a valid point. While subject to interpretation, it's not off the mark to say it means that filmmak-ers learn how to make movies by making movies. Sort of like finding that thing you do and keep doing it better and better. But in order to make the next one even better, it's important to continually find way to improve your skills.

So let's break down the top ten things you should consider to make the best possible movie. Unlike the Late Show With David Letterman, this top ten list doesn't have any specific order. It's just about making a good movie. While many of these apply to moviemaking in general, they are right at home with GoPro.

Planning Each Shot

It's nearly impossible to assemble a piece of furniture from Ikea without looking at a diagram, so why would you try that with your GoPro movie. Whether you're

making a POV movie, capturing an action event, or taking the camera into the wet stuff, the mantra remains the same: Plan it out and stick to the plan. Strategically planning each shot increases the potential for an amazing movie, while the alternative leads to ineffective capture, poor framing, damage to your GoPro, and bumps and bruises for you.

When shooting your next GoPro movie, consider the following:

>> **Work with a script:** It doesn't have to be a traditional screenplay, just one that provides enough structure to anticipate each shot, or multiple camera setup.

>> **Calculate your shots:** Think of the effective ways to effectively capture the subject. Or do the opposite. Figure what will not work, and don't do it (see Figure 16-1).

>> **Budget the necessary time:** The bigger the adventure, the more time you will need to plan and gather the proper mounts.

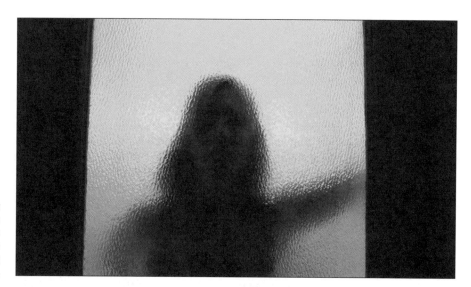

FIGURE 16-1:
This unique glass door was worked into the shooting script.

Telling a Concise Story

Some of the best GoPro movies show the same activity from multiple perspectives. Whether you're using multiple cameras to capture the scene, or shooting several times with the same camera, consider the importance of showing the scene from different angles.

Whether you're shooting a BMX bike jump, a skateboard trick, or a day at the pool, consider shooting the action the following ways:

» **Toward the camera:** Position the camera so action moves toward it.

» **Away from the camera:** Place the camera behind the subject.

» **POV:** Wear the camera to capture that point-of-view perspective.

» **Side view:** Capture the action passing the camera.

» **Overhead view:** Shoot a graphic perspective of the scene from above as shown in Figure 16-2.

» **From below:** Cover the action as it passes over the camera.

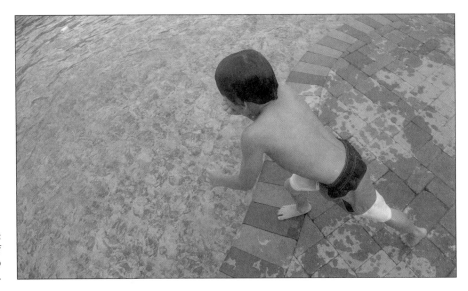

FIGURE 16-2: Overhead of kid about to jump in pool.

Shoot to Edit

If you've got the first two under your belt, this one shouldn't present a problem. Remember to shoot your movies with variations of the scenes you plan to use. There's a misnomer that suggests shooting as much footage as possible, sort of like the Alfred Hitchcock version of a gorging bear, so you have a lot to put together later.

Not the best plan. It will take you a long time to make sense of it, and you'll also find that you use the key scenes you intended to shoot anyway.

Instead, try to capture the necessary shots with the appropriate variations with camera angle, focal length, and camera to subject distance. So if you wish to depict the subject entering a key location, you can concentrate on the variety of ways that happens with an eye on how it comes together in editing.

For each scene, consider the following variations:

>> **Wide, Medium, Tight:** Shoot each scene with these variations. Since GoPro provides three settings of an ultra-wide view, it means these variations are accomplished by alternating your distance to the subject.

>> **Hold each shot:** Whether you need two seconds in your movie or two minutes, always shoot the scene much longer than you anticipate on using it. A good place to start is recording each shot for at least 10 seconds.

>> **Vary your angles:** Don't shoot the entire movie at eye-level; instead, break up shots by placing the camera up high or down low.

>> **Establishing shot:** Be sure to shoot a strong opening shot for the film as well as for each key scene.

>> **Limit each take:** This is where rehearsing comes in handy. Try not to shoot more than three takes, unless you're looking to be William Fincher (*Fight Club*, *The Social Network*). He's notorious for shooting tens of takes. Clint Eastwood, on the other hand, shoots many of his scenes in a single take.

Use the Proper Mounts

The GoPro goes anywhere, doing so with an impressive set of mounting options. Some are quite specific to activity; such as using the Handlebar/Seatpost/Pole mount on your bicycle, as shown in Figure 16-3, or the Surfboard mount for — wait for it — your surfboard. Other mounts are more universal, such as the Suction Cup, Flex Clamp, or adhesive mounts. Then, there is the Head Strap, Chesty, and the Strap for times when you want to wear your GoPro. You can also go old school by using a tripod adapter and attaching it to your three-legged friend for stability.

Consider the following:

>> **Use the right mount:** There are dozens of mounting choices for your GoPro; choose the one that works for your shot. Also, make sure it's properly secured, so you don't mess up the shot, damage your camera, or hurt someone.

- **Use a tripod:** The diminutive GoPro will be hardly noticed atop your tripod, but looks aren't everything. While as disproportionate as a cartoon character with a tiny head and a large body, the benefits are overwhelming when it comes to great stability and precise framing. You will need an optional adapter, but it's worth it.

- **Rehearse your moves:** For those times when you're wearing the camera, the difference between capturing impressive footage and having trash can discards lies in effectively moving though the scene. That's why it's a good idea to practice your moves before hitting the record button. Use the app to view your movements and tweak them for capturing the scene.

FIGURE 16-3: GoPro mounted on bicycle handlebars using the Handlebar/ Seatpost/Pole mount.

Understand GoPro like the Stats for Your Favorite Team

Or simply download the Capture app. Why? Because there's nothing worse than fumbling with your GoPro as an important shot passes before your eyes. That little bit of uncertainty often becomes the difference between success and failure. GoPro movies are slightly more complicated than hitting the record button, while at the same time, not really complicated at all. It's just a matter of knowing where the controls are located and what they do, so that you can adjust them on the fly. While you can do it on the camera, it's even easier to download and sync the Capture App.

Here's what it does:

» **Control camera functions:** Remotely control your GoPro from near or afar. Change camera modes, adjust settings, or delve deeper with ProTune. You can make sure it all looks good without even being near the camera. But you need to know where they are and what they do, first.

» **Live preview:** No more contorted positions when you can observe the scene through your smartphone or tablet. What could make it easier to frame the perfect shot?

» **Share it immediately:** Feedback is an important part of the process, and the ability to share a clip or photo right after you take it can be helpful. Share photos and videos to Instagram, Facebook, Twitter, and more.

Using Light to Your Advantage

Waiting for the right light shares similarities with going to the Department of Motor Vehicles; it's essential, but sometimes it requires waiting, and other times, being in the proper direction. Obviously, early morning and late afternoon light is the most flattering, but don't count out the clouds either, as their cover helps capture even illumination. Whatever the case, many GoPro situations put you in a passive situation controlling the light.

Consider the following:

» **Observe the direction of light:** Make sure the action is effectively illuminated. It's hard to always have the sun at your back, especially when the camera is separated from you. Nonetheless, the light must illuminate subject, not backlight it.

» **Take advantage of overcast condition:** Cloud cover offers many advantages. You don't have to worry about the direction of light because our cumulus friends act like a giant diffuser, providing a flattering illumination from all sides.

» **Shoot night scenes:** Sometimes the subject is light, or at least illuminated, as shown in Figure 16-4.

» **Watch out for lens flare:** That super wide-angle view is both a blessing and a curse. Actually, the wide-angle view is a blessing, but you need to keep an eye out for lens flair (that's when light comes into the lens).

FIGURE 16-4:
The primary
light source
for this
scene is the
subject itself,
along with its
reflection.

Never Skimp on Composition, A.K.A. Occupy Frame!

Compose to create visual prose is what I always say. Sadly, I'm no poet, and many let me know it. But I digress. How you fill the frame determines the strength of each shot. The more you consider what happens in that rectangular space, the better your movie will look. Remember, the audience will never know anything more than the visuals they see on screen. You have the power to influence them, depending on how you frame the shot.

Remember this:

>> **Look before you leap:** Besides being literal advice for us GoPro shooters, it also means that you should check your shot and direction of the action before pressing the record button. (See Figure 16-5.)

>> **Don't forget the rule of thirds:** Because the subject dead smack in the center of the frame rarely looks good, dividing the frame into thirds like a tic tac toe board helps prevent this *faux pas*. The subject never appears center square, rather on points of intersecting lines.

>> **Change the Field of View:** Altering the size of the subject in the frame provides de facto versions of wide, close-up, and normal views.

>> **Shoot at different angles:** Besides shooting at eye level, place the camera high and shoot down on the subject, or mount the camera low and shoot up at the subject.

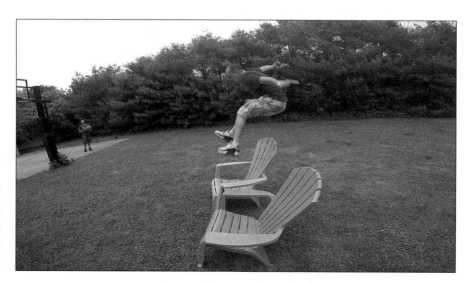

FIGURE 16-5: While it's an actual leap, it was necessary to position the camera in an effective place.

Remember to Get Enough Cutaways

While they're not the main subject, cutaways are an essential part of the sequence, and ultimately, the movie. Cutaways are best defined as those shots of anything other than the subject that either cue the audience to something they need to know or to serve as an interruption to the action.

So many subjects, and parts of subjects, for that matter, fall into this category. For example, the tapping foot of a musician, or a hand pulling a set of car keys out of a tray certainly qualifies.

Here are some other to consider:

>> **Crowd shots:** Think concert film and those fans mouthing the words.

>> **Animals moving away quickly:** The flock of birds taking off, the cat running away, or a barking dog giving chase all let the audience know something bad is about to happen.

>> **Exterior details:** Capture visual details that let the viewer know something about the story you're trying to tell. Show some local flavor, address number, equipment indicative to the activity, or any other relevant objects (see Figure 16-6).

FIGURE 16-6:
A sandy foot
adds a nice
touch to a
beach movie.

Don't Forget about Sound

Admit it! Part of the fun of watching a GoPro action movie is hearing it. That's because great movies have great sound. So take the time to make sure you're getting good clean tones for your next shoot. GoPro audio capture has improved, especially on the HERO5. That's because the waterproof housing no longer smothers the camera's built-in microphone. Still, it's not perfect when it comes to wind noise.

You can also connect an external microphone to your GoPro using the optional Pro 3.5mm Mic Adapter, but a more practical solution for high-quality audio is to capture audio separately with an audio recorder. Not only does this device offer more control over audio capture, it also allows you to connect a variety of microphones. Afterward, just match the camera audio with the separate recording.

These include:

>> **Stick microphone:** These work great for interviews, and when used close to the subject (no more than 12 inches.)

- >> **Shotgun:** This long, narrow microphone excels at picking up sounds directly in front of it, and not affected by sounds to its side. And as long as you aim a shotgun microphone accurately, it has a long range.

- >> **Lavaliere:** Clip one on your actor or subject, and have no worries of using the right microphone. Just make sure you position it correctly so that the fabric doesn't create any noise.

Watch Lots of GoPro Movies

While it's true that a filmmaker learns how to make films by making films, watching films is equally beneficial. You can learn a great deal from your fellow GoPro moviemakers, and be entertained while doing it. You can absorb ideas about a variety of areas from technique and subject ideas to positioning and mounting the camera. You can also share your movies, so others can do the same. But it doesn't stop there. You can learn a great deal from feature films, too.

Consider the following:

- >> **Connect with GoPro Plus:** This subscription service from GoPro allows you to access and share content on the cloud immediately after you capture it. Go to www.gopro.com for more details.

- >> **View GoPro action movies:** Search on YouTube to find GoPro movies and channels. You can also create your own account to become part of the community.

- >> **Watch the masters**: Observe how Alfred Hitchcock uses visual language or how Woody Allen works with so many actors.

- >> **Break down really bad movies:** Same observation but with a different intent. The idea here is to find the aspects that don't work well in the movie, or perhaps, almost work.

- >> **Have a healthy DVD collection:** You can watch movies on television, but buying them at a discount store is your best option. Sometimes you can get these movies you more than likely never heard of for a buck or two. You can watch them frame-by-frame or in slow motion to learn from the best . . . and the worst.

Index

A

H

H264 video compression format, 228
hair light, 149
halogen bulbs, 138
hand strap, 11, 50, 115, 251
handholding camera, 47, 112
handlebars, mounting to, 44, 129, 130
The Handler, 37
hard drives
 archiving on, 239
 types of, 177
harnesses. *See also* Chesty harness
 Fetch, 49
 Karma, 51
HD (high-definition) video, 13–14, 16, 18, 20
HD 1080p export option, GoPro Studio Edit,
 227, 229
HD 720p export option, GoPro Studio Edit, 227, 229
H.Dynamic slider, GoPro Studio Edit, 216
Head Strap
 crowd shots, 250–251
 overview, 11, 48
 personal watercraft shots, 127
 for POV shots, 116
 roller coaster shots, 118
 tips for using, 112–113
headphones, working with, 167–168
helmet mounts, 12, 48–49, 129, 246
Help menu, GoPro Studio Edit, 192
HERO model, 21
HERO Session, 18–19
HERO4 Black, 19–20, 23–24
HERO4 Silver, 20–21, 23–24
HERO5 Black, 15–17, 23, 36, 37, 39
HERO5 Session, 17–18, 23, 39
high angle shots, 107
high-definition (HD) video, 13–14, 16, 18, 20
high-intensity discharge (HID) lights, 140–141,
 147–148
Hightail, 241
Hi-Light Tag, 20, 68–70
home security uses, 263

horizon
 balancing, 80
 rule of thirds, 99
Horizontal slider, GoPro Studio Edit, 216
Hot Day preset, GoPro Studio Edit, 221
hot spots, 145, 146
household lighting, shooting in, 137–140
H.Zoom slider, GoPro Studio Edit, 216

I

ice skating shots, 247
icons, explained, 3
iMac series, 172–173, 174
Image feature, GoPro Studio Edit, 218
image sensor, 57–58
image size, viewing in GoPro Studio Edit, 210
iMovie, 182
Import & Convert pane, GoPro Studio Edit, 187,
 197–198
Import Bin, GoPro Studio Edit, 197, 207
importing media, GoPro Studio Edit, 189, 192–193,
 197, 207–208, 223
in and out points, GoPro Studio Edit, 211–213
incandescent light bulbs, 139, 145
independent filmmaking, 263
indoor shooting, 137–140
instrument mounts, 46
intellectual property, protecting, 241
intelligent battery, HERO Session, 19
internal hard drive, 177
interviews, shooting, 261
intimate wide shots, 95, 96
ISO settings, 63–64, 78

J

Jaws Flex Clamp, 43

K

Karma Controller, 51
Karma drone, 51, 130–132, 252, 273–274

About the Author

John Carucci has written about technology for more than 20 years and has published several books on the subject, including *Webinars For Dummies* and *Digital SLR Video and Filmmaking For Dummies*.

John has written more than 100 articles on photography, video, and technology. His work has appeared in many publications, including *American Photo, Popular Photography, PDN, Shutterbug, Photo Pro, PC Photo*, and others. He was also a contributing editor to *Popular Photography Magazine* from 2000 to 2002, writing about digital image and video technology. In addition, he was a contributing writer to *Photo Insider*, for which he wrote a bimonthly called "Digital Bytes" from 1998 to 2002.

Currently, John works as an entertainment news producer for Associated Press Television, where he covers music and theater. Those responsibilities include arranging and conducting studio interviews, covering field assignments (red carpets, news events, interviews, and so on), script writing, and editing both television packages and online segments. In addition to his television work, John writes general news stories on the entertainment beat. Prior to that appointment, he was a photo editor covering sports, national, international, and features.

Dedication

To my usual suspects, who make their way on stages, sets, and boats.

Author's Acknowledgments

Although it's always fun, it's not always easy to use a GoPro camera effectively. It's even more complicated when you try and explain how to do it. It takes a lot of support to get it done, so I need to thank some folks.

Let's start the folks at Wiley Publishing, starting with executive editor Steve Hayes for continuing to provide challenges, and for having the patience to continually modify the plan to accommodate my busy schedule. Thanks to editor Colleen Diamond for piecing this ever-evolving set of words and pictures together in a cohesive form.

I would also like to extend a great deal of gratitude to the folks at GoPro. There's nothing like getting sound advice from the people who make the camera. Special thanks to Jennifer Meyer.

Thanks to my agent Carol Jelen for continuing to find great projects for me. Appreciate all your help.

And once again, thanks to Jillian, Anthony, Stella and Alice for the necessary grounding.

Publisher's Acknowledgments

Executive Editor: Steve Hayes

Project Manager: Colleen Diamond

Development Editor: Colleen Diamond

Copy Editors: Colleen Diamond

Technical Editor: Steve Perez,
 Perez.com Productions, LLC

Editorial Assistant: Serena Novosel

Sr. Editorial Assistant: Cherie Case

Production Editor: Tamilmani Varadharaj

Cover Photo: Ian McDonnell/iStockphoto